Futurism

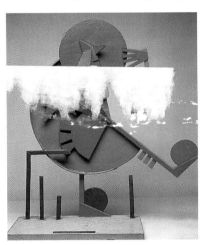

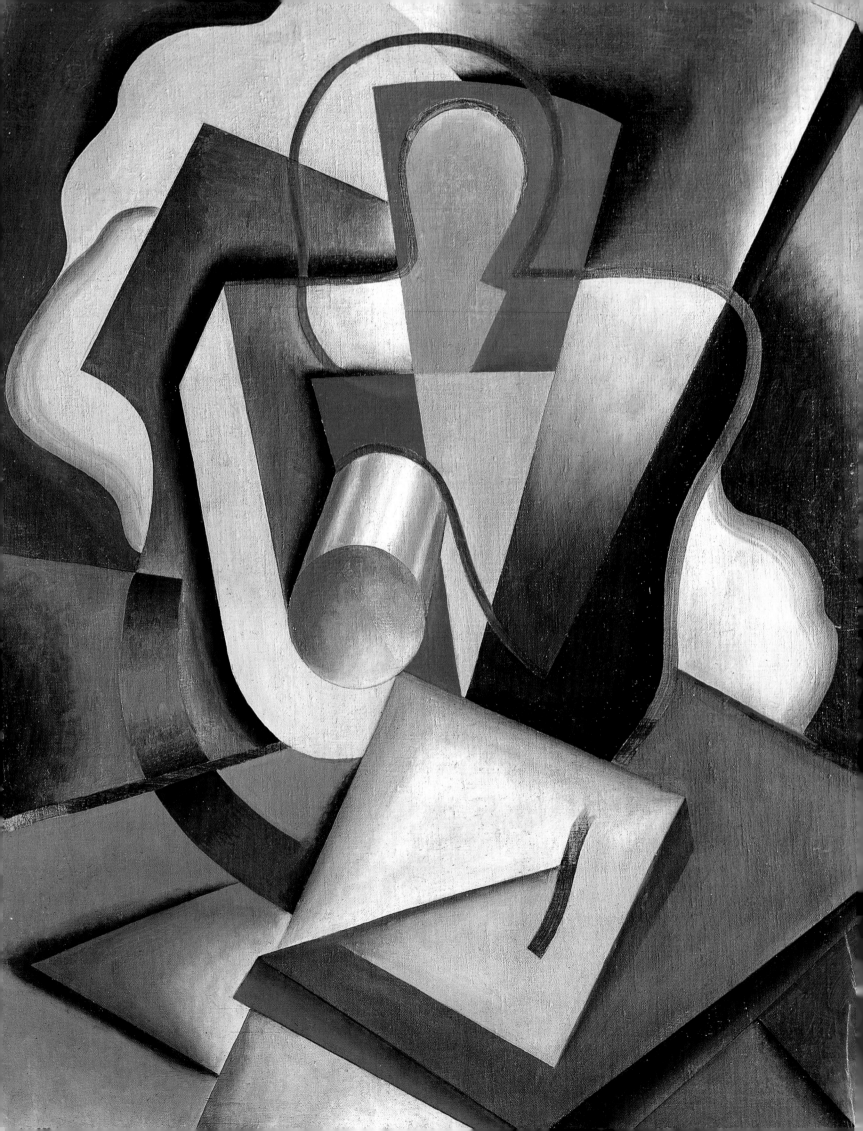

GIOVANNI LISTA

Futurism

Cover illustration
Ivo Pannaggi
SPEEDING TRAIN
Detail. 1922, oil
on canvas, 100 x 120 cm
(39 3/6 x 47 1/4 in).
Cassa di Risparmio, Macerata.

| Fortunato Depero
THE TOGA AND THE MOTH
1914, cardboard
and varnished wood,
58 x 54 x 10 cm
(22 13/16 x 21 1/4 x 3 15/16).
Museo d'Arte Moderna e Contemporanea,
Trento – Rovereto.

Page 2
Nicolay Diulgheroff
THE PROFESSOR
OF RATIONAL MECHANICS
1930, oil on canvas,
94 x 74 cm
(37 x 29 1/8 in).
Private collection.

Editor: Geneviève Rudolf
Layout: Marthe Lauffray
Translation: Susan Wise
Copy editor: Hélène Cœur
Iconography: Laurence Debecque-Michel
Lithography: Litho Service T. Zamboni, Verona

Published with the assistance of French Ministry responsible for Culture,
Centre National du Livre.
© FINEST S. A./ÉDITIONS PIERRE TERRAIL, PARIS 2001

Publication number: 281
ISBN: 2-87939-234-9
Printed in Italy

Nicolay Diulgheroff |
RATIONAL MAN
1928, oil on canvas,
99 x 113,5 cm
(39 x 44 11/16 in).
Private collection.

Pages 8-9 |
Luigi Russolo |
THE REVOLT
Detail.1911, oil on canvas,
230 x 150 cm
(90 9/16 x 59 9/16 in).
Kunsten der Gemeente Museum,
The Hague.

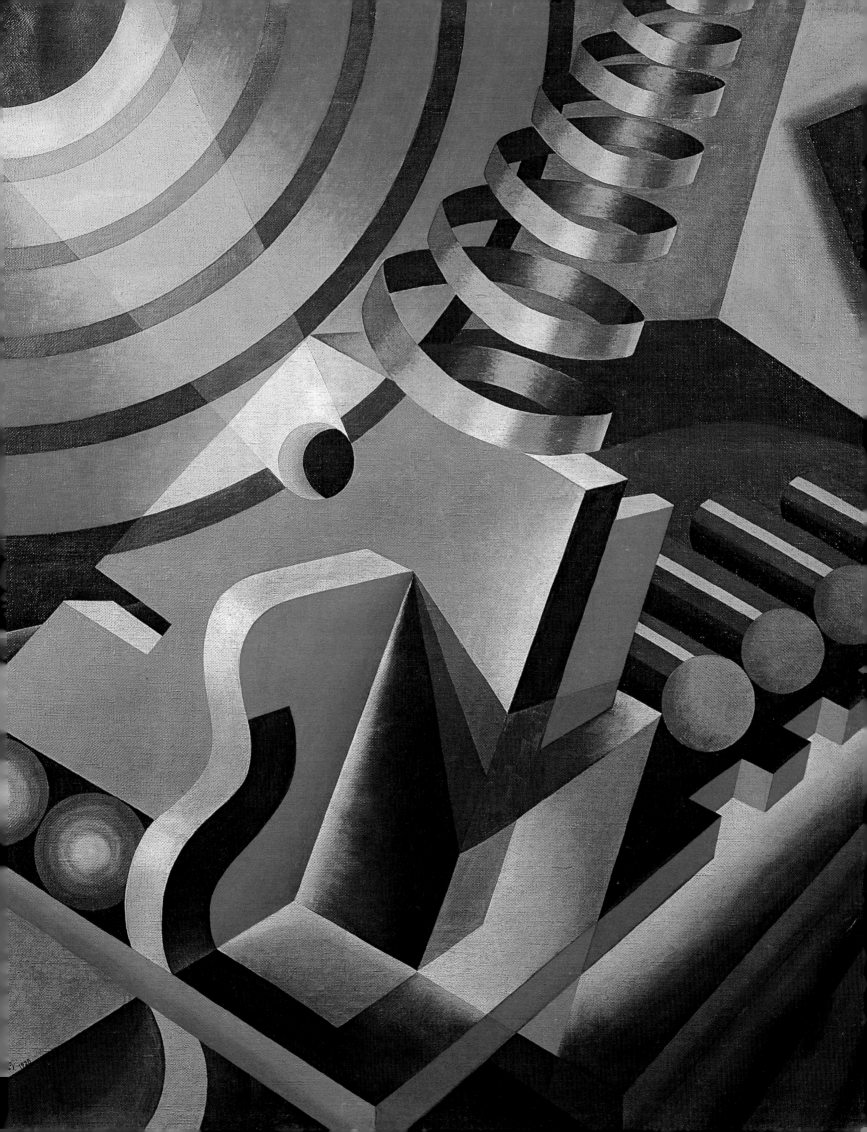

Italy,
that for ages lagged
behind the great nations, must resume
its role as **CREATOR** and forerunner, that's why an
ENERGETIC action of rejuvenation and liberation
is pressing and necessary.
Giovanni Papini,
1913

Futurist
MOVEMENT
means assiduous, organized and
systematic encouragement of creative originality,
even if at first sight it seems **INSANE.**
Filippo Tommaso Marinetti,
1913

I am a Futurist because
the excessive veneration for the " Glorious
Past ", the golden ages and the eternal, **IMMORTAL**
academy with its thousands of wiles mortifies intelligence, abases the soul,
curbs inspiration and finally renders **STERILE** the
peoples that fail to react in time.
Giovanni Papini,
1913

A
RACING car
with its trunk enhanced with
huge pipes like fire-snorting snakes...
A **ROARING** automobile, that looks like it's racing
over a hail of bullets, is more beautiful than
the "Victory of Samothrace."
Filippo Tommaso Marinetti,
1909

Pictorial
works will be **SWIRLING** musical
compositions of huge colored **GASSES** that, on the stage
of a free horizon, will touch and **ELECTRIFY** the complex
soul of a crowd we cannot yet even **IMAGINE.**
Umberto Boccioni,
1910

Everything
is moving, running,
CHANGING fast. A profile is never
still before our eyes, but incessantly appears and
disappears...Moving objects multiply, change shape as they follow one
upon another, like headlong **VIBRATIONS**, in space.
That is how a **RUNNING** horse does not
have four legs, but twenty...
Umberto Boccioni,
1910

We
get far more
ENJOYMENT out of ideally
combining noises of tramways, automobiles, **CARS** and
vociferous crowds than by listening all over again
to, say, the "Eroica or the Pastoral".
Luigi Russolo,
1913

The
cinematograph
gives us the dance of an object that
splits and is **RECOMPOSED** without man's
intervention. It gives us the backward thrust of a a diver whose feet
spring up out of the sea and **FORCEFULLY** bounce
on the diving board. It gives us a man running
at 200 kilometers an hour.
Filippo Tommaso Marinetti,
1912

Giacomo Balla |
BALTRR PLASTIC NOISISTICS
1914, watercolor, collage
of various papers and tinfoil
on paper, 113 x 98 cm
(44 1/2 x 38 1/2)
Private collection.

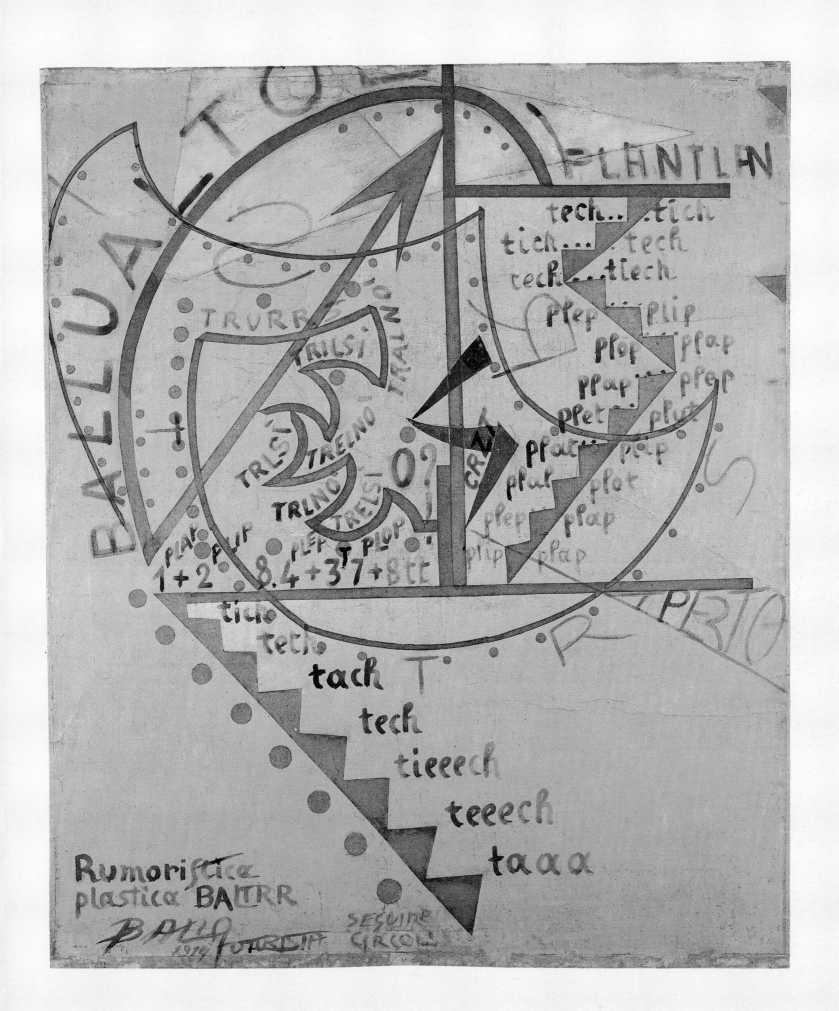

Contents

Introduction

Futurism, the first avant-garde movement of the twentieth century, was founded in January 1909, in Milan, by the writer Filippo Tommaso Marinetti. It was neither a school of painting nor of literature, but a revolutionary movement whose aim was to create a new sensibility and a new approach to the world in general and to art in particular. Thus, in his founding manifesto, Marinetti strived to define the attitude man and art should assume faced with the driving force of progress. In proclaiming the repudiation of the past, Marinetti wished to be the herald of an unconditional advent of modernism, the apostle of a positive faith in the perpetual renewal of man's social environment and existential conditions. So Futurism was an anthropological project: a new vision of man faced with the world of machines, speed and technology. Last, in Marinetti's view, Futurism was a mental discipline. Being a Futurist meant pursuing the perpetual regeneration of all things, that is, seeking the utmost integration of human life with the logic of becoming.

The "Futurist movement" substantiated that mental discipline through the will for renewal, activist militancy and creative enthusiasm, that committed a whole group of poets and artists to a common program. As soon as it was founded, Futurism assumed the role of a philosophy in action and in progress, embodied in a permanent cultural revolution that sought to branch out to all fields of human activity, from art to politics. Being the ideology of the boundless promises of the future, in the long run, it would come to express the values and the spirit of the entire century, by representing the enthusiasm of youth, by shaping the buoyancy and the natural optimism of the modern world, by introducing art in the everyday media, and by exalting the mythology of the new over the conformism inherent to traditions.

This advent of Futurism on the European cultural scene, in the first years of the twentieth century, marked the birth of the avant-garde: art was no longer willing to be a sterile contemplative activity limited to academies and museums. It sought to be a vital force at work in the very midst of society. As for the artist, after being a marginal personality, either a bohemian or a genius, according to the romantic model, he was elevated to the role of a cultural operator, claiming for himself a new role in society and a direct participation in history. His revolutionary activism abolished any distinction between creation and action.

Another task of Futurism was to bring art closer to life. The Futurists wanted to reformulate the myth of the total work of art, attuned with urban civilization and its vital, sensorial experience: words-in-freedom, music of noises, kinetic sculptures, mobile, sonorous and abstract plastic compositions, glass, iron and concrete architecture, art of motion, plastic dancing, abstract theater, tactilism, simultaneous games, and so on. Their experiments concurrently expressed a constant aspiration to re-invent, through art, everyday life: fashion, design, toys, mail, graphic creation, typography, furniture, sport, cuisine, behavior, sexuality, as so forth. The Futurists' challenge was to combine all the aspects of modernism within esthetic creation, re-inventing them both in the same dynamic movement.

Futurist art contributed to the denial of any kind of absolute, instead glorifying the ephemeral and the transitory as new, non-religious forms of eternity. In calling forth the future with all his might, Marinetti refused to elaborate a vision of utopia. He had no intention of drawing up the design for an ideal city: his Futurism rejected utopian speculation, so as to dedicate itself to an immediate activism, iconoclastic and provocative, open to every possibility. With its emphasis on action, Futurism proved its revolutionary intent, found in other avant-garde movements of the century, that would in turn seek to materialize the connection between art and society, between creation and the political gesture, sometimes at the cost of grave mistakes.

So Futurism is above all a philosophy of becoming, that is expressed by an activism exalting history as progress and celebrating life as the constant evolution of being. Such a philosophy, since it always plays an active role in its time, leads to a creative process and to concrete actions, necessarily determined by the world around it. In other words, a Futurist of today would be a fan of computer-generated images, a Futurist of the sixties would have been a visionary of the space conquest, each period providing the most contingent contents of an idea that in itself is eternal. As a consequence, a Futurist of the beginning of the twentieth century had to understand his time and symbolize its new myths, such as electricity, flows of energy, the metropolis and the machine, tamed at last beyond the realm of factory-production paces.

At the beginning of the twentieth century, discoveries in the fields of chemistry, electricity and technology con-

stantly followed one on another, producing an incandescent mood that spread throughout Europe. Artists were seeking ideals and images that could embody these new realities. A decisive change came about when electricity replaced coal, thus altering the very notion of modernism. The advent of electricity, coinciding with a new awareness of energy as a vital flow, as omnipresent as it was impossible to grasp, inspired an art that was able to appropriate, as well as represent, this new factor. The myth of electric energy gave rise to the fantasy of the Electricity Fairy, while that of the vital flow inspired Loïe Fuller to create Serpentine Dancing: an art of immateriality entirely devoted to the "poetry of motion." Completely suppressing the narrative role and the anthropomorphic dimension of dance, Loïe Fuller created a perpetual whirling of colors and forms expressing the uninterrupted action of the energy that generates universal life. Her dazzling performances became emblematic of the dawning century. Futurism is the only movement in which this aspiration toward an art that could provide a response to the forms of this new modernism would be actually embodied in a program and a new original organized approach.

A while later, the automobile, an instrument of speed, took over the city, reduced distances and opened the era of machines entirely submissive to human desire. Its epic tale unfolded in sports racing, where records were broken one after another. It seemed as though machines might multiply human capacities. The new man was a man of speed, able to rebuild space and time around his own power. This is obvious in the various monuments raised to the heroes of automobile racing, like the one honoring Léon Serpollet, speed recordman, on the place Saint-Ferdinand in Paris. Another monument, erected at the Porte-Maillot, in Paris celebrated the engineer and racing driver Émile Levassor who, in 1895, set a record with his Panhard car by covering the distance from Paris to Bordeaux at the remarkable speed of 24.6 kilometers an hour. That public work, some eighteen years after the Eiffel Tower, showing the new man as the master taming a lunging wild beast-automobile, was neither glorifying industry nor the new materials necessary to the technical progress of man, but indeed the triumphant spirit of speed. It was in keeping with that spirit that the Futurists would sanctify the automobile in art, seizing upon it both as a model of a new esthetics and as a wonderful symbol of modernism.

Henri de Toulouse-Lautrec |
**LOÏE FULLER AT
THE FOLIES-BERGÈRE**
1893, oil on canvas,
63 x 45 cm
(24 13/16 x 17 3/4 in).
Musée Toulouse-Lautrec, Albi.

It was also the period when an age-old dream came true: the conquest of the air. Feats of aviation, from the Wright brothers to Blériot, never ceased, setting more and more daring records. Flight offered contemporary man the thrilling sensation of going beyond his physical limits, just as the telephone and the telegraph gave him the gift of ubiquity. Such an extension of human capacities found its match in photography and the motion pictures, that dematerialized reality, causing the phenomenological appearances of matter to explode. Photography allowed to rediscover the world from a new point of view, while its use in scientific fields revealed the infra-visible and triumphed over the opacity of bodies. Cinematographic projection paved the way for the new visual culture of swift, moving images. Staging life as a performance, the cinema expressed in objective terms, by its realistic effect, all kinds of imaginary and subjective visions of time and of space.

In the literature of the day, the haunting obsession of the "tentacular cities" of Émile Verhaeren, the celebration of the locomotive by Walt Whitman and Giosué Carducci, or the glorification of the automobile by Mario Morasso and Octave Mirbeau, illustrated the mythology of a changing world. The state of mind of the man wandering amid the huge crowds of the metropolis inspired Jules Romains'"unanimism", while social conflicts and the harshness of the modern world gave writers like Paul Adam the opportunity to renew the Naturalistic novel. The attitude of the Symbolist poets, expressing their longing for an inaccessible ideal, now appeared a thing of the past. For artists, the automobilist and the aviator, those new masters of the tamed machine, summed up the figure of the new man. Grappling with these powerful mechanisms, they expressed, by their feats, the brutality, the dionysian giddiness and the strength that seemed to typify the coming civilization. Youth, having to assert its enthusiastic love of life and its ambition to reshape all values, moral as well as intellectual, perceived in Nietzsche's Overman the spiritual model that could embody the radicality of the transformation under way.

Although it reflected an entire era, Futurism took root above all in Italy. It was in that country that the academic spirit and conservative traditionalism were the most adamantly opposed to the advent of the new ideas. The development of big industry did not begin there until 1880, concurrently with the building of the first electric plant. In 1884, the first *Mostra Internazionale di Elettricità* was held in Turin. The development of the "industrial triangle" connecting Turin, Genoa and Milan, led to the demands of the workers, who were inspired by the anarchist utopia and by revolutionary unionism. In Milan, the first Workers'House was founded in 1891, two years later, electric tramways were running and electric clocks ticking away. In 1895 Guglielmo Marconi, in his home near Bologna, invented the T.S.F. (Wireless Telegraphy). The first automobile race took place in 1897, over a distance of 31 km, in the vicinity of Novara. In 1898, a second *Esposizione Internazionale di Elettricità* opened in Turin, the city where the following year FIAT was born, an automobile trademark that was to have a great development. The swift extension of the railway network, particularly in the north of the peninsula, climaxed in 1899 with the inauguration of the first electrified railroad connecting Monza with Milan. In 1901, on the occasion of the first International Automobile Exhibition, in Milan, the Grand Prize of the city was awarded to Ettore Bugatti, a name that would become famous in automobile sport. Because the modernization of society promoted a civilization of leisure, the Italian Touring Club opened in Milan in 1904. In 1905, industrial concentration led to the forming of ILVA, the first Italian steel-manufacturing trust. In 1906, Milan held a great *Esposizione Internazionale* to celebrate the opening of the Simplon railway tunnel that, crossing the Mont Blanc from Italy to Switzerland, was the longest in the world for its day. Last, sports became widely popular: during the same year, 1907, the first Milan-Sanremo bicycle race was held; the Pekin-Paris 11,000 km-raid was won by the Italians Scipione Borghese and Luigi Barzini; the German Cup and the French Grand Prix were carried off by the official driver of FIAT, Felice Nazzaro. Futurism was part of this process of acceleration, in which all of youthful Italy wanted to be in the front rows of modernism, and to shift from the pluri-secular traditions of a local, regional civilization to a national culture open to the European dimension.

Born in Italy, Futurism was to become a reference for the avant-gardes of the 1910s and 1920s: Russian Cubo-Futurism and Constructivism, Brazilian Modernism, Spanish Ultraism, English Vorticism, Swedish Electricism, Mexican Ardentism, Hungarian Activism, Polish Formalism, and so on, not to mention Dadaism and Surrealism. In most of these movements we can find, along the same lines as in Futurism, the strategy of manifestos and "*soirées*," the organization of performances, the projection of cultural action in the very midst of the social environment. Its historical role has been enormous, since its exemplarity made it the paradigm of what has been called "the century of the avant-gardes."

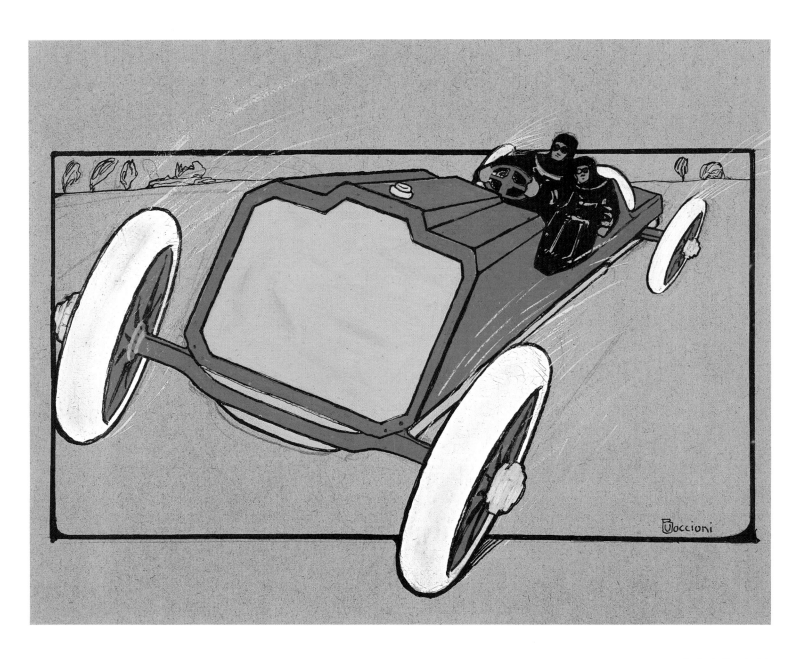

Umberto Boccioni |
RED AUTOMOBILE
1904-1905, tempera on
cardboard, 20,4 x 30 cm
(8 x 11 13/16 in).
Private collection.

1

A Dream of Italy

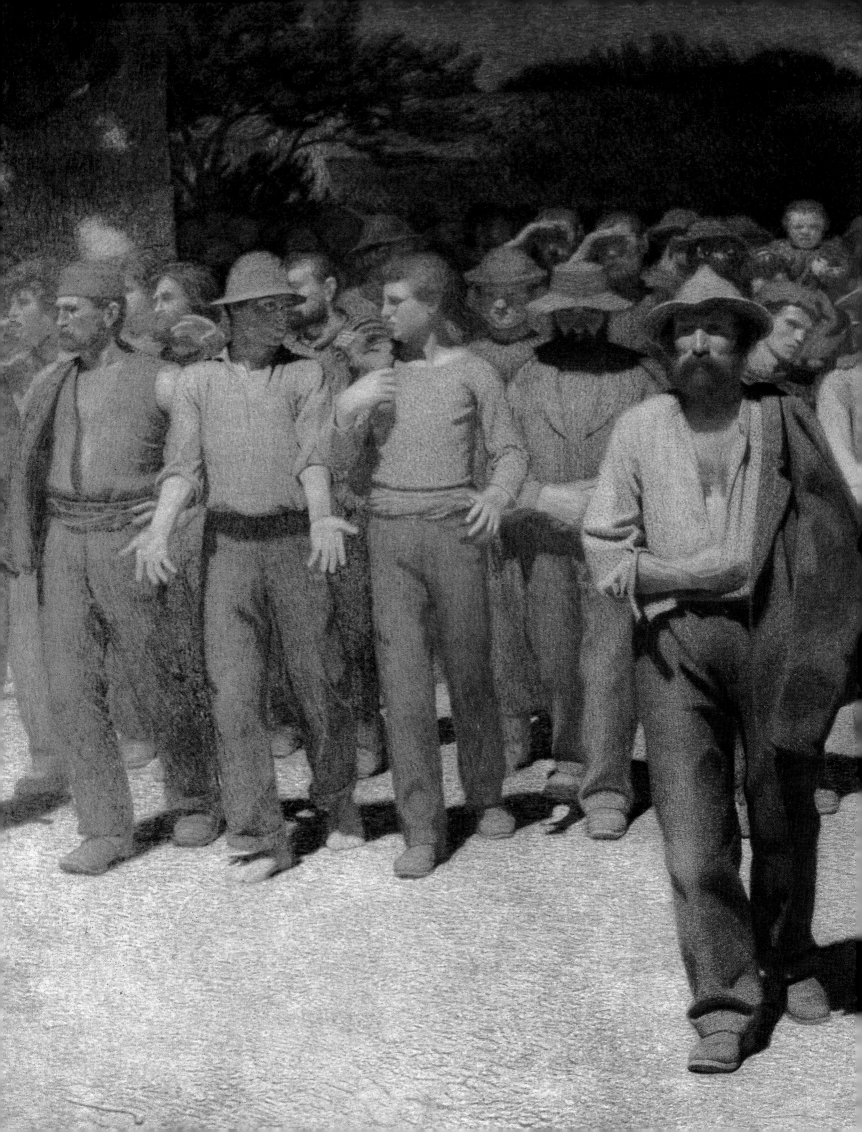

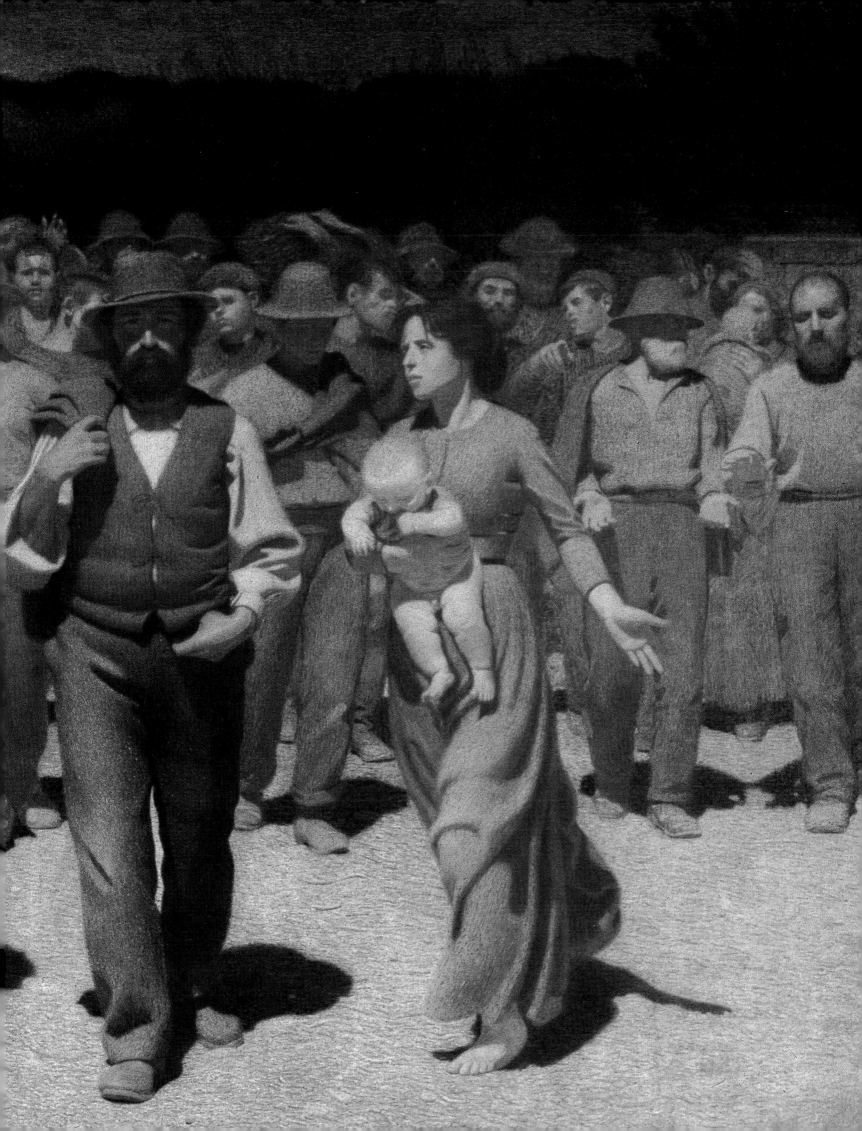

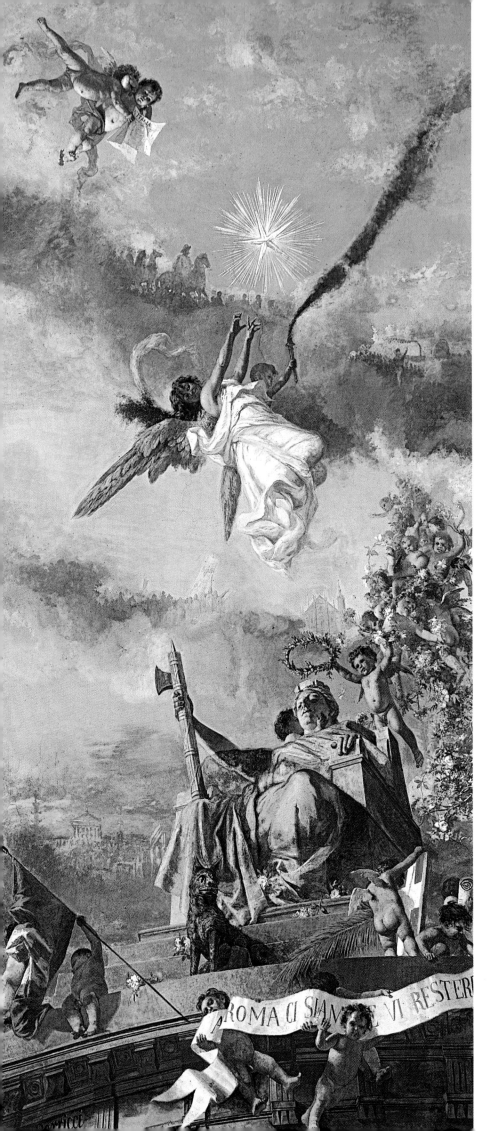

Pages 16-17
Giuseppe Pellizza Da Volpedo
THE FOURTH ESTATE
Detail. 1901, oil on canvas,
285 x 543 cm
(112 1/4 x 213 13/16 in).
Civica Galleria d'Arte Moderna, Milan.

Ignazio Perricci
THE STAR OF ITALY
1884, fresco of the ceiling
of the Sala della Lupa
(Hall of the Capitoline Wolf).
Chamber of Deputies,
Palazzo Montecitorio, Rome.

Cesare Maccari |
FREE ITALY
1882-1889, fresco of the
ceiling of the Main Hall.
Senate, Palazzo Madama, Rome.

By the middle of the nineteenth century, subsequent to the battles of the *Risorgimento*, Italy had finally achieved its political unity. Cavour had chosen the name "*Risorgimento*" (literally, coming back to life) to challenge the notion that Italy could no longer be anything but "the land of the dead," according to an image spawned by Romanticism. It was in 1807, in *Corinne ou l'Italie*, that Mme de Staël had claimed that all that Italy had left was "its glorious dead," and that Rome had become "the land of tombs." In turn, Lamartine had written in 1825 in his *Dernier chant du pèlerinage d'Harold*, in the manner of Byron, that Italy was nothing but "the land of the past." For the French poet, who spoke of Italians as "shades of a race," Italy was no more than a "monument in ruins," peopled by "the dust of men." A number of times throughout the *Risorgimento* the Italians reacted with pride to that manner of thinking. As for instance, to avenge that affront, Colonel Gabriele Pepe encountered Lamartine in a duel. In turn, Giuseppe Mazzini, the ideologist and apostle of Italian national unity, wrote: "A dead nation is so very beautiful! Less disturbing, at any rate, than a suffering one."

The Star of Italy

The concept of *Risorgimento*, as the idea of a national resurrection, was in fact the expression of a recurrent myth in Italian history. Indeed, ever since the Renaissance, and in keeping with the notions of Petrarch and Vasari, but also with the study of "Roman-ness" as encouraged by the political trend of Humanism that had led up to Machiavel, every conception of progress or renewal within Italian culture was always expressed in terms of a regeneration, meaning the capacity to achieve a return to the past and to be revitalized by the sources of the great classical models. At the time of the *Risorgimento*, that idea had been embodied in the two thousand-year-old symbol of Italy: Hesperus, the evening star, actually the planet Venus, whose name changes when it rises – when it is reborn – as the morning star. The Italian signification of that star stems from a dual origin associated with the myth of Rome's Trojan descendance.

The Greeks had given Italy the geographic name of Esperia: for them it was the land lying to the west, toward which the first evening star appears, the planet Venus, the brightest star, that Homer had called Esperos. The Latin form of the name, Hesperia, was quoted as of the third century B.C. by Ennius, and then by Virgil, Horace, Ovid, Cicero, Macrobius and many other Latin authors, particularly when Italy was forming its first cultural identity, as the central province of the Roman Empire. When Julius Caesar, at the time of the conquest of the Gauls, claimed he was a descendent of the goddess Venus, he had given that symbol a political value. After his death, in his honor, the Roman Senate raised in the Forum a statue bearing a star on its forehead. Besides, the Romans believed the spirit of Julius Caesar dwelt on the planet Venus, whence he watched over the greatness of Rome. The *Caesaris astrum* was thus mentioned by Virgil, in the *Aeneid*, as the "paternal star" that accompanied the glory of Augustus. The poem also celebrated a Rome laden with Italian virtues, Virgil indicating Hesperia as the *terra antiqua* where the history of Italy merged with that of Roman victories.

The myth of the star of Italy was to be updated at the time of the Renaissance. The allegorical image of Italy, as a woman dressed in flowing robes, her head turretted and starred, that is, the descendant of Rome and bearer of the star of Venus, was suggested by Cesare Ripa in his famous treatise *Iconologia*, published in 1593. From then on, cartographical representations of the peninsula always featured the star Hesperus. A few years later, it was also included, as the symbol of Italy, in the iconographical decoration of the marriage banquet celebrating the nuptials of Henri IV and Maria de'Medici in Lyons. The symbol was equally taken up by Rubens in his painting *The Nuptials of Henri and Maria at Lyons*, conserved in the Louvre. During the seventeenth century, Jules Mazarin would be the one to introduce the star of Venus in his coat of arms. Indeed he saw himself, like the Pope Jules II, as being the spiritual heir of Julius Caesar. He went about in a carriage crowned by a gilt star, the *Stella Veneris*, a symbol that can be seen today all over the palace he bequeathed to the Institut de France. The following century, Napoleon in turn was to use that myth: in December 1797, returning from the campaign of Italy, he arranged to enter Paris around six o'clock in the evening on a day when, according to a rather uncommon, but not utterly rare, astronomical event, the star of Venus was clearly visible in the sky. The Paris crowds saw it as the star of Italy following his triumph. The reference to the star of Italy also featured in the iconographical commissions given to the painters selected to celebrate the birth of the Emperor's son, destined to become the king of Rome.

So in the nineteenth century, the myth of Venus, after having traveled the course of history, became the symbol of the *Risorgimento*, perceived as the vital regeneration of Italy. In 1830, the cenotaph raised to Dante, created by Stefano Ricci in the Santa Croce church of Florence, featured a statue of Italy, turretted and starred. Concurrently Mazzini spoke in terms of the coming advent of the "third Italy": after the Rome of the Caesars and of the Popes, a new Rome was to arise that would guide the country to become once again a model of civilization. And so once again the star of Venus would shine on Italy's brow. Then in turn the Bandiera brothers, the *Risorgimento* heroes, took over the myth, founding their secret society, Esperia, in order to fight against the foreign oppression ruling the peninsula. At the time of the revolutionary uprisings of 1848, the first bills the insurgent patriots printed and the first coins they minted featured the turretted and starred female image of Italy, thus immortalizing that allegorical representation, that was to become official with the unity of the nation. In 1861, the year the Italian *Risorgimento* was completed, the astronomer Giovanni Schiaparelli discovered an unknown asteroid and decided to name it Esperia. Once again the myth was celebrated on the occasion of the inauguration of the parliament of reunified Italy, by the king Vittorio Emanuele II, on November 27, 1871. The ceremony took place while the planet Venus was shining in broad daylight over Rome, arousing the crowds' enthusiasm. Everyone saw in it the "lucky star" of what Rudyard Kipling would call "the most ancient and the youngest of the European nations."

The national star did indeed play a certain role in the mythology of the Futurist revolution. Its dazzling image can be found in paintings by several Futurist artists, including Soffici, Depero, Conti, Monachesi, Sironi and Balla. The latter offered various allegorical illustrations of it throughout his work. Besides, today the star of Venus still figures in the middle of the emblem of the Italian Republic. Italians casually refer to it as "*lo stellone*," the big star. For them it is the symbol of Italy's cultural identity as the land of Eros, the "land of beauty and of love," according to a mythical vision that, from Virgil's *Laus Italiae* to the "Italian tour" of the Romantic era, has lent itself to countless literary and artistic interpretations.

Yet the achieving of national independence had failed to produce a real revival of Italian art or the advent of a unified culture, that would have allowed to go beyond the traditional mosaic-pattern of an Italy shaped by its different regional cultures. And above all, Italian art had not been able to assimilate an authentic Romantic revolution. Indeed Mazzini, the apostle of the *Risorgimento*, had called for a "historical painting" that would be able to educate Italians to the ideals of the "new national vision." But the painters Hayez, Morelli, Celentano and Altamura, who saw themselves as the expounders of that artistic theory, had not succeeded in going beyond a theatrical view of the great episodes of Italian history. Landscape painting, that had been asserted in Milan with Fontanesi and Il Piccio, and in Naples with Gigante and the Posilippo school, had failed to embody a true revolutionary spirit. In other words, Italian culture had experienced Romanticism merely as a style of behavior,

| Odoardo Borrani
THE RED CART AT CASTIGLIONCELLO
| 1867-1868, oil on canvas,
| 12,6 x 66 cm (4 15/16 x 26 in).
| Private collection.

Giovanni Fattori |
ROTUNDA AT THE PALMIERI BATHS
1866, oil on wood, |
12 x 35 cm
(4 3/4 x 13 3/4 in).
Galleria d'Arte Moderna of Palazzo Pitti, |
Florence.

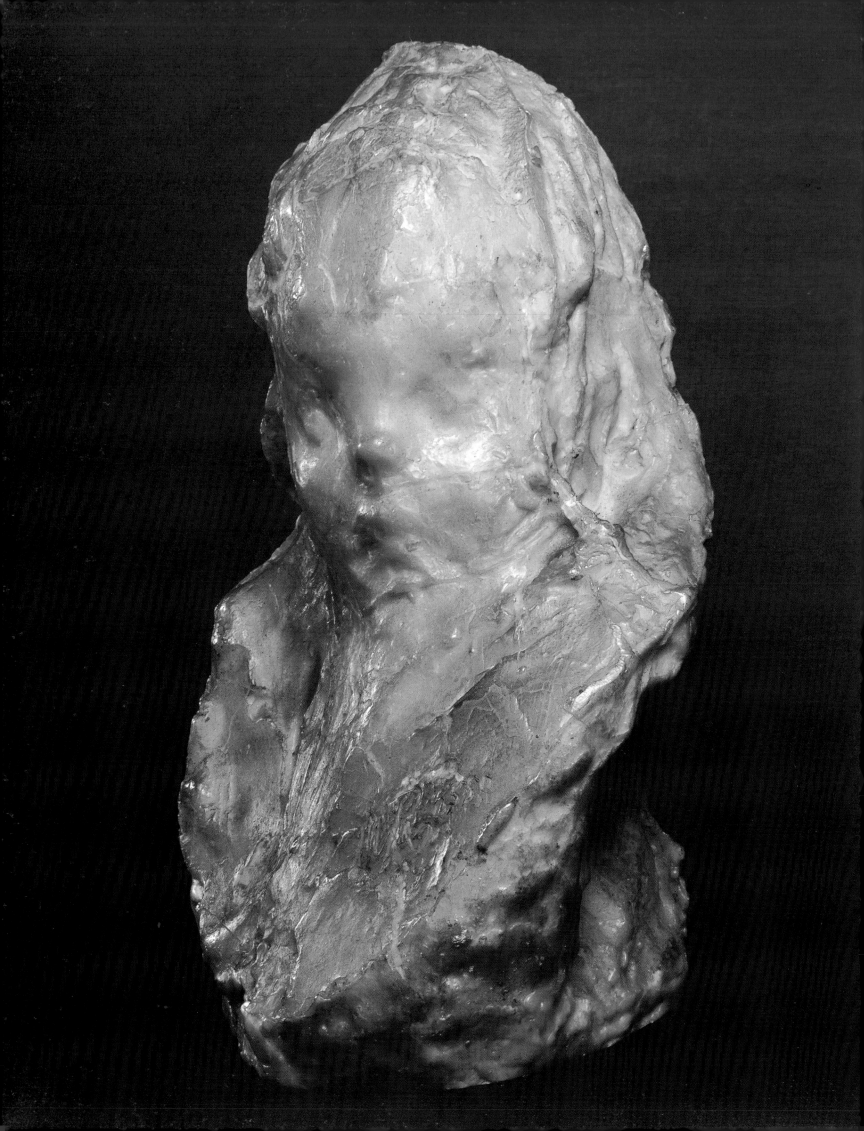

considered as political commitment: many artists had taken a direct, active part in the battles for the unification of their country, some of them even being among Garibaldi's legendary red-shirted followers. So by 1861, the year the unity of Italy was proclaimed, the revolutionary mood of the *Risorgimento* seemed to be no more than an experience of the past. The two artistic trends that were the most representative of post-unity modern Italian art were the Macchiaioli in Florence and the Scapigliatura in Milan. The artists of the first group rendered the impressions they received from reality by merely juxtaposing spots of color, as we can see in Fattori's masterpiece *Rotunda at the Palmieri Baths* (1866). Influenced by photography, they painted works in daringly panoramic dimensions. Yet in their compositions they sought to recapture the formal idiom of fourteenth- and fifteenth-century painters. And their eyes lingered on the world of the Tuscany countryside, ignoring the effervescence of industrial cities. For them, the coming of modernism could not be separated from the will to perpetuate the legacy of the past. With far greater foresight, the Scapigliatura artists denounced the failure of the *Risorgimento* ideals. Criticizing the ineffectiveness

of the last Romantics, they advocated a greater embracing of the realities of modern life. Their art endeavored to analyze sensations and to study the dissolving of forms under the fluid, dynamic influence of light. Their research reached its highest expression in the sculpture of Medardo Rosso.

The Macchiaioli, like the Scapigliati, devoted several works to the main episodes and the great figures of the *Risorgimento*. Thus Lega painted Mazzini lying on his bed, wrapped in the patriot Carlo Cattaneo's plaid shawl, on the threshold of death, about to enter into the sleep of the righteous. Cremona drew a portrait of ageing Garibaldi, seized in an idealized vision, but without the usual rhetorics of official portraits. Boldini executed a portrait of Verdi that displayed great psychological depth. By then those men had already become legendary figures. This failure to bring back to life the spirit of the *Risorgimento* except in a nostalgic vein, and to envisage a renewal of Italy except by looking to the past, would last throughout the turn of the century. D'Annunzio then became the spokesman of the painters of the In Arte Libertas society that, like the Pre-Raphaelites, longed for a return to the esthetic forms of the Renaissance. Instead,

| Medardo Rosso
CHILD IN THE SUN
| 1892, sculpture in colored wax over plaster, 38 x 22 x 26 cm (14 13/16 x 8 5/8 x 10 1/4 in).
| Private collection.

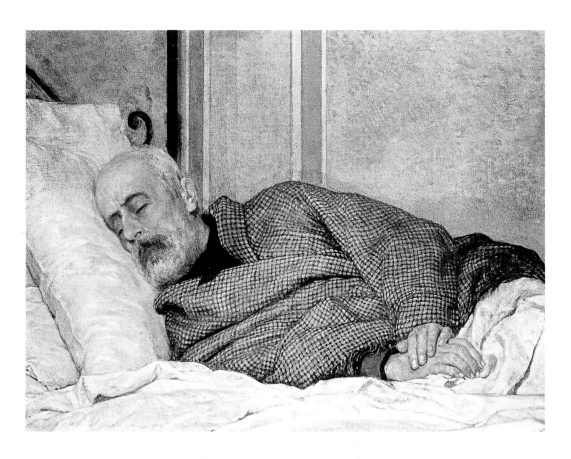

| Silvestro Lega
THE DYING GIUSEPPE MAZZINI
| 1873, oil oncanvas, 60 x 90 cm (23 5/8 x 35 7/16 in)
| Rhode Island Museum of Art, Providence.

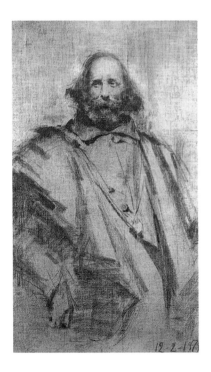

| Tranquillo Cremona
GIUSEPPE GARIBALDI
| 1875, charcoal on canvas,
| 159 x 90,5 cm
| (62 5/8 x 37 3/8 in).
| Museo Centrale del Risorgimento, Rome.

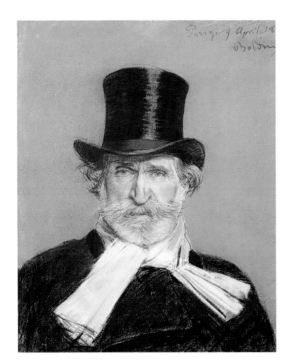

| Giovanni Boldini
GIUSEPPE VERDI
| 1886, pastel on paper,
| 65 x 54 cm
| (25 9/16 x 21 1/4 in).
| Galleria Comunale d'Arte Moderna, Rome.

Giuseppe Pellizza Da Volpedo |
THE FOURTH ESTATE
1901, oil on canvas, |
285 x 543 cm |
(112 1/4 x 213 13/16 in). |
Civica Galleria d'Arte Moderna, Milan. |

the Divisionist painters were the ones who would contribute the greatest innovations. Their works elaborated a symbolist, lyrical interpretation of the chromatic principle of the "divided stroke." Segantini sought an art inspired by a pantheistic form of spiritualism. Pellizza Da Volpedo wanted his art to serve the aims of humanitary Socialism, as we can see in his monumental canvas *The Fourth Estate* (1901), an idealized image of the proletariat striding toward the future. Previati wrote the treatise *Scientific Principles of Divisionism*, where he attempted to reconcile the need for subjective expression with *fin-de-siècle* positivism. He painted in long meandering brushstrokes compositions with ondulating rhythms that seemed to dematerialize form, turning it into light. In 1905, the first Italian feature motion picture was shown, Alberini's *The Taking of Rome*. In the final scene, the dazzling "star of Italy" appeared over the Italian troops enter-

ing the Eternal City. The youngest of the arts was thus made to serve the rhetorics of the nation.

So it was left up to Futurism to impose all over again the revolutionary spirit of the *Risorgimento*, backed by a mythical perception of Italy, that had always remained alive for Marinetti. He was to guide Italian art toward modernism in the name of that ideal vision that had inspired him ever since his earliest years.

A Revolutionary Calling

"My lyrical, impetuous temperament was always torn between the scarlet tunic and white surplice of the Whitsuntide procession and the frays between pupils organized and cheered by the French Jesuit priests in the tropical garden of the school." That was how Marinetti remembered his childhood in Alexandria, where he was born on December 22, 1876, in a house overlooking the

harbor, the very spot where, many centuries before, the greatest library of the Classical world had burned down. In other words, nearly a predestined place for the biblioclast this founder of Futurism would grow up to become. Marinetti was educated by Jesuits who taught him the love of literature, but they did not succeed in curbing his unruliness. Thus he did not hesitate to get into fights with his schoolmates, Greek and French, guilty of insulting "the name of Italy." When he was fifteen, he went through a profound mystical experience, seriously considering becoming a priest, but a while later fell passionately in love with Mary, a young Egyptian girl. He was temporarily dismissed from school for having dunked in the soup a biography of Pius IX where Garibaldi was called a "brigand." A year later, guilty of having brought some novels by Zola to school, he was definitively expelled.

His mother, Amalia Grolli, a highly cultivated and sensitive woman, the only daughter of a literature teacher, was the one who passed down to him the love of Italy, raising him in the ideals of the *Risorgimento* and in the worship of a faraway mother country, called to a glorious new destiny. In the evening, she would take him to the far end of the wharf to show him the sea horizon beyond which lay Italy. When, still a youth, he published his very first poems, in a magazine he had just founded, Marinetti chose the pen name of Hesperus. He most probably had read the well-known novel bearing that title by Johan Paul Friedrich Richter, but he was referring above all to Esperos, the evening star, the star of Italy. The works of his youth also featured verses dedicated to Garibaldi. That ideal image of Italy would not be confronted with reality until 1894, when he settled in Milan, at the age of eighteen.

Giuseppe Previati
THE DANCE OF THE HOURS
1899, tempera on canvas,
133,5 x 199 cm
(52 9/16 x 78 3/8 in).
Banca Cariplo, Milan.

Marinetti, because he was born on foreign soil, and then lived in a certain seclusion in the Italian society of the dawning century, was always to have a slightly out-of-focus conception of Italy. He would always remain oblivious to the country's real economic problems, to its social conflicts, to the real issues of its social and industrial development. Quite the opposite, he persisted in his ideal vision, opposing it to every realistic perception of the country. Even his political program continued to assert the great revolutionary principles of the *Risorgimento*, that is, on the one hand the anti-clerical struggle, insofar as the Church had always opposed the achieving of the unity of Italy, and on the other hand, the republican struggle, in the spirit of Mazzini and Garibaldi, against a henceforth outdated monarchy. Besides, true to the patriotism of the *Risorgimento*, Marinetti was always to claim he was "invincibly Italian."

In the course of the first years of the century, Marinetti attended Parisian literary circles and followed the formal debates on poetry. He became friends with Gustave Kahn, a theoretician of free verse and of the new "street esthetics" inherent to modern cities. Marinetti, wishing

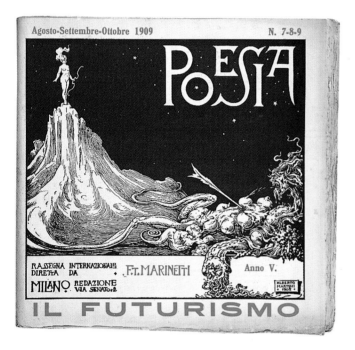

Agosto-Settembre-Ottobre 1909 N. 7-8-9

POESIA

RASSEGNA INTERNAZIONALE DIRETTA DA • F.T. MARINETTI Anno V.

MILANO. REDAZIONE VIA SENATO 2

IL FUTURISMO

THE MAGAZINE *POESIA*
Published in Milan, from
1905 to 1910, by Marinetti.
Cover designed by Alberto
Martini, 28,5 x 28,5 cm
(11 3/16 x 11 3/16 in).
Private collection.

Pages 30-31 |
THE *MANIFESTO OF FUTURISM*
First edition put out
in January 1909, in Italian
and in French, by Marinetti,
leaflet folded in two,
29 x 23 cm
(11 7/16 x 9 1/16 in).
Private collection. |

to become the catalyst of a renewal of Italian poetry, published in 1905 his magazine *Poesia*, giving it a motto that again referred to the notion of regeneration: "May lifeless poetry herein be reborn." Drawn to the artists of visionary symbolism, he asked Alberto Martini and Romolo Romani to design the cover and illustrations. The latter artist, who was to join the Futurist movement, in his drawings displayed symbolical geometric forms, expressing in abstract rhythms his hallucinated visions. The poets Marinetti invited to his magazine, Buzzi, Altomare, Lucini, Cavacchioli, Palazzeschi, would equally be the ones to form the very earliest Futurist group. The progression toward the founding of the "Futurist movement" lasted over a few years. Marinetti took several initiatives, created literary awards for young poets and launched an international survey on free verse. By so doing he was striving to break up Italy's provincial spirit and its perpetual backward-looking classicism. In August 1905, he published the free verse poem *To the Automobile* and, already displaying that revolutionary calling that was to cause him to be dubbed "the Bakunin of literature," he published a pamphlet in which, paraphrasing Marx, he appealed to every single Italian intellectual and creator: "Idealists, workers of the mind, unite, to show that inspiration and genius go hand in hand with the progress of the machine, of aircraft, of industry, of trade, of science, of electricity." At that point his magazine had become Futurism's cradle. At the end of 1906, for the very first time he used the word "avant-garde," combining it with the word "future." Lucini, his fellow-traveler, was to write: "Born in the privileged classes, Marinetti broke with the facile ways of a soft, passive existence, exposing his revolutionary poetry to the fiery perils of free verse and subversive theories."

For Marinetti, free verse, as an ideological model, was the embodiment of a value superior to the artistic forms of the past. He felt that art, in the name of an evolutive impulse and through its own formal revolution, would be able to create an authentic ethics of progress. He held free verse form to be the best-suited to the disruption of tones and the dynamism of contrasts, thus enabling poetry to achieve a "polyphonic dimension" and become the interpreter of the "feverish" mood of the dawning century. The thoughts he devoted to free verse and to the historical significance of its advent were to lead directly to the avant-garde spirit: the break with tradition, the demand for a constant renewal of art, the rejection of a closed, predetemined form, the assertion of individual creative freedom against every social hierarchization, the catalyst role of the artist amid the cultural and political dynamics of his time. At the same time Marinetti had come to believe that words were no longer enough to promote the advent of modernism in Italy: the time had come to move on to direct action.

And yet, in fact that urge to act would only become fulfilled after the automobile accident he had in June 1908, in Milan. While driving at breakneck speed at the wheel of his 100-horse power car, as he was trying to avoid two cyclists, he quit the road and landed in a ditch full of water. The poet, crushed under the weight of the car, struggled against both the machine and the mud, striving to keep his head above water. He experienced split seconds of utter panic and had the feeling his survival depended on sheer will power. He escaped death thanks to the workers of a nearby factory who succeeded in blocking the car with girders, preventing it from gradually sinking down into the mud.

Founding of the Futurist Movement

"A roaring automobile, that looks like it's racing over a hail of bullets, is more beautiful than the *Victory of Samothrace*." Such was the guiding notion upon which Marinetti established the very principle of his Futurism: a speeding automobile embodied the parameters of energy and dynamism that were to serve as points of reference for the art of the new century. It was in Milan, the most modern city in Italy, that he founded the "Futurist movement." In January 1909, he launched his pamphlet the *Manifesto of Futurism*, outlining in eleven points the program of an authentic cultural revolution. He used a language full of striking formulas, devastating and provocative. He condemned the worship of masterpieces and museums, the veneration for the Italian "art cities," the dusty culture exhaled from libraries, and everything that made man insensitive to the forces of life. Rather than a theoretic essay on art, his manifesto was a call to insurrection: "And go and set fire to the library shelves! Divert the courses of canals to flood the cellars of museums!" Marinetti wanted to put an end to every narcissistic, contemplative, initiatory and Saturnian conception of art. He recalled that art is an objective immanent to life itself, and claimed that, faced with the modern world, artistic creation had to be action and a tool toward progress. At the time, the word "futurism," that went back to the early nineteenth century, belonged to the political language of left-wing Hegelian stamp, and it is quite obvious that Marinetti's imperious undertaking drew its inspiration from Marx and Engels so as to make his manifesto a clear break with the past. The coming of Futurism was supposed to play the same role, in cultural and artistic fields, as the one played by the coming of Communism in political and social spheres.

The *Manifesto of Futurism* was printed in several thousand copies and sent out to those poets and artists who were already in touch with Marinetti, and then to the press all over the world. The mailing of the pamphlet included a long press release in which Marinetti claimed to act out of "an imperious desire for struggle and renewal at any cost" to liberate contemporary creation, that he saw as being "a wretched slave to the past and to a thousand traditions or conventions that have become unbearable and that have made it blind, deaf and mute in front of the wonderful spectacles the boundless ardor of contemporary life has to offer to artists." He defined Futurism with respect to literature, while using the words "avant-garde" and "future," to explain he was the leader of a group of young poets who "all feel the powerful, irresistible force of the *New* and who, tired of having all too-long held the past in veneration, are outstretching their arms to the future that they call forth with all their lungs." Thus Futurism was "the ardent banner" of a revolt proclaimed by "the extreme avant-garde of the Italian intelligentsia." The Futurist manifesto thus inaugurated the "tradition of the New" that was to characterize twentieth-century art.

A month later, Marinetti went to Paris to publish his manifesto, which appeared on the front page of the February 20th issue of the *Figaro*. The text appeared there in its unabridged version, that is, preceded by a prologue in which Marinetti elevated the historical act of writing the manifesto to a heroic deed. The automobile accident the writer had been in a few months earlier was turned into the prodigious event of a new birth, of a resurrection to another life. Thus, Marinetti could boast the right to speak to "all *living* men on Earth" so as to bring them good tidings. He claimed that the glorious past of Italian culture and art was nothing but a dead weight, that had to be shaken off in order to unleash new man's creative energy. What he was saying went against the traditional attitude of Italian culture which, from Petrarch to D'Annunzio, had made the return to the values of the past the requisite for any step forward. For Marinetti, quite to the contrary, Italy, the land with the richest artistic history in the world, had to give up living in the worship of past times. The day had come to be willing to face the bereavement of that all-so glorious past that had been the very foundation of Western art. The adventure of Futurism was determined to be exemplary: building the modern cultural identity of Italy meant unreservedly embracing the future, this proclaimed modernism owing to itself to become a model for the rest of the world.

Marinetti's most important ideas, such as the need for a continuous evolution of the language of art, the insistence on the transitoriness of the work of art, or the demand for a renewal responding to the changed conditions machines imposed on man, were founded on an authentic faith in the regeneration that life itself simply performs on its own. In the name of that imperative of renewal, Marinetti became the apostle of a perpetual revolution: art should be in a permanent state of insurgency, so as to play within society the same role that the Bergsonian *élan vital* (vital impulse) plays within nature.

La Revue Internationale " POESIA „

vient de fonder une nouvelle école littéraire sous le nom de " FUTURISME „.

DIRECTEUR :
F. T. MARINETTI
MILAN - RUE SENATO, 2

MANIFESTE DU FUTURISME

1. Nous voulons chanter l'amour du danger, l'habitude de l'énergie et de la témérité.

2. Les éléments essentiels de notre poésie seront le courage, l'audace et la révolte.

3. La littérature ayant jusq'ici magnifié l'immobilité pensive, l'extase et le sommeil, nous voulons exalter le mouvement agressif, l'insomnie fiévreuse, le pas gymnastique, le saut périlleux, la gifle et le coup de poing.

4. Nous déclarons que la splendeur du monde s'est enrichie d'une beauté nouvelle: la beauté de la vitesse. Une automobile de course avec son coffre orné de gros tuyaux tels des serpents à l'haleine explosive... une automobile rugissante, qui a l'air de courir sur de la mitraille, est plus belle que la *Victoire de Samothrace*.

5. Nous voulons chanter l'homme qui tient le volant, dont la tige idéale traverse la Terre, lancée elle-même sur le circuit de son orbite.

6. Il faut que le poète se dépense avec chaleur, éclat et prodigalité pour augmenter la ferveur enthousiaste des éléments primordiaux.

7. Il n'y a plus de beauté que dans la lutte. Pas de chef-d'oeuvre sans un caractère agressif. La poésie doit être un assaut violent contre les forces inconnues, pour les sommer de se coucher devant l'homme.

8. Nous sommes sur le promontoire extrême des siècles!... A quoi bon regarder derrière nous, du moment qu'il nous faut défoncer les vantaux mystérieux de l'impossible? Le Temps et l'Espace sont morts hier. Nous vivons déjà dans l'Absolu, puisque nous avons déjà créé l'éternelle vitesse omniprésente.

9. Nous voulons glorifier la guerre, — seule hygiène du monde — le militarisme, le patriotisme, le geste destructeur des anarchistes, les belles Idées qui tuent, et le mépris de la femme.

10. Nous voulons démolir les musées, les bibliothèques, combattre le moralisme, le féminisme et toutes les lâchetés opportunistes et utilitaires.

11. Nous chanterons les grandes foules agitées par le travail, le plaisir ou la révolte; les ressacs multicolores et polyphoniques des révolutions dans les capitales modernes; la vibration nocturne des arsenaux et des chantiers sous leurs violentes lunes électriques; les gares gloutonnes avaleuses de serpents qui fument; les usines suspendues aux nuages par les ficelles de leurs fumées; les ponts aux bonds de gymnastes lancés sur la coutellerie diabolique des fleuves ensoleillés; les paquebots aventureux flairant l'horizon; les locomotives au grand poitrail, qui piaffent sur les rails, tels d'énormes chevaux d'acier bridés de longs tuyaux, et le vol glissant des aéroplanes, dont l'hélice a des claquements de drapeau et des applaudissements de foule enthousiaste.

C'est en Italie que nous lançons ce manifeste de violence culbutante et incendiaire, par lequel nous fondons aujourd'hui le *Futurisme,* parce que nous voulons délivrer l'Italie de sa gangrène de professeurs, d'archéologues, de cicérones et d'antiquaires.

L'Italie a été trop longtemps le grand marché des brocanteurs. Nous voulons la débarrasser des musées innombrables qui la couvrent d'innombrables cimetières.

Musées, cimetières!.... Identiques vraiment dans leur sinistre coudoiement de corps qui ne se connaissent pas. Dortoirs publics où l'on dort à jamais côte à côte avec des êtres haïs ou inconnus. Férocité réciproque des peintres et des sculpteurs s'entre-tuant à coups de lignes et de couleurs dans le même musée.

Qu'on y fasse une visite chaque année comme on va voir ses morts une fois par an !... Nous pouvons bien l'admettre !... Qu'on dépose même des fleurs une fois par an aux pieds de la *Joconde*, nous le concevons !... Mais que l'on aille promener quotidiennement dans le musées nos tristesses, nos courages fragiles et notre inquiétude, nous ne l'admettons pas !... Voulez-vous donc vous empoisonner ? Voulez-vous donc pourrir ?

Que peut-on bien trouver dans un vieux tableau si ce n'est la contorsion pénible de l'artiste s'efforçant de briser les barrières infranchissables à son désir d'exprimer entièrement son rêve ?

Admirer un vieux tableau c'est verser notre sensibilité dans une urne funéraire au lieu de la lancer en avant par jets violents de création et d'action. Voulez-vous donc gâcher ainsi vos meilleures forces dans une admiration inutile du passé, dont vous sortez forcément épuisés, amoindris, piétinés ?

En vérité la fréquentation quotidienne des musées, des bibliothèques et des académies (ces cimetières d'efforts perdus, ces calvaires de rêves crucifiés, ces régistres d'élans brisés !...) est pour les artistes ce qu'est la tutelle prolongée des parents pour de jeunes gens intelligents, ivres de leur talent et de leur volonté ambitieuse.

Pour des moribonds, des invalides et des prisonniers, passe encore. C'est peut-être un baume à leurs blessures, que l'admirable passé, du moment que l'avenir leur est interdit... Mais nous n'en voulons pas, nous, les jeunes, les forts et les vivants *futuristes !*

Viennent donc les bons incendiaires aux doigts carbonisés !... Les voici !... Les voici !... Et boutez donc le feu aux rayons des bibliothèques ! Détournez le cours des canaux pour inonder les caveaux des musées ! Oh ! qu'elles nagent à la dérive, les toiles glorieuses !... A vous les pioches et les marteaux !... sapez les fondements des villes vénérables !

Les plus âgés d'entre nous ont trente ans ; nous avons donc au moins dix ans pour accomplir notre tâche. Quand nous aurons quarante ans, que de plus jeunes et plus vaillants que nous veuillent bien nous jeter au panier comme des manuscrits inutiles !... Ils viendront contre nous de très loin, de partout, en bondissant sur la cadence légère de leurs premiers poèmes, griffant l'air de leurs doigts crochus, et humant, aux portes des académies, la bonne odeur de nos esprits pourrissants, déjà promis aux catacombes des bibliothèques.

Mais nous ne serons pas là. Ils nous trouveront enfin, par une nuit d'hiver, en pleine campagne, sous un triste hangar pianoté par la pluie monotone, accroupis près de nos aéroplanes trépidants, en train de chauffer nos mains sur le misérable feu que feront nos livres d'aujourd'hui flambant gaiement sous le vol étincelant de leurs images.

Ils s'ameuteront autour de nous, haletants d'angoisse et de dépit, et tous exaspérés par notre fier courage infatigable, s'élanceront pour nous tuer, avec d'autant plus de haine que leur cœur sera ivre d'amour et d'admiration pour nous. Et la forte et la saine Injustice éclatera radieusement dans leurs yeux. Car l'art ne peut être que violence, cruauté et injustice.

Les plus âgés d'entre nous n'ont pas encore trente ans, et pourtant nous avons déjà gaspillé des trésors, des trésors de force, d'amour, de courage et d'âpre volonté, à la hâte, en délire, sans compter, à tour de bras, à perdre haleine.

Regardez-nous ! Nous ne sommes pas essoufflés... Notre cœur n'a pas la moindre fatigue ! Car il s'est nourri de feu, de haine et de vitesse !... Ça vous étonne ? C'est que vous ne vous souvenez même pas d'avoir vécu ! — Debout sur la cime du monde, nous lançons encore une fois le défi aux étoiles !

Vos objections ? Assez ! Assez ! Je les connais ! C'est entendu ! Nous savons bien ce que notre belle et fausse intelligence nous affirme. — Nous ne sommes, dit-elle, que le résumé et le prolongement de nos ancêtres. — Peut-être ! Soit !... Qu'importe ? Mais nous ne voulons pas entendre ! Gardez-vous de répéter ces mots infâmes ! Levez plutôt la tête !...

Debout sur la cime du monde, nous lançons encore une fois le défi aux étoiles !

<div align="right">

F. T. MARINETTI

DIRECTEUR DE " POESIA ,,.

</div>

MILAN - RUE SENATO, 2

POLIGRAFIA ITALIANA—MILANO - 1149

Futurist Woman

IRMA VALERIA
| Ravenna, 1916.

When he founded Futurism, Marinetti proclaimed: "contempt of woman." Actually he intended to counter the decadent image of the woman as vestal and dispenser of pleasure that D'Annunzio had imposed on the Italian imagination. Reactions were immediate, especially in Parisian feminist circles, and Marinetti had to specify that it was merely a battle slogan launched against romantic and nostalgic culture. Indeed the Futurist political program demanded the parity of salaries, legal equality and the right to vote for women, of which he rejected any sort of reductive and traditional image. Among the very first pictures by Futurist painters, we find canvases depicting prostitutes, like *The New Priestesses* (1910) by Carrà, while Boccioni emphasized the sensibility of modern woman in *Futurist Woman* (1910). In 1912, when he was in London with Marinetti, Boccioni contributed his support to a suffragettes' demonstration. Valentine de Saint-Point, the great-grand niece of Lamartine, was the first to adhere to the Futurist movement, declaring: "My life and my work, in perfect

| Adele Gloria
FUTURIST WOMEN
| 1932, tempera and collage
on paper, 42 x 30 cm
(16 1/2 x 11 13/16 in).
| Private collection.

Wanda Wulz |
ME + CAT
1932, photomontage,
29,3 x 23,2 cm
(11 1/2 x 9 1/4 in).
Private collection.

| Umberto Boccioni
THE FUTURIST WOMAN
| 1910, oil on canvas,
64 x 66 cm (25 3/16 x 26 in).
| Private collection.

harmony, endlessly aspire to the eternal and modern virtues Futurism demands." So she published the *Manifesto of Futurist Woman* (1912), where she suggested a model of modern woman as "a creature whose instinct is highly lucid." Soon after, the *Futurist Manifesto of Lust* (1913) came out. Challenging traditional feminism, she called for the erotic liberation of woman in the name of life force and creation: "Lust must be made to become a work of art." The anti-conformism of her feminist ideology lay in this struggle for a total emancipation of desire and the revolutionary glorification of its power to inspire wonder. In the course of the following years, Futurism was the avant-garde movement that counted the greatest number of women: writers and poets, photographers, dancers, sportswomen, aviators, painters and sculptors, philosophers, actresses, including Irma Valeria, Barbara, Marisa Mori, Benedetta, Artemesia Zimei, Regina, Adele Gloria, Annaviva and Maria Goretti. They developed a feminine interpretation of Futurism, striving to offer by their own unconventional life the model of modern woman: free and active, capable of questioning the institution of the family and of participating without complexes in the advent of the society of the future. ■

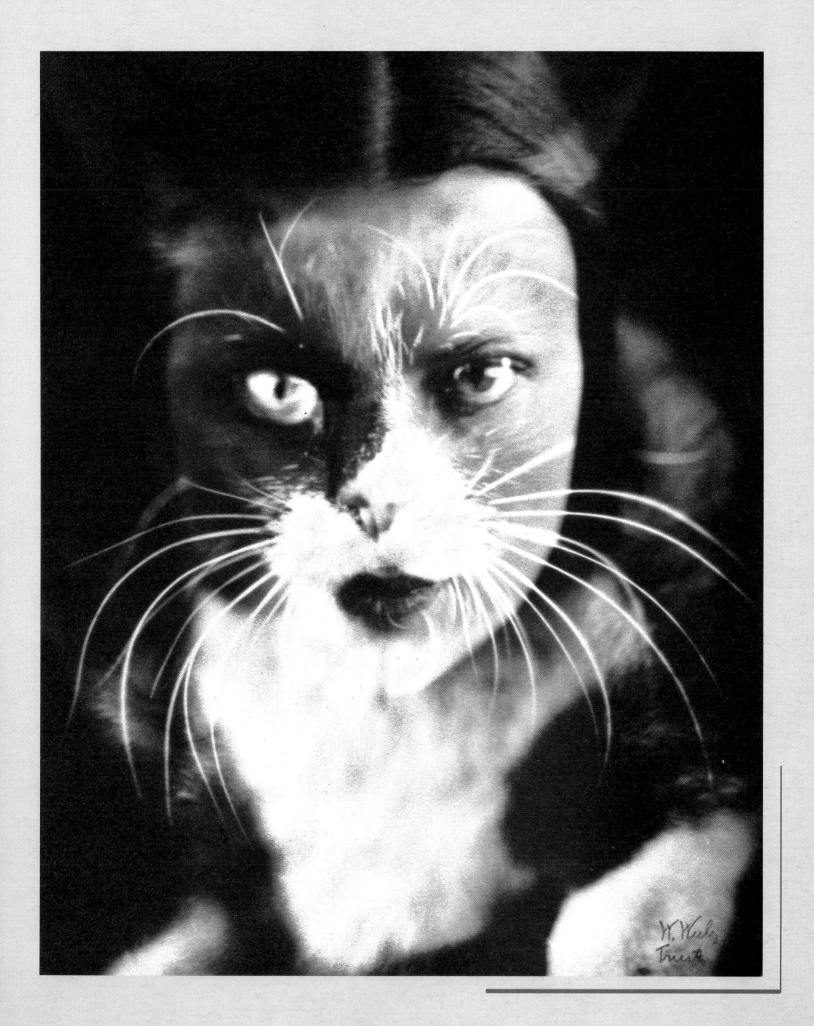

In so doing, Marinetti established the rules of the avant-garde spirit that was to rule twentieth-century art. With Futurism, art became a disruptive force that was no longer practiced in terms of the past, but with respect to life itself. By his works as well as by his life, the Futurist artist should provoke an acceleration of becoming, by encouraging society to assimilate the new esthetic values of urban and technological modernism. Indeed, it was the machine that constituted the model of an unknown reality. A daughter born without a mother, she was the promise of a future that would demolish every tradition. A few months later, expressing his ideas in allegorical terms, Marinetti launched *Let's kill the moonlight!*, a second Futurist manifesto. It featured the symbolic image of a return to the mother's womb, a regenerative act allowing a new birth that conferred onto new man the powers of immortality. He then published the novel *Mafarka the Futurist*, creating the myth of a mechanical, winged Overman. That Icarian god, delivered from the past and from death, was fantasized as the "glorious body" of the Futurist mystique and of its determination to celebrate the epic tale of industrial progress. In other words, the machine could free man from the determinism of the genetic chain, while guaranteeing the irreversability of history. Marinetti, in the preface to his novel, called upon the painters who were capable of carrying out his Futurist program, that he had just presented in a lecture at the *Famiglia Artistica* circle in Milan.

Founded in 1873, in the wake of the Scapigliati, that renowned Milanese institution was the stronghold of the artists who did not identify themselves with official culture. Among its youthful members there were the painters Boccioni, Carrà, Romani, Bonzagni, and Russolo. Boccioni, a painter with a romantic temperament, had an unstable character, marked by a high level of ideal and moral exigency. He had already been to Paris and to Russia. A few years earlier, with his friend Severini, he had been Balla's pupil in Rome. Balla was the one who had taught him Divisionism and made him become aware of the transformations of the working world. Indeed Balla, more than any other of the Italian painters of the time, embodied modern investigative research, combining photographic cut outs of the image, social verism and a free interpretation of the Divisionist technique. As for Carrà, he had spent some time in Paris and London, mixing with anarchist circles. He had then

Romolo Romani |
SILENCE
1904-1905, pencil on paper,
61,5 x 46 cm
(24 3/16 x 18 1/8 in).
Galleria d'Arte Moderna, Brescia.

| Giacomo Balla
AGAVE ON THE SEA
| 1906, oil on canvas,
90 x 143 cm
(35 7/19 x 56 5/16 in).
Private collection.

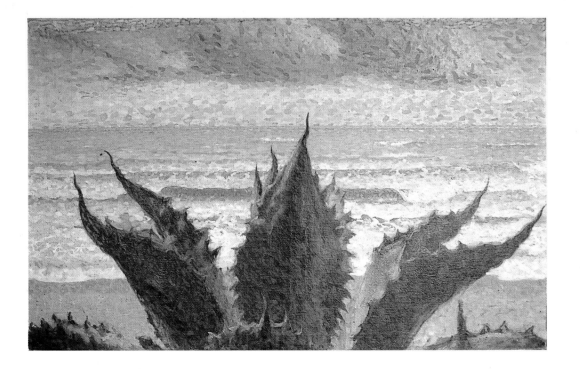

Umberto Boccioni |
FACTORIES AT PORTA ROMANA
1909, oil on canvas,
75 x 145 cm
(29 1/2 x 57 1/16 in).
Banca Commerciale Italiana, Milan.

| Luigi Russolo
SELF-PORTRAIT WITH SKULLS
| 1909-1910, oil on canvas,
| 67 x 50 cm
| (26 3/8 x 19 11/16 in).
Civica Galleria d'Arte Moderna, Milan.

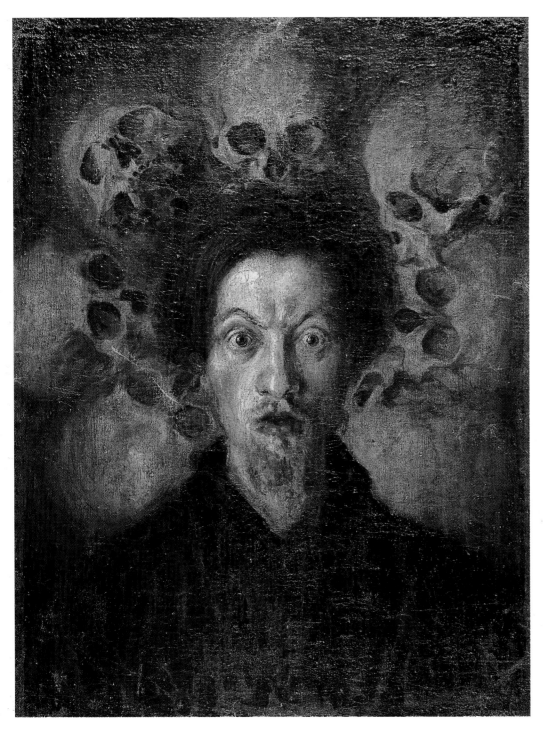

Carlo D. Carrà |
LIGHTS AT NIGHT
1910-1911, oil on
canvas, 35 x 30 cm
(13 3/4 x 11 13/16 in).
Private collection.

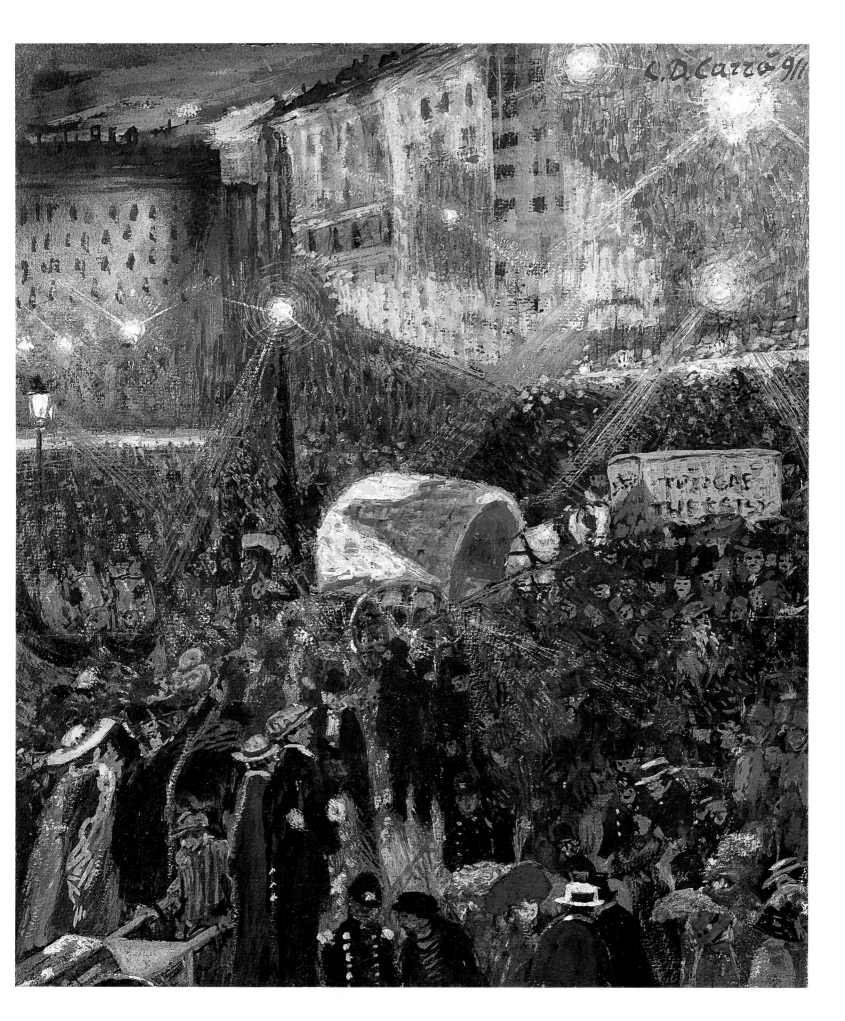

returned to the Brera Academy, where he had the opportunity to discover Divisionist painting. Romani and Bonzagni excelled in drawing, the former elaborating a symbolism tending decisively toward abstraction, the latter evolving toward an Expressionist-style grotesqueness. Russolo had studied music with his father before becoming a self-taught painter. He was already known for his Symbolist-style etchings and watercolors. Just recently, in December 1909, all these painters had taken part in the annual *Famiglia Artistica* exhibition.

That was how, spurred by Boccioni, the group of Futurist painters was formed. In the last week of Febraury 1910, Boccioni, Russolo and Carrà wrote the *Manifesto of Futurist Painters*. The essay began like a political proclamation, addressed: "To the young artists of Italy!" It was a violent affirmation of the need to free Italian art from the yoke of the past: "Comrades! We want you to know that the triumphant progress of the sciences has led to such profound changes for humanity that an abyss has opened up between the docile slaves of the past and ourselves, free and confident in the radiant magnificence of the future. We are sick of the shameful sloth that, ever since the Renaissance, has made our artists live off a permanent misappropriation of the glories of the past. For the other nations, Italy is still a land of the dead, an immense Pompei of whitened sepulchers. But Italy is being reborn, and its political *Risorgimento* is being echoed by its intellectual rebirth." The reference to the political ideals of the *Risorgimento* was direct. Such writings, calling so peremptorily to action, may well not be found anywhere else in the entire history of art.

Ten days later, the group of "Futurist painters" held its first official exhibition in a room of the *Famiglia Artistica* in Milan. The trends these novices of Futurism displayed were those of the artistic circles of the time: symbolism, modernist and socio-humanitary aspirations, Divisionism and social Verism. Russolo had just painted his *Self-Portrait with Skulls*, a vision of himself stemming from the occultist practice of divining the future in the black mirror. Carrà continued to use the Divisionist brushstroke, painting night street scenes. Romani's highly personal symbolism contrasted with the Divisionism of Boccioni who, as far as he was concerned, was interested in the landscapes of the working class suburbs of Milan.

Strategy of Cultural Agitation

As soon as he had enrolled painters in his movement, Marinetti began thinking about creating Futurist music. He handed over the task to Balilla Pratella, who in turn wrote some manifestos. At the same time the movement began setting in motion its cultural agitation: distribution of leaflets, controversies in the press, posters, pamphlets, street events, meetings in theaters, and so on. This noisy, constant activism was meant to show the determi-

VENEZIA FUTURISTA

Noi ripudiamo l'antica Venezia, estenuata e sfatta da voluttà secolari, che noi pure amammo e possedemmo in un gran sogno nostalgico.

Ripudiamo la Venezia dei forestieri, mercato di antiquarî falsificatori, calamita dello snobismo e dell'imbecillità universali, letto sfondato da carovane di amanti, semicupio ingemmato per cortigiane cosmopolite.

Noi futuristi vogliamo guarire questa tediosa città ammalata. Siano colmati i suoi più fetidi canali con le macerie dei suoi palazzi lebbrosi; la rigida geometria dei ponti metallici e degli opifici chiomati di fumo abolisca le curve cascanti delle vecchie architetture, e la divina Luce Elettrica liberi finalmente Venezia dal suo venale chiaro di luna da camera ammobigliata.

I PITTORI FUTURISTI:

U. Boccioni – A. Bonzagni – C. D. Carrà
L. Russolo – G. Severini, ecc.

I POETI FUTURISTI:

F. T. Marinetti – Paolo Buzzi – A. Palazzeschi
E. Cavacchioli – Armando Mazza
Libero Altomare
Luciano Folgore – G. Carrieri, ecc.

POLIGRAFIA ITALIANA-MILANO - 1910

LEAFLET *FUTURIST VENICE*
Thrown by Marinetti and the Futurist group from the top of the Clock-Tower down onto Piazza San Marco, July 8, 1910, in Venice, 23 x 17 cm (9 1/16 x 7 11/16 in).
Private collection.

nation to create the necessary conditions for an artistic and cultural *Risorgimento* all over the country.

Announced by tremendous advertising campaigns, the famous "Futurist *soirées*," authentic acts of provocation and propaganda, were organized in several Italian cities. Marinetti would appear on stage, surrounded by the poets, painters and musicians who had joined his movement. He expounded his esthetic and political ideas, and replied point by point to the audience's objections. It was then the young Futurists'turn to speak, their contribution being to recite poems and proclaim manifestos, present paintings, explain their new theories on art. Confronted with the Futurists'invectives, the spectators would shout at the top of their lungs, throwing coins and firecrackers onto the stage. As for Marinetti, he carried his provocation to such extremes that the audience would become idiotic. When the spectators whistled and booed at the

Un quadro futurista sfregiato dai Passatisti

Noi Futuristi denunciamo al disprezzo universale la vigliaccheria dei nostri avversari passatisti, i quali hanno sconciamente sfregiato il quadro « *La Risata* » di Umberto Boccioni.

Questi anonimi nemici, esasperati dal grande successo della PRIMA ESPOSIZIONE LIBERA D'ARTE, ideata da noi, e nella quale trionfano, senza possibilità di confronti, CINQUANTA NOSTRI QUADRI FUTURISTI, credettero senza dubbio di offuscare così la nostra nuova vittoria, mentre dovunque la gloria sorride al nostro inesauribile, oceanico genio creatore. Costoro ci fanno schifo e pietà insieme.

I Pittori futuristi

Carrà, Russolo, Boccioni

PRIMA ESPOSIZIONE LIBERA

VIALE VITTORIA, 21 (EX STABILIMENTO RICORDI)

Ingresso: Cent. 25 a totale beneficio della CASSA DISOCCUPATI della CASA DI LAVORO.

FOTOGRAFIA ITALIANA·MILANO

LEAFLET *A FUTURIST PAINTING SCRATCHED BY THE PASSEISTS*
Handed out in the streets of Milan, May 9, 1911, by Futurist painters, 22,5 x 15 cm (8 7/8 x 5 7/8 in).
Private collection.

confusion of lines and forms of a Futurist painting, he would stride over to the front of the stage holding an empty frame, hold it up to his face and imperturbably announce: "Self-portrait." On other occasions, he would present with the utmost gravity a concert that the Futurists performed by running behind a piano that was being shoved about the stage. The Futurist *soirées* were soon to become unforgettable events.

The havoc these parties provoked was such that Romani and Bonzagni took fright and left the movement. Boccioni then wrote Severini, who was living in Paris, inviting him to join the Futurist movement. After that, he remembered his master Balla, and traveled down to Rome to persuade him to come and join them in their overall struggle to renew Italian art. At the age of thirty-nine, Balla was an established painter. Yet he did not hesitate to expose himself in the adventure of the avant-garde. Born in Turin, the city that had been the capital of the *Risorgimento*, Balla could but share Marinetti's ideals. So he approached Futurism using the symbolic language of the manifesto: *Let's kill the moonlight!* to create the image of that new Italy Marinetti was promising them. His picture, painted in 1910, is an allegorical vision bearing the date of the founding of Futurism: *Electric Light 1909*. Balla identified the star of Italy with a lamppost whose beams light the night, dimming the moonlight. According to him, the star of this new Italian *Risorgimento* could no longer be the mythical star of Venus, but an electric star whose supreme blaze confirmed the power of a technology and an energy totally controlled by man.

The *Risorgimento* was the true source of inspiration of the ideology of Futurism, of its idealism, its revolutionary action, and even of its very conception of the avant-garde. In Italian culture at the beginning of the twentieth century, Marinetti's *Manifesto of Futurism* played the same role as the *Manifesto of Young Italy* Mazzini had launched in the preceding century: ideas became a moral obligation, and thoughts were expressed by deeds. So from the start, Futurism could not have been a mere literary coterie, nor a school of painting. The "action-art" Marinetti called for was a direct extension of Mazzini's "action-thinking." So Marinetti considered the organization of his Futurist movement practically in the same terms as Mazzini had thought up the associative form for his Young Italy. A nucleus of militant Futurists should take to action in every city, in every province, driven by the sole purpose of "engaging Italy in revolution," according to Mazzini's expression.

Garibaldi had claimed that Italy, as a nation, was "an invention of poets" rather than a collective affirmation. A century later Gramsci, the theoretician of revolutionary Marxism, was to point out to what degree the Italian *Risorgimento* had been the result of the voluntary commitment of the élites as opposed to the passivity of the popular masses. Marinetti, with his Futurist drive, exemplified that same poetic vision and that same voluntaristic and revolutionary idealism. It was through the activism of his movement that he intended to create, in Italy, an authentic modern culture on a national scale. He was thus to mobilize, during over thirty years, the forces of Italian youth, winning it to the cause of the avant-garde. What he had defined as the "Italian Futurist movement" was actually the sum of several active trends, or even of different autonomous groups of the Italian avant-garde – such as Cerebrism, Newism, Presentism – that his untiring militancy succeeded in grouping in a shared unity. So the history of Futurism is the history of an enduring passion that was expressed in countless initiatives and, by glorifying modernism, continued to work toward the construction of a new Italian culture.

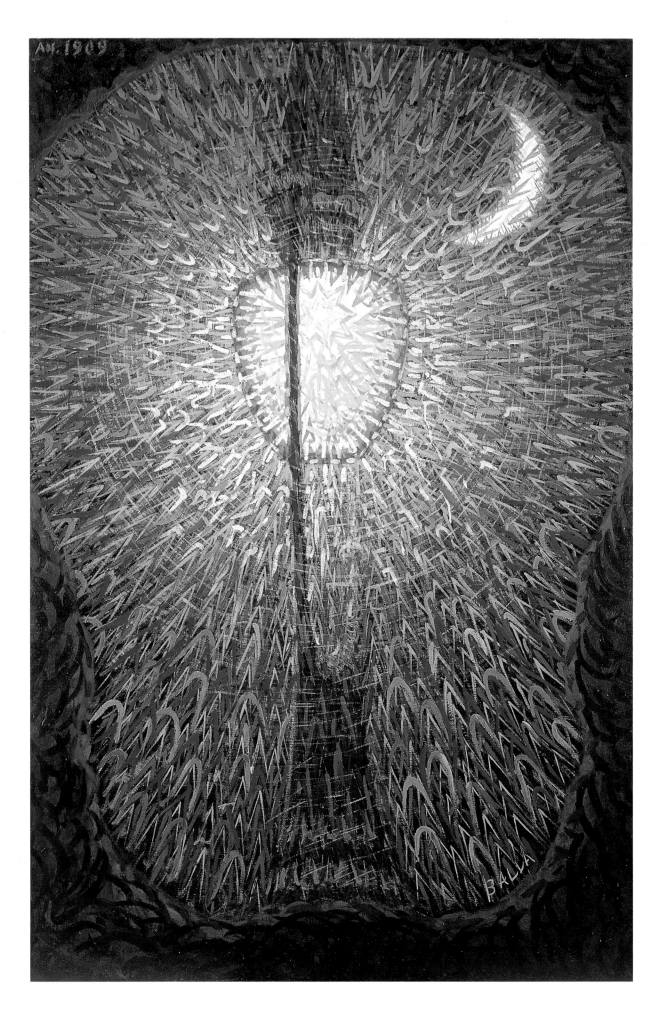

| Giacomo Balla
**ELECTRIC LIGHT
YEAR 1909**
| 1910-1911,
oil on canvas,
174,7 x 114,7 cm
(68 3/4 x
45 3/16 in).
Museum of Modern Art,
New York.

Political Action

At the far end of Marinetti's commitment to the cultural revolution of Futurism, another form of more direct militancy appeared, that he was to engage in on his own, right after the founding of his movement. Immediately going beyond the traditional role of the poet as the herald of moral and social values, in January 1909 he published the manifesto *Trieste, the powder-keg of Italy*, where, in the name of the irredentism of the Trentino, at the time still under Austrian rule, he legitimized his nationalistic ideology. Actually, the uproar his call to burn down museums and libraries had occasioned had overshadowed a sentence in the *Manifesto of Futurism* that expressed in provocative terms his bellicose beliefs: "We glorify war – the only hygiene in the world –, militarism, patriotism, the Anarchists' gesture of destruction." In Marinetti's eyes, history is only expressed through violence, and life itself is nothing but a series of clashes between antagonistic forces. In all the coming years, he would never be brought to come back on those ideas, drawn from the Social-Darwinism of the time. He would not hesitate to claim: "War considered as a violence serving the law reflects an obsolete view. Actually war is a cosmic phenomenon that can only be furthered and used to one's own benefit." None of the young Futurists of the early days shared these positions of Marinetti's. He was again alone when on the occasion of the general elections of March 1909 he launched his first *Political Manifesto for Futurist Voters*, where he claimed: "The only political program we have is pride, energy and national expansion." The year after, he tried to organize a political alliance between the Futurist movement and the small anarchist and anarcho-syndicalist groups. With that objective in view, he financially backed the Milanese magazine *La Demolizione*, whose radical positions were inspired by George Sorel. The theories the latter had expounded in his *Reflexions on Violence* were extremely popular at the time in Italian revolutionary circles, that called for a "revision of Marxism." Marinetti, in 1910, published the manifesto *Our Common Enemies*, where he declared he was favorable to a unified action between the proletariat of culture and the proletariat of labor, two avant-gardes that should join forces in order to create a common front against the enemies of any kind of revolution: "Clericalism, Racketeerism, Moralism, Academism, Pedantism, Pacifism, Mediocrism." Then he would appeal directly to the working class: he held a lecture on the *Necessity and Beauty of Violence* at the Trades Union Center in Naples, the Workers' House in Parma and the Socialist Club in Milan. He called the revolutionary syndicalists to a new actuation of violence seen as a force of progress and the true course of history. He claimed: "We can no longer admit the authority of the State as a halt to the people's libertarian desires: instead we believe the people's revolution-

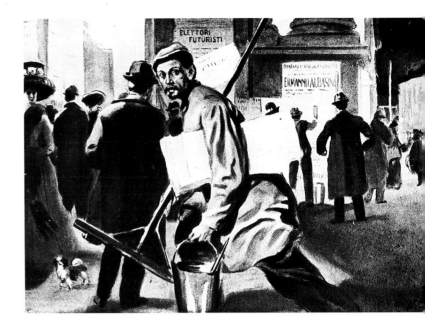

| Luigi Bompardi
THE BATTLE OF THE ELECTIONS IN MILAN: THE BATTLE OF POSTERS (THE FUTURISTS' MANIFESTO)
| Drawing appearing in *L'Illustrazione italiana*, March 14, 1909, Milan.
| Private collection.

ary spirit must put a halt to the authority of the State and to its conservative spirit, a symptom of old age and gradual paralysis. Isn't violence a nation's youth? Don't order, pacifism, moderation, the spirit of diplomacy and of reforms merely mean arteriosclerosis, old age and death? Only through violence can we bring the notion of justice, henceforth compromised, not back to its fatal acception, that of the law of the fittest, but back to the hygienic, healthy law of the bravest and the most unselfish, meaning the notion of heroism." That lecture caused him to lose the sympathy of the anarchists, who up to then had observed with interest Futurism's subversive views.

Indeed, Marinetti's evolutionist vitalism was beginning to go in a direction that a good number of revolutionaries of the Italian left could no longer continue to endorse.

His ostentatory nationalism, that the Futurists themselves often criticized, should be interpreted as an intrinsic aspect of a political evolution in the Italy of the times, in which a middle-class, that had close ties with budding Italian industrial capitalism, was appearing on the scene. Therefore Marinetti's political thinking contained the ferments of a perversion of the *Risorgimento* spirit, which was equally to involve most of the post-war Italian intellectuals.

2
An Art of Dynamism

Pages 44-45
Luigi Russolo
**AUTOMOBILE
DYNAMISM**
Detail. 1912,
oil on canvas,
104 x 140 cm
(40 15/16
x 55 1/8 in)
Musée National d'Art
Moderne, Paris.

**FILIPPO TOMMASO
MARINETTI**
1909, Milan.

UMBERTO BOCCIONI
1914, Milan.

In the beginning, Futurist painting was mainly represented, in its theories as in its works, by Boccioni, Carrà and Russolo, who all three lived in Milan, alongside Marinetti. In their first manifesto, the Futurist painters had been content to make a statement of principle, that actively opposed the academic and museum-oriented conception of art, as well as art critics, held to be "useless and dangerous." They called for a return to the "subject," so that painting might "express and magnify present-day life, that was being constantly and overwhelmingly transformed by the triumphs of science." A second text, the *Technical Manifesto of Futurist Painting*, came out in April 1910, in order to spell out the theoretic postulates of the new painting, considered to be an art of dynamism.

Aligned on Marinetti's positions, Futurist "pictorial dynamism" rejected the traditional subjects of art, wishing it to become the reflection of a world governed by city life, by the machine and by speed. The artist was supposed to express himself in complete freedom, against all predetermined forms and all established conventions.

Art, by its own formal revolution, had to become engaged in the transformation process that technology was imposing on society. The dynamism and heightening of simultaneous sensations were the new values best-suited to harmonize art with the throbbing pace of industrial cities. The Futurist program was exactly the opposite to that of the artists who, from Gauguin to the Expressionists, had opted for primitivism in the name of a negative view of industrial progress and of the positivist myths of middle-class society. For those artists, the progress of science and industry was paving the way for the decline of European culture and of Humanism. Instead, the Futurists believed that scientific progress could provide the foundations for a renovation of artistic expression, and that art should be in tune with the forms and lifestyles of the modern world. Boccioni, Carrà and Russolo thus raised the issue of an immediately perceptible vision, in direct contact with reality. With that aim in mind, they resolutely turned to Divisionism and the very latest scientific experiments, both allowing a new visual approach to the phenomena of life. Painting had to grasp and to represent reality

CARLO D. CARRÀ
| 1910, Milan.

LUIGI RUSSOLO
| 1913, Milan.

GIACOMO BALLA
| 1915, Rome.

exactly as it appeared in the midst of modern cities and through the discoveries of science. For them, painting and art were first and foremost instruments of knowledge bound to serve human progress and modernism.

Dematerialization of Bodies

"Motion and light destroy the materiality of bodies": such was the Futurist painters'claim. Obsessed by the perpetual movement that generates the becoming of the universe, and by light that dematerializes form, they proclaimed: "Painting has to render the dynamism of the universe as dynamic sensation." So they established a formal principle, based on the instinctive disassociation of the sensation of light in complementary colors: "Intrinsic complementarity is an absolute requisite for painting, just like free verse is for poetry and polyphony for music." And Russolo went further to explain: "We are extending and developing the principle of Divisionism, but without doing Divisionism. We are applying an instinctive complementarity that, according to us, is not an acquired technique, but a *way of seeing* things." The principle of

the "divided brushstroke" was adopted in keeping with the values of dynamism. Decomposing light by color meant simultaneously decomposing and interpenetrating forms produced by motion. Already in November 1910, Boccioni was to declare: "As regards the ultimate aim of our artistic revolution, we claim that through a series of syntheses every single accidental, individual appearance should be made to attain a *typical, symbolic* and *universal* appearance. And that is what makes us go way beyond the French Impressionists." So the investigative research was outlined. It would be developed in several stages, but would always remain true to those early postulates.

Boccioni, Carrà and Russolo, in seeking to carry out their artistic theory of pictorial dynamism, started from the most advanced formal investigations in Italian art: Previati's Divisionist painting and Romani's Symbolist-style geometric compositions.

Previati's manner would inspire the first Futurist paintings expressing the dematerialization of bodies effected by kinetic and luminous vibrations. In *Perfume*, to render the irradiation of a form in space, Russolo used long wavy

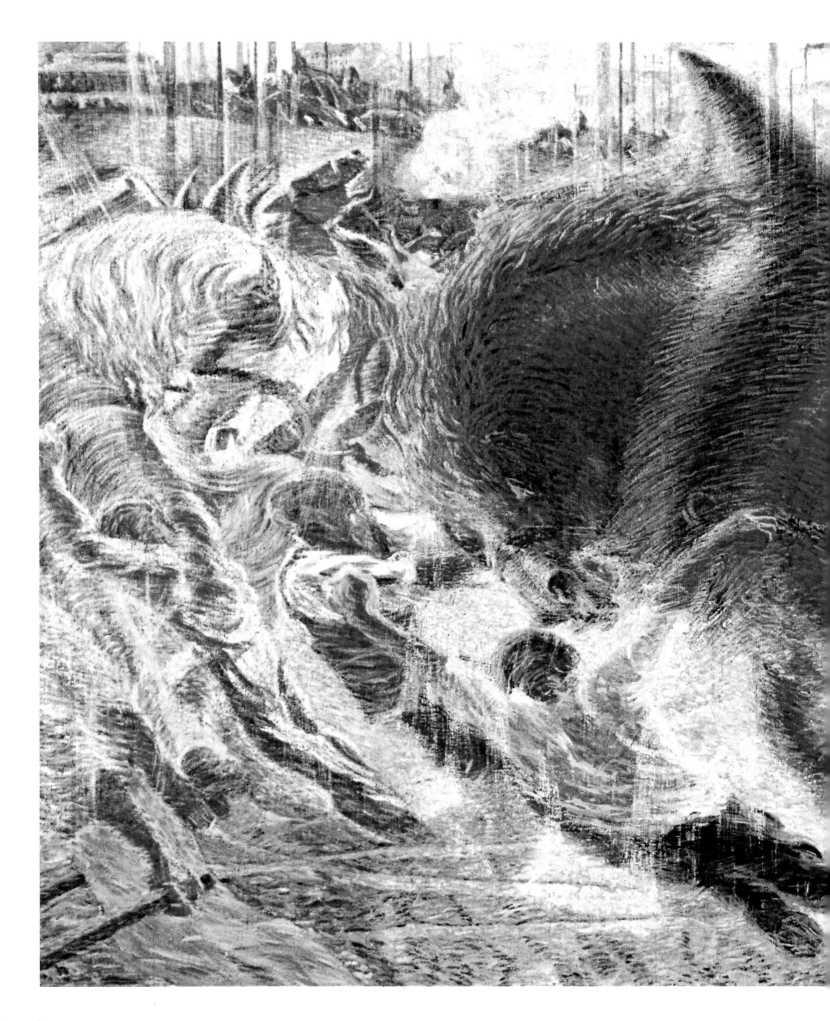

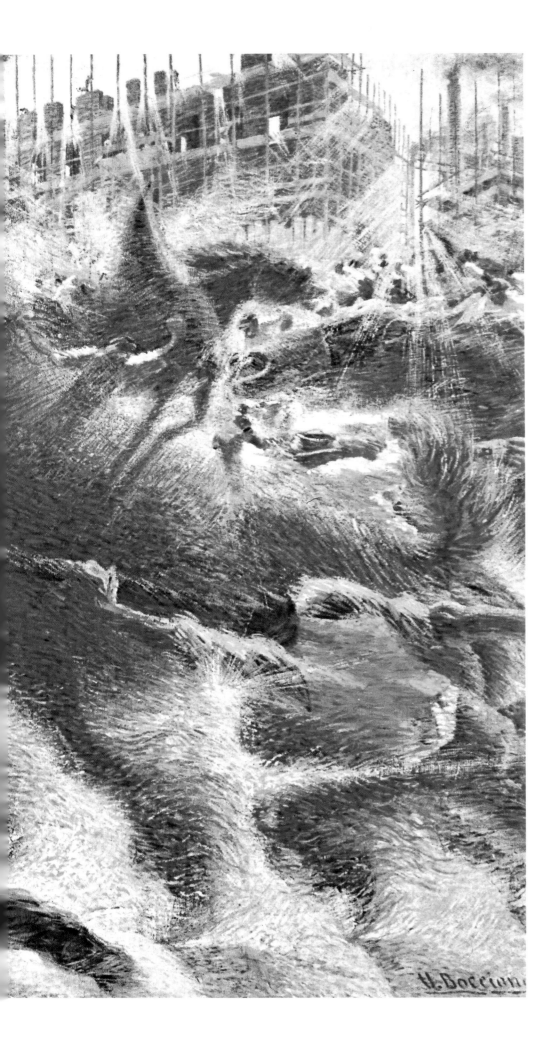

| *Umberto Boccioni*
THE CITY RISING
1910, oil on canvas,
200 x 290,5 cm
(78 3/4 x 114 3/8 in).
Museum of Modern Art, New York.

Luigi Russolo |
PERFUME
1910, oil on canvas,
64,5 x 65,5 cm
(25 3/8 x 25 3/4 in).
Private collection.

Carlo D. Carrà |
SWIMMING
1910, oil on canvas,
155 x 105 cm
(61 x 41 5/16 in).
Carnegie Institute, Museum
of Art, Pittsburgh.

Carlo D. Carrà |
THE DOCKER
1910, oil on canvas,
140,5 x 120 cm
(55 5/16 x 47 1/4 in).
Private collection.

brushstrokes. He accentuated the Divisionist dynamic fluidity, at the same time combining it with a chromatic intensity recalling Expressionism. In *Swimming*, Carrà pursued the shredding of forms. He even had his painting *The Docker* examined by Previati himself, who approved of it in the name of that Divisionism that by now had come to coincide with modern man's approach to reality. Boccioni, the main theoretician of the group, painted *The Rising City:* a "great synthesis of labor, light and movement," that he conceived as "an entirely mental vision generated by reality." In the middle of the picture, a huge red horse, the color of energy, swept up in its straining the workers of a yard in full swing. The tremendously bright-colored canvas is an authentic allegory of Bergson's statements on the *élan vital* (vital impulse): "Like whirls of dust, cast about by the passing breeze, living things spin around, upheld by the great breath of life."

For Boccioni, Previati's spiritualist Divisionism was the first Italian example of an art of "states of mind." He aspired to a painting where the fluidities of the form would suggest above all the inner rhythms of the subject. His triptych *States of Mind – Farewells* was the first achievement of that research. To render the emotional experience of "the ones who remain behind," he drew larval silhouettes sinking into a monochrome space crisscrossed with linear grids, like so many abstract notations of the energy flow. The aim was to incorporate in Futurist painting "sensations" grasped with their psychic associations. At the time, the Futurists were not looking to Paris, since instead they considered Munich and Vienna to be "the centers of modern European art." That is why the post-Divisionist orientation of their works tended toward Abstract Expressionism.

Going beyond Divisionism, in order to structure the image and counter the proneness to abstraction surfacing in their paintings, either latent or openly expressed, between 1910 and 1911, the Futurists also worked on the graphic geometrizations that Romani used in his drawings to materialize the extra-sensory part of psychic energy. So then Russolo painted *Music*, where lines and colors rendered the spreading of sound waves in space, while the

ghosts of the great dead composers were embodied in their "mediamistic masks." Furthermore, by multiplying the pianist's hands, that painting introduced the repetition of form in a process meant to express motion. Indeed, after having assimilated the most innovatory forms of an autochtonous tradition of modern painting, the Futurists now turned toward the experimental sciences to appropriate other means for giving shape to kinetism and dynamic sensation, since their aim was to represent the incessant action of energy lying deep in the heart of life.

They turned their attention to all the experiments that the most famous scientists of the time were performing on the physiology of the human body, on the characteristics of motion and the laws of energy contained in matter. In their painting, they incorporated every visual discovery of scientific photography, including all the graphic and linear formalizations performed by the mechanical eye. The multiplication of form in Marey's chronophotographs gave them the idea of representing motion in time. The "cyclograms" by Marey and

| Umberto Boccioni
STATES OF MIND I:
THE ONES WHO ARE LEFT BEHIND,
| 1911 (first version), oil on canvas,
| 71 x 96 cm (27 15/16 x 37 13/16 in).
Civica Galleria d'Arte Moderna, Milan.

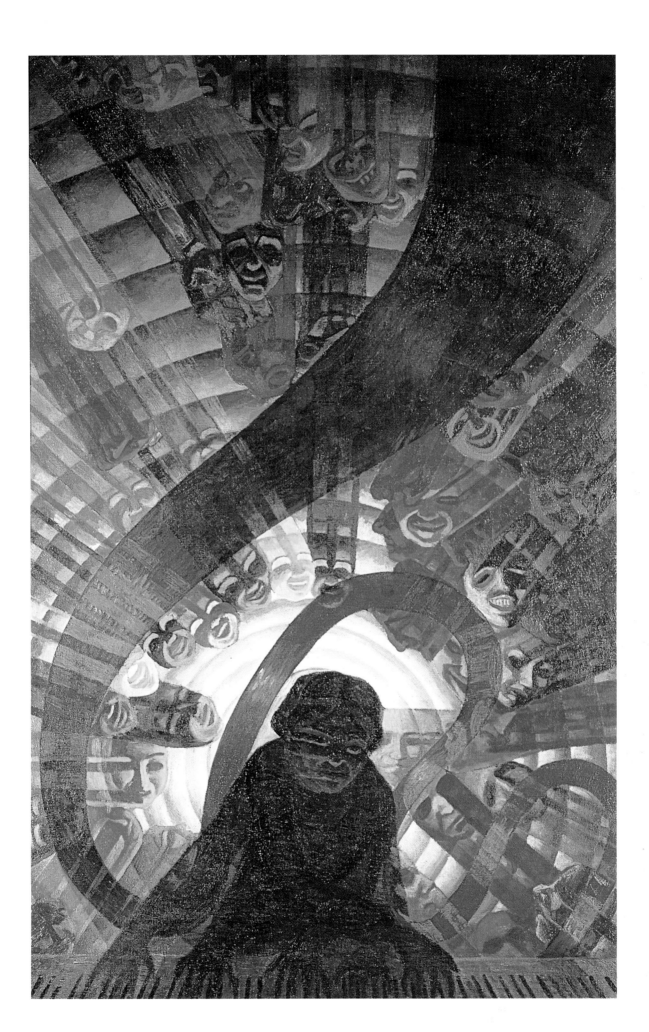

| Étienne-Jules Marey
STORK IN FLIGHT
| 1886, chronophotograph
on fixed plate.
| Bibliothèque Nationale de France, Paris.

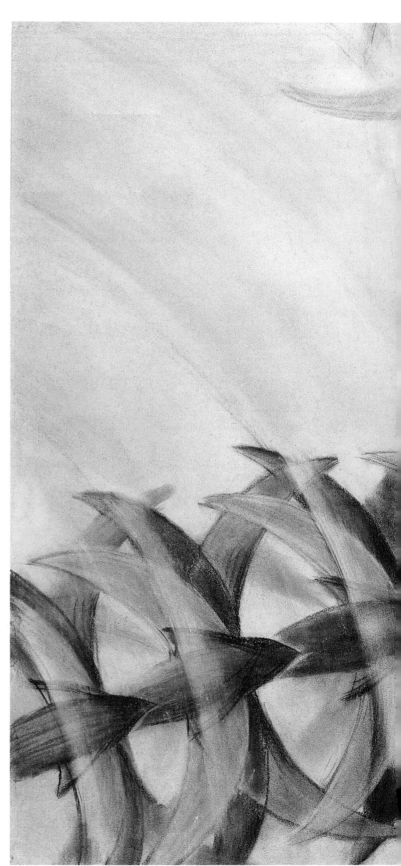

Gilbreth, that is, the trajectories of motion seized in the three spatial dimensions, would be borrowed by Balla as "lines of speed." The transparency of bodies, thanks to Röntgen's X-Rays, was perceived as a proof of the dematerialization of things, continuously subjected to universal dynamism. Graphic representations of shock-waves, that Mach was studying, were used to create a symbolic image of speed, following the course of an object in space. The vortex produced by an object spinning, as Matson had photographed it, enabled them to visualize the "virtual volume of the form," produced by its energetic expansion in the surrounding space. Muybridge's photographic sequences, that seized a same motion from several different points of view, were interpreted by Boccioni as being able to render the emotional evocation of a gesture in terms of a "state of mind." It was the same story with the double-exposures of spiritist photography, that Flammarion and Richet explored, and that Boccioni saw as being figurations of reminiscences and psychic repercussions of the image. Last of all, the bending of the field and the optical distortions of Goertz' wide-angled lenses were equally taken advantage of to glorify the vitality of the image, through an irradiating perspective that put the viewer "right in the middle of the painting."

What the Futurists were seeking was to draw a new formal vocabulary from analytical scientific investigations, their attitude being somewhat similar to that of Seurat's neo-Impressionism, but without the slightest systematic approach. Instead, Carrà, Boccioni and Russolo, appealing to the Futurist artist's intuitive spontaneity, to not say his "bursts of genius," wanted to call up the vital intensity of movement, and even its emotional, lyrical dimension, rather than concentrating on its optical reconstruction. That explains why in their paintings those dynamic signs took on a symbolic connotation, becoming the emblems of spiritual movement, rather than signs of actual movement. In that fashion, Mach's

Giacomo Balla |
FLIGHT OF SWALLOWS
1913, charcoal and colored pencils on paper,
54 x 85 cm (21 1/4 x 33 7/16 in).
Private collection.

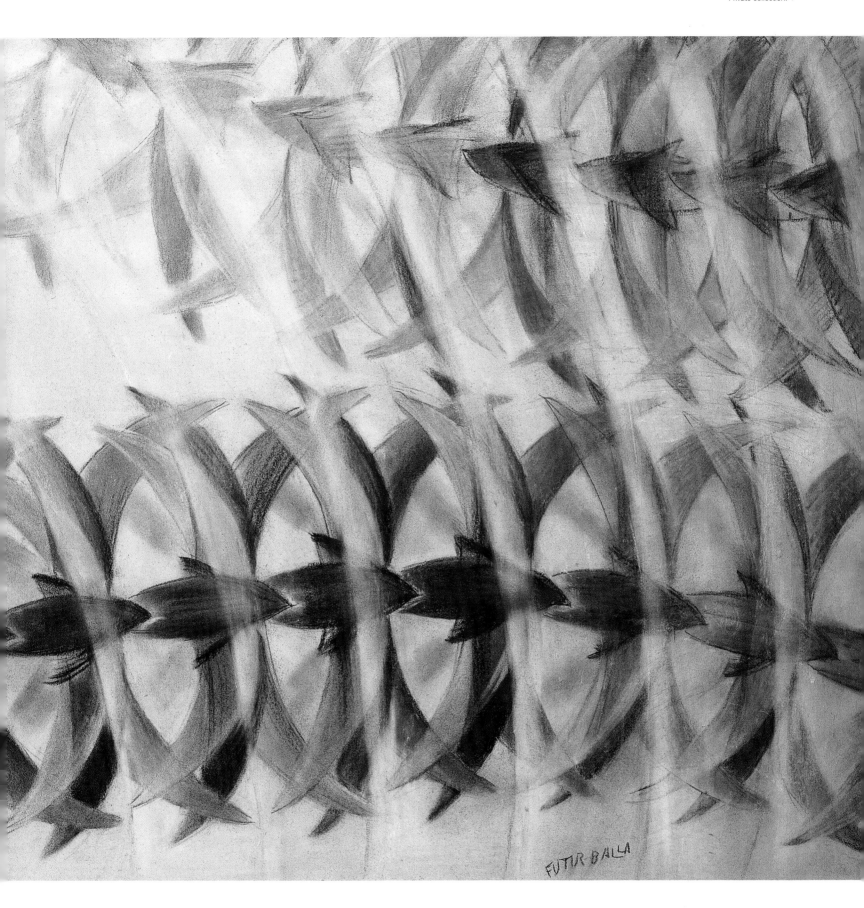

| Ernst Mach
**SHOCK WAVES PRODUCED
BY A PROJECTILE FOLLOWING
A RECTILINEAR LINE
IN THE AIR**
| 1887,
microphotographs.
| Private collection.

Luigi Russolo |
THE REVOLT |
1911, oil on canvas, |
230 x 150 cm |
(90 9/16 x 59 9/16 in). |
Kunsten der Gemeente Museum, |
The Hague. |

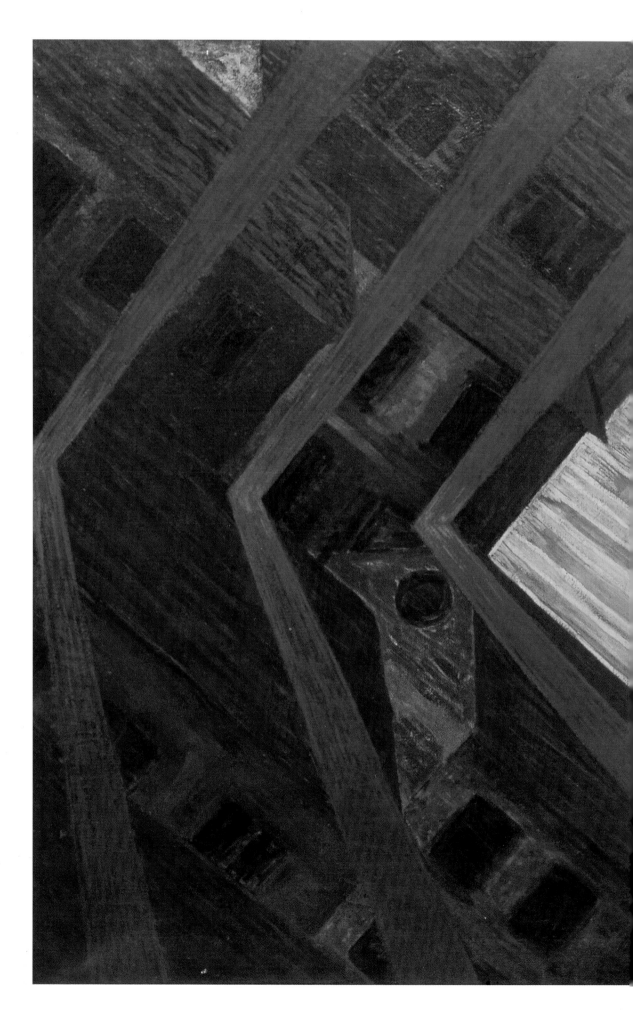

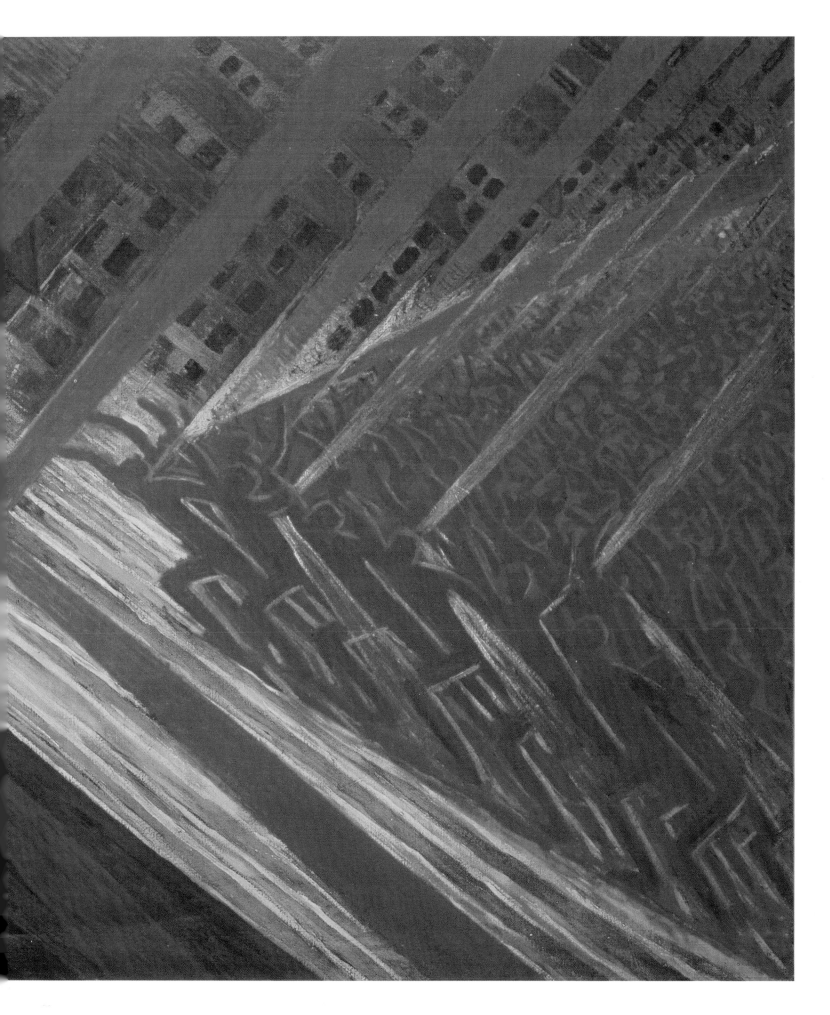

sharp angle, that had become a part of this new formal language, was used in a conceptual way in Russolo's *The Revolt*. Likewise, the chronophotographic repetition of form became a lyrical transposition of the musical gesture in Balla's *The Violinist's Hand*.

That first stage of Futurism, marked in the same degree by the post-Divisionist brushstroke and the reelaboration of the signs of the experimental sciences, reached its climax in the middle of 1911, illustrated by two major events: a large group exhibition in Milan and Boccioni's milestone lecture in Rome.

So in May 1911, spurred by Boccioni, the Futurist group organized through the Workers House in Milan, an *Esposizione d'Arte Libera* to which workers, avant-garde artists, amateur painters and even children were invited, with the purpose of "showing that the feeling for art, considered the privilege of a chosen few, is inherent to human nature, and that its forms of expression merely coincide with the degree of feeling of whomsoever materializes them." The very first experiment of its kind in Italy, the exhibition was offered in May, in a dismantled factory, for the benefit of unemployed workers. Boccioni used the occasion to launch a new attack against the censorship exercised by the "official bureaucracy whose impudent authoritarian attitude violates the work of art's right to exist." The three painters stood in front of their pictures to explain them to the public. For Boccioni that

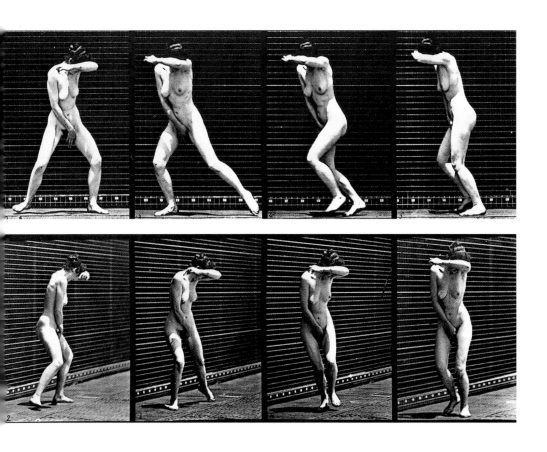

| Edward Muybridge
CHASTE WOMAN, STUDY OF MOTION
| 1884, photographic series.
Bibliothèque Nationale de France, Paris.

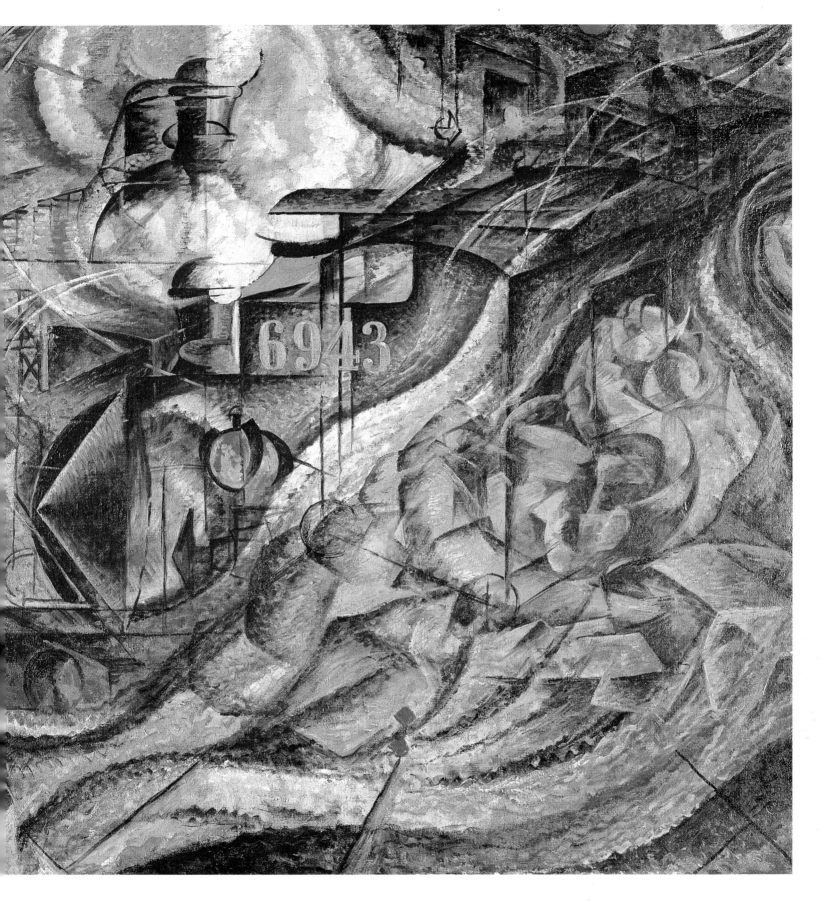

Umberto Boccioni |
STATES OF MIND I: FAREWELLS
1911 (second version), oil on canvas,
71,2 x 94,2 cm (28 x 37 1/16 in).
Museum of Modern Art, New York.

| Giacomo Balla
**DYNAMISM OF
A DOG ON A LEASH**
| 1912, oil on canvas,
90,8 x 110,2 cm
(35 3/4 x 43 3/8 in).
Knox Art Gallery,
| Buffalo.

initiative was of the utmost importance. In fact, it would not be until 1913 that he would acknowledge the disappointments experienced in his contacts with the representatives of both the Anarchist and the Socialist lefts in Italy: "We Futurists always found them to be violently opposed to every revolutionary research in art."

On May 29th, Boccioni held a lecture in Rome to explain the technical foundations of Futurist pictorial dynamism. He first reasserted the necessity of "intrinsic complementarity," meaning organized solely in keeping with the dissonances of tones and according to an "intuitive disorder in unison with the explicative disorder of the universe." He then presented the principle of the interpenetration of forms owed to the expansion of their "forces" in space, whereby Futurist painting expressed the action of energy in the midst of matter: the aim was to achieve the fusion of the object with its surroundings, an extreme vision of reality where everything is merely a transition of energy. Last, he went into the postulate of the total disappearance of form: "The painting, with its childish, unmoving materiality, will no longer be adequate when colors, infinitely multiplied, will express our very feelings, beyond the control of forms." In contemplating the subsequent disappearance of the picture in the name of a greater and freer expression of dynamism in space, Futurist painting had achieved its first theoretic maturity.

Right after that lecture, the Bragaglia brothers began in Rome their experiments on "photographic dynamism," the latest front line set up by the Futurist avant-garde. By introducing, in the field of photography, the principles of pictorial dynamism, they strove to seize a gestural movement "in the form of a vibration, a sensation, an emotion." Their photographic images provided a sort of concrete confirmation of Boccioni's ideas: by reaching behind the veil of objective reality, the mechanical eye seemed able to grasp the energy of the gesture while transcending matter. The Bragaglias' "photodynamics" did indeed create the same fluid mobility, dematerializing bodies and engulfing the image, as did Futurist paintings. In other words, what Boccioni had presented as the result of a victory of painting could be achieved by the mechanical eye as well. That was how photographic creation began to directly threaten the specificity, if not the actual justification, of Futurist pictorial dynamism.

Italian Futurism
and French Cubo-Futurism

It was toward the middle of the year 1911 that Futurist painting began loosing its homogeneity: Balla and Severini undertook their own experiments, presenting a style of Futurist painting that had discarded its Expressionist components connected with the theme of "states of mind," while Boccioni, Carrà and Russolo had set about to discover Cubism.

Anton Giulio
and Arturo Bragaglia
THE ROSES
1913,
photodynamic,
8,5 x 11,2 cm
(3 5/16 x 4 3/8 in).
Private collection.

For some time now, Balla had been interested in giving the image a photographic layout, interpreting pictorial dynamism merely as an optical reconstruction of form's becoming in space. For him, movement was first and foremost the object of an analytical approach drawn from Marey: representing time by the repetition of form. His *Dynamism of a Dog on a Leash* borrowed the model of chronophotography in a joking, ironic vein, making the painting a sort of pictorial version of the kinetograph. Severini, whose Neo-Impressionist starting point was more rigorous, was intent on attaining "orchestrated modulations" of color, and on representing the dynamism of fashionable haunts. In *Yellow Dancers*, he verged on abstraction by painting a mosaic-pattern of light tones, thus displaying how "forms are dissolved by electric light and movement." He was the one who spread the first news about Cubism to Milan, then urging Boccioni and Carrà to come to Paris to discover Cubist

Anton Giulio and Arturo Bragaglia |
THE BOW
1911, photodynamic,
8,5 x 11,2 cm (3 5/16 x 4 3/8 in).
Private collection

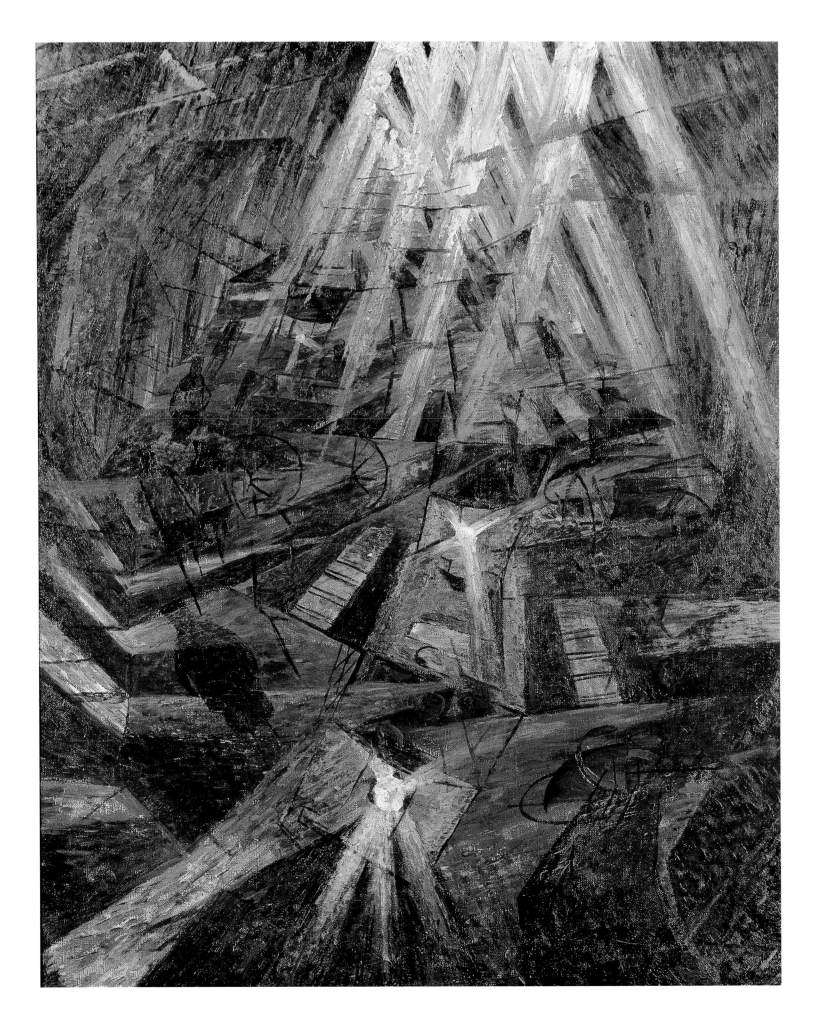

| Gino Severini
YELLOW DANCERS
| 1911, oil on canvas,
45,7 x 61 cm (18 x 24 in).
Fogg Art Museum, Cambridge,
| Massachusett.

| Umberto Boccioni
FORCES OF A STREET
| 1911, oil on canvas,
100 x 80 cm
(39 3/8 x 31 1/2 in).
| Private collection.

painting. So early in October 1911, the two artists joined Severini, who introduced them to Apollinaire and took them to visit the *Salon d'Automne*. They went to the Kahnweiler gallery, too, where Picasso was being shown, before meeting the artist himself in his studio. Back in Milan, Boccioni wrote Apollinaire, asking him to give his regards to Picasso: "He is an admirable painter whose work fascinates me in a truly special way."

At the time, the Futurist group was preparing an exhibition that would open four months later at the Bernheim Jeune gallery in Paris. Boccioni decided to paint a second version of his *States of Mind* triptych. The picture *Farewells* was one of the very first effective assimilations of Cubism, by the geometrization of volumes and the rhythmed fragmentation of the subject. The post-Divisionist brushstroke, just like the Futurist compositional elements, were not discarded for all that. Inspired by Mach's scientific experiments, the curves with varying radial lines surrounding the top of the locomotive lyrically emphasized its thrust in space, while the acute angle, materialized by the profile of its boiler, symbolized the fatality of departure. Last, in a visual sequence influenced

by Muybridge, an embracing couple appeared, repeated several times within the space. Using a like approach, Carrà painted *The Funeral of the Anarchist Galli*. They were both striving to give a new expression to the imperatives of Futurist pictorial dynamism in accordance with the Cubist decomposition of form. They had to blend their conception of matter as energy, the cornerstone of Futurist pictorial dynamism, with the formal analysis of the constituents of the object, which was the technical principle of Cubist deconstruction.

Futurist experimental research was growing more methodical. After the fluidities of post-Divisionist dynamism, with its linear brushstrokes overwhelming the surface of the painting, more organized compositions now appeared, in particular with the crystallization of forms. Boccioni produced an abrupt sonorous scansion of space in *The Burst of Laughter*, while Carrà, in *Rhythms of Objects*, turned the analysis of forms into rhythmic values. Other paintings, on city themes, expressed dynamism by a splintered, off-centered structuring of space, that destabilized the built forms of the city, plunging them amid the throbbing street scene. Thus, in *Simultaneous Visions*, Boccioni used the frame of the window to express on the canvas the intensity of sensorial events: a dynamic tension shook the façades of the buildings, creating an overall vortex of the image, while uneven spirals materialized the sonorous energy of the noises rising from the street. Obeying to the principle of "polyphonic simultaneity," the painting opened onto all the sensorial components of space, striving to seize the din, the smells, the lights, the colors, the moving forms of modern cities.

The exhibition organized in February 1912 in Paris, that signaled the group's first appearance in the international arena, was one of the highlights of the Parisian artistic scene of the time. Marinetti went so far as to hire the large luminous signs set up on the Boulevard des Italiens to announce the Futurists' arrival in Paris. For the exhibition catalogue, Boccioni wrote a new theoretic essay, pointing out the formal means for constructing "dynamic sensation" in Futurist painting: "lines of force" and "battles of planes" that, by extending the object in space, created the interaction of its forms with its surroundings. The evening of the opening, Marinetti held a lecture in which he claimed: "Instead of becoming crystallized in this or that manifesto, pictorial Futurism is undergoing and will continue to undergo constant transformations owing to the ideological dynamism that characterizes true Futurist spirits." Yet Boccioni, having a poor mastery of French, had a hard time expressing his views. Then the Futurists were invited to Gertrude Stein's *salon*, and a banquet was held in their honor at the premises of the *Mercure de France*, that Erik Satie and Gustave Kahn, among others, attended. Their exhibition caused an uproar, but the event had come about too late to have a real effect in Paris on the evolution of the new painting. As a matter of fact, Futurist theories had already been around for some time in Parisian art circles. The newspaper *Comœdia* had published, on May 18, 1910, the *Manifesto of Futurist Painters*, thus commenting: "The few principles they suggest as guiding the art of the future will most certainly revolutionize the painters' world." Since then, Delaunay, Léger, Kupka, Picabia, Duchamp, Villon, Marchand, Dunoyer de Segonzac and many others had taken up, in one way or another, the Futurist themes of dynamism, kinetism, and the machine. Delaunay had created his first *Eiffel Tower* with its out-of-joint composition, and Léger had painted his *Nude Figures in a Wood*, causing the critic Roger Allard to observe: "Disassociating the objects that compose an appearance so as to cause them to become a shifting interpenetration: there is something that singularly reminds us of a certain Futurist manifesto…" Kupka had used the chronophotographic multiplication of forms in his series of pastels like *Woman Picking Flowers* and in the canvas *Planes by Colors*, before attempting to analyze how light destroys the forms of reality. Picabia had expressed movement in his pictures like *Dancing by the Spring*, his experiments confirming the important role Futurist theories were playing in the advent of abstract art. As for Duchamp, he had investigated the various principles of Futurism, such as the transparency of bodies, the plastic metaphor of the machine, the chronophotographic repetition of the form, the variable contractions of a moving body in space. Between 1910 and 1911, he had experimented in several paintings, including *Coffee Mill, Lady-love, The Chess-Players, Melancholy Young Man in a Train*, climaxing in the first version of *Nude Descending a Stairway*. Parisian painters had assimilated Futurist theories, backed all the while by another modernism, the one going from Cézanne to Picasso, that enabled them to achieve a formal plenitude that was still lacking in a good number of Futurist paintings.

So, when the Futurists showed their works in Paris in February 1912, and claimed they were contributing revolutionary innovations, their reception was far from enthusiastic. The critic Roger Allard could not refrain from pointing out that Delaunay and Léger had gone way beyond the Futurists in terms of practical accomplishment, since the program put forward by Marinetti, for whom "the supreme objective of painting was to express movement" was not new to Paris, where "his ideas have been known and discussed for some time." And Apollinaire went on to add: "The originality of the Futurist school of painting is that it wants to reproduce movement. That is a perfectly legitimate subject of investigation, but French painters solved that problem, insofar as it can be solved, simply ages ago."

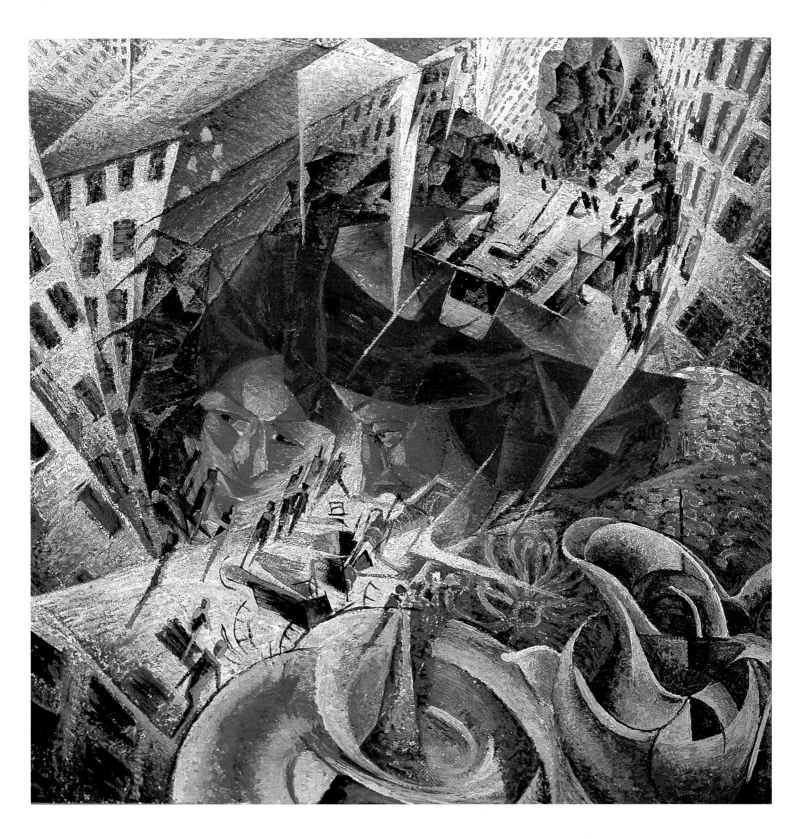

Umberto Boccioni |
SIMULTANEOUS VISIONS
1911, oil on canvas, 70 x 75 cm |
(27 9/16 x 29 1/2 in).
Van Der Heydt Museum, Wuppertal. |

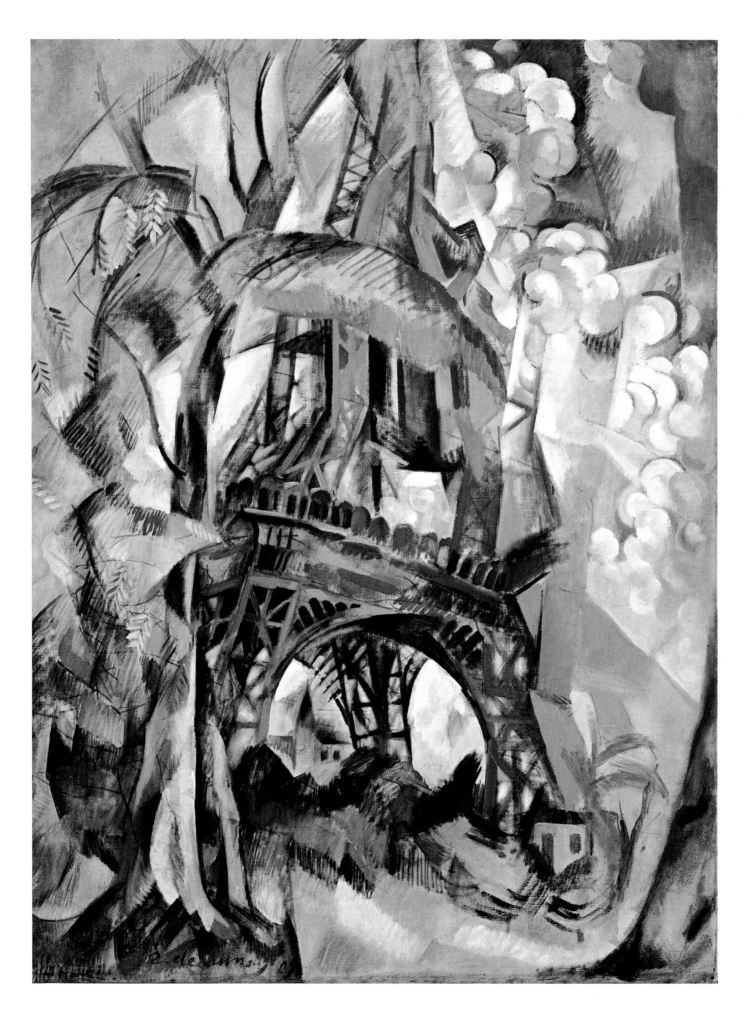

Franz Kupka |
WOMAN PICKING FLOWERS
1910, pastel on paper, 45 x 47,5 cm
(17 11/16 x 18 11/16 in).
Musée National d'Art Moderne, Paris.

| Robert Delaunay
EIFFEL TOWER WITH TREES
| 1910, oil on canvas, 124 x 90 cm
(48 13/16 x 35 7/16 in).
Solomon R. Guggenheim Museum, New York.

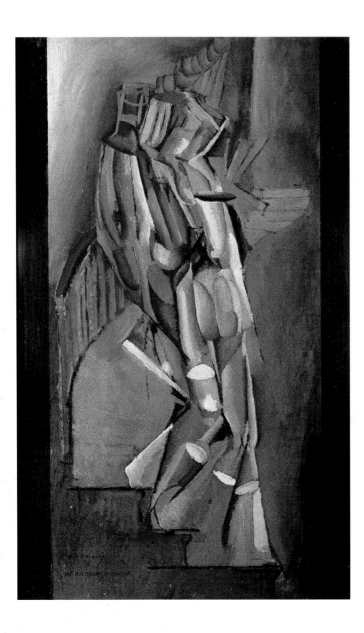

| Marcel Duchamp
NUDE DESCENDING A STAIRWAY Nº 1
| December 1911, oil on cardboard,
96 x 60 cm (37 13/16 x 23 5/8 in).
| Philadelphia Museum of Modern Art, Philadelphia.

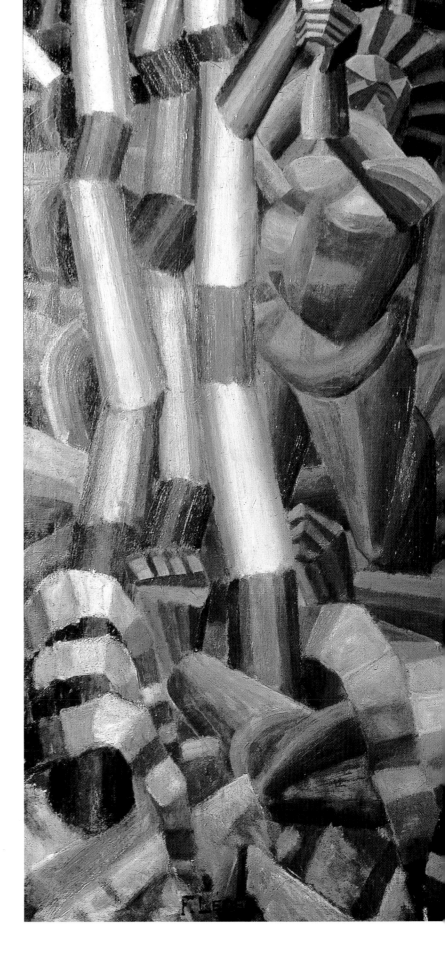

Fernand Léger |
NUDE FIGURES IN THE FOREST
1910-1911, oil on canvas,
120 x 170 cm
(47 1/4 x 66 15/16 in).
Kröller-Müller Museum, Otterlo.

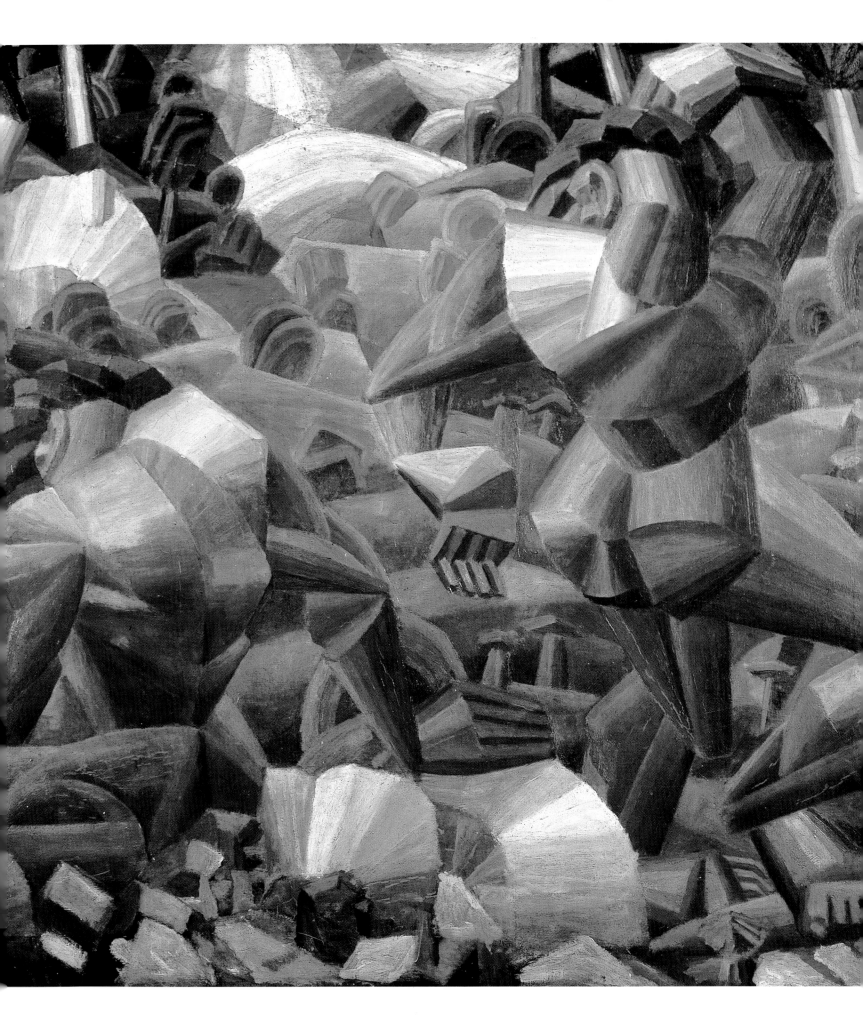

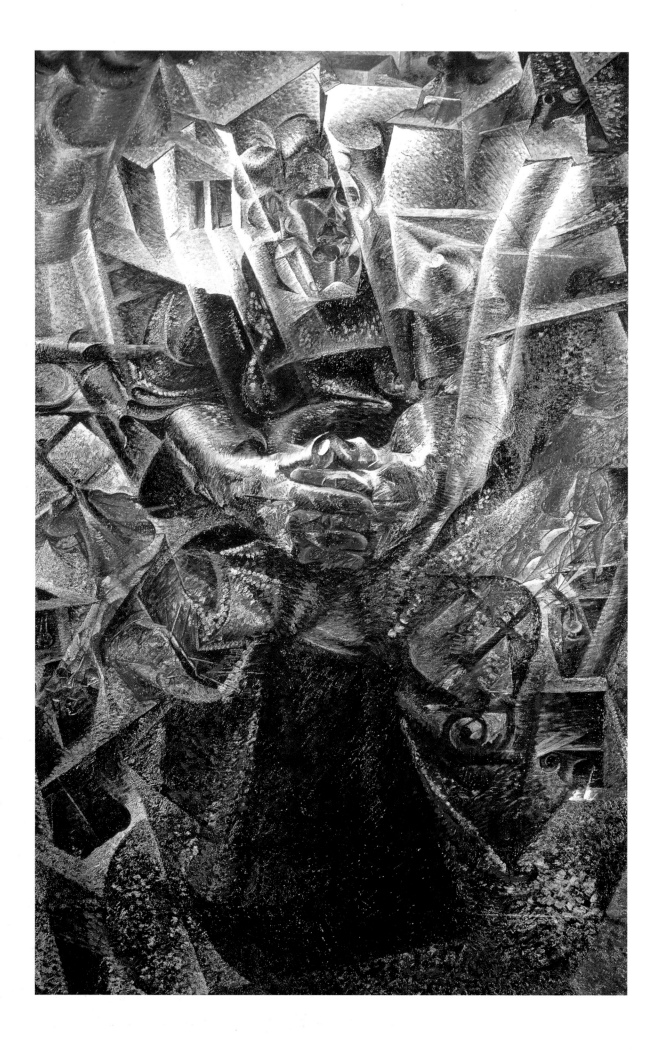

Indeed, over the previous two years, French painters had absorbed the ideas contained in the *Manifesto of Futurist Painters*. Nonetheless, on the occasion Duchamp and Léger met Boccioni and Carrà. As for Gleizes, he claimed: "To yesterday's plastic signs we should add some new ones, that provide better answers to our present-day needs, to our time, and that have considerable dynamic power. That dynamism which is all around us, and within us, cannot be ignored by artists." So an agreement might be reached; Boccioni's and Carrà's discussions with Léger and Gleizes continued at the *Closerie des Lilas*. They talked about painting, each one verifying the validity of his own ideas.

But the vainglorious attitude of the Futurists, naively claiming they were the leaders in the new pictorial experiments, provoked a reaction of rejection. Thus, in order to avoid any further confusion, the Cubist group compelled Duchamp to withdraw his second version of the *Nude Descending a Stairway* from the *Salon des Indépendants*. Much later, Duchamp was to claim he had attempted, in that painting, to achieve "the Cubist interpretation of a Futurist formula." As a matter of fact, the evolution of painting in Paris continued to echo the Futurist program which, for the critic Roger Allard, wanted "to express movement, human gestures, cosmic forces in their overall intensity." In October 1912, in an article appearing in *Gil-Blas*, the critic Marcel Boulenger called the painters on exhibit at the *Salon d'Automne*

"Cubo-Futurists," coining an expression that immediately traveled to Russia. In turn, Adolphe Basler was to speak about the September 1913 *Salon d'Automne* in terms of "Cubistico-Futurist speculations." Later, at the *Salon des Indépendants* of March 1914, Apollinaire could but bear witness: "The *concetti* of cavaliere Marinetti are presently sweeping over France."

"Plastic Dynamism"

By the middle of the year 1912, it looked like Futurist painting had been definitively emancipated from Marinetti's theoretic authority. It then became, particularly thanks to Boccioni, the most innovatory discipline of Futurist experimentalism. Boccioni, with his temperament at once passionate and fragile, stubbornly insisted on challenging Cubist painting, not hesitating to describe it as sheer formal virtuosity, meant for museums and "lacking in ethical vigor." For that reason, right after the Paris exhibition, he turned a portrait of his mother into a highly allegorical work that he called *Matter*. The principle of the interpenetration of bodies, expressing his energetic conception of space, was displayed in a fan-shaped composition. He then entered in a controversy with Léger, Delaunay and Apollinaire. He defended the legitimacy of Futurist experiments, of which he was the theoretician, and insisted that they acknowledge the catalyzing role the *Manifesto of Futurist Painters* had played in the evolution of Parisian painting. Clashing

THE FUTURISTS RUSSOLO, CARRÀ, MARINETTI, BOCCIONI AND SEVERINI
In February 1912, in Paris, on the occasion of the exhibition at the Galerie Bernheim Jeune, at the time near the Madeleine, in the building presently the premises of a department store.

| Umberto Boccioni
MATTER
1912, oil on canvas, 225 x 150 cm (79 9/16 x 59 1/16 in).
Peggy Guggenheim Collection, Venice.

| Umberto Boccioni
DYNAMISM OF A SOCCER-PLAYER
| 1913, oil on canvas, 195 x 200 cm
(76 3/4 x 78 3/4 in).
| Museum of Modern Art, New York.

Umberto Boccioni |
HORSE + RIDER + HOUSES
1913-1914, oil on canvas,
105 x 135 cm
(41 5/16 x 53 1/8 in).
Galleria Nazionale d'Arte Moderna, Rome.

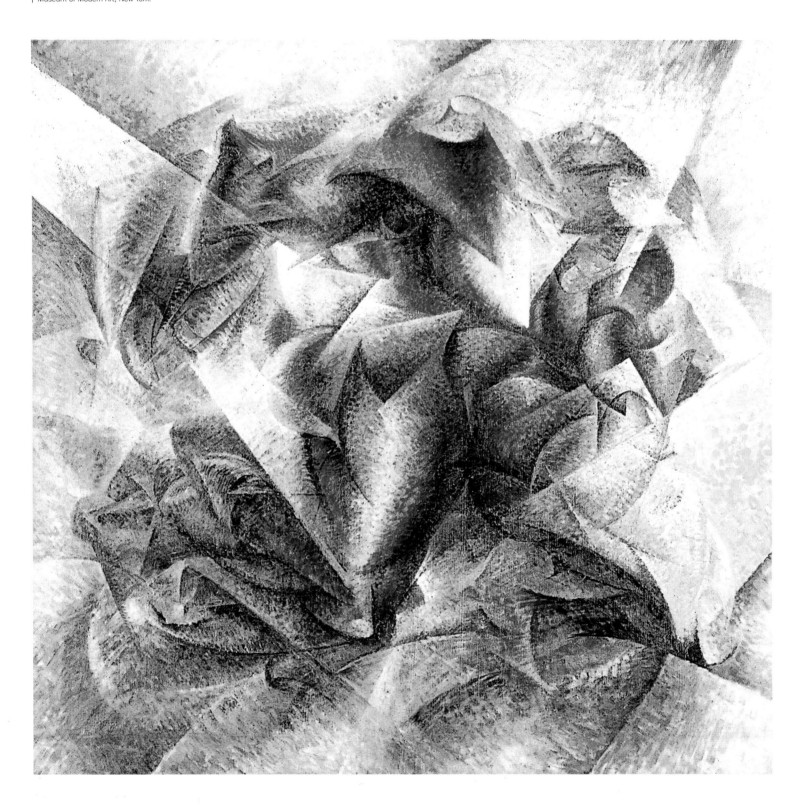

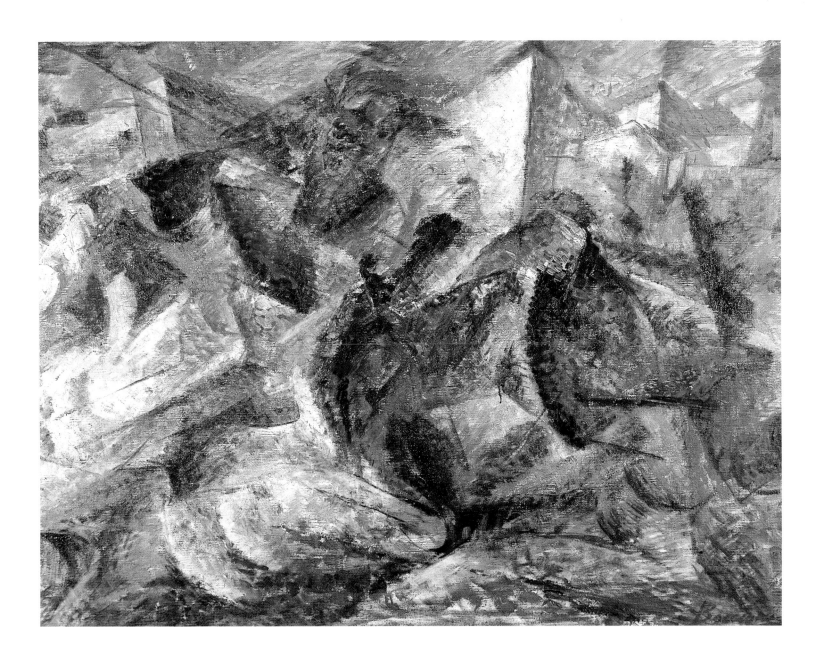

with the Cubists, who were accusing him of producing mere anecdotes on the theme of modernism, he claimed the ideological choice of dynamism was the ethical dimension of Futurist art, therefore receptive to the spiritual values of its time.

Boccioni had reacted in particular to arguments advanced by Léger, who, in an article addressed to him, had contrasted "visual realism" with "realism of concept," the former having now become the sole sphere of photography and motion pictures, whereas the latter was the one direction of investigation left to modern painting. Between 1912 and 1913, the two artists engaged in a real theoretic sparring match. In the series *Contrasts of Forms*, Léger displayed his own interpretation of Cubo-Futurism: he expressed dynamism by using only the specific language of painting. In a series of pictures on the theme of sports, Boccioni instead expressed dynamism as a tangible experience, seizing it in actual kinetic events. In *Dynamism of a Soccer-Player*, he forced the Cubist syntax of form to achieve an emotional, suggestive dimension, building

with obliques and diagonals a sweeping image of the energy tensions contained in the athlete's gesture. He sought to render sharp-edged, faceted volumes, without for all that giving up expressing the condensations of energy and the molecular vibrations of matter expanding in space. In August 1913, in a new controversial response to Léger, for the first time Boccioni used the expression "plastic dynamism." With those terms he defined the latest stage in Futurist experimentation, that was to lead him to approach abstraction in other works, such as *Horse + Rider + Houses*.

Since Boccioni could not go along with the constantly varying stances of Marinetti, for whom the avant-garde had to be a permanent revolution performed regardless of the style being used, he felt that with plastic dynamism he had reached the conclusive stage of the formal idiom of Futurist painting. Becoming the guardian of its orthodoxy, he termed "literature" the experiments performed by Ginna and Corra, who by 1910 had made abstract short films conceived as "symphonies of colors." His new

attitude equally meant that he utterly rejected the Bragaglia brothers' photodynamism, demanding they be excluded from the Futurist movement. For him, they were guilty of not going beyond the first stage of Futurist investigational research. At this point, plastic dynamism tended to become for Boccioni a codified system, open to its own enrichment, but closed to every experimentation that might ignore its fundamental postulates. As a consequence, no young neophytes could be admitted to the group of painters. Soffici was the one and only artist allowed to join up with the five founding fathers of Futurist painting.

Yet Soffici's work did not contribute a significant innovation to the Futurist artistic theory. Instead, the singular formal economy of his paintings, with their highly restrained rhythmic articulations, seemed more prone to Cubo-Futurism. In fact, his constant striving toward a balanced ordering of the composition had little to do with the vitalistic glorification of plastic dynamism as Boccioni saw it. Soffici followed that direction with his canvas *Decomposition of the Planes of a Lamp*, which Carrà thus commented to him: "It seems to me that painting, by the strength of matter expressed there, may be your

best work. You combined the element-light with the elements of the volumes in a manner I would call perfectly balanced." With Papini, Soffici succeeded above all in making his magazine *Lacerba*, published in Florence, become one of the leading publications of the European avant-garde.

On the other hand, Severini and Balla carried out further experiments bearing on dynamic abstraction. Since one of them was in Paris and the other in Rome, they were able to avoid Boccioni's control over Futurist painting. Severini, being interested in the theme of dance, broke up forms in accordance with a rhythmic identity intuitively associated with musical sound. In his painting *The Dancer in Blue*, the dynamic fragmentation of forms expressed the explosive force animating the dancer's body and putting it in motion. Severini claimed he was seeking a "painting of sounds obtained by the contrast between lines and complementary zones." Later he introduced "constructive and optical dynamism," by creating irradiating rhythms of forms and colors developed by consonances. He painted images that appeared as though refracted in a prism of signs and colors. Obsessed by the sphere of dance, he ended up by giving it absolute

| Gino Severini
THE DANCER IN BLUE
1912, oil on canvas,
61 x 45 cm
(24 x 17 11/16 in).
Private collection.

Gino Severini |
SEA = DANCER |
1913-1914, oil on canvas, |
100 x 80,5 cm |
(39 3/8 x 31 11/16 in). |
Peggy Guggenheim Collection, Venice. |

Page 78 |
Gino Severini |
DANCER |
1914, pastel on cardboard, |
49 x 42 cm (19 1/4 x 16 1/2 in). |
Staatsgalerie, Stuttgart. |

Page 79 |
Ardengo Soffici |
DECOMPOSITION |
OF THE PLANES OF A LAMP |
1912, oil on canvas, 30 x 35 cm |
(11 11/13 x 13 3/4 in). |
Estorick Collection, London. |

G. Severini 1913

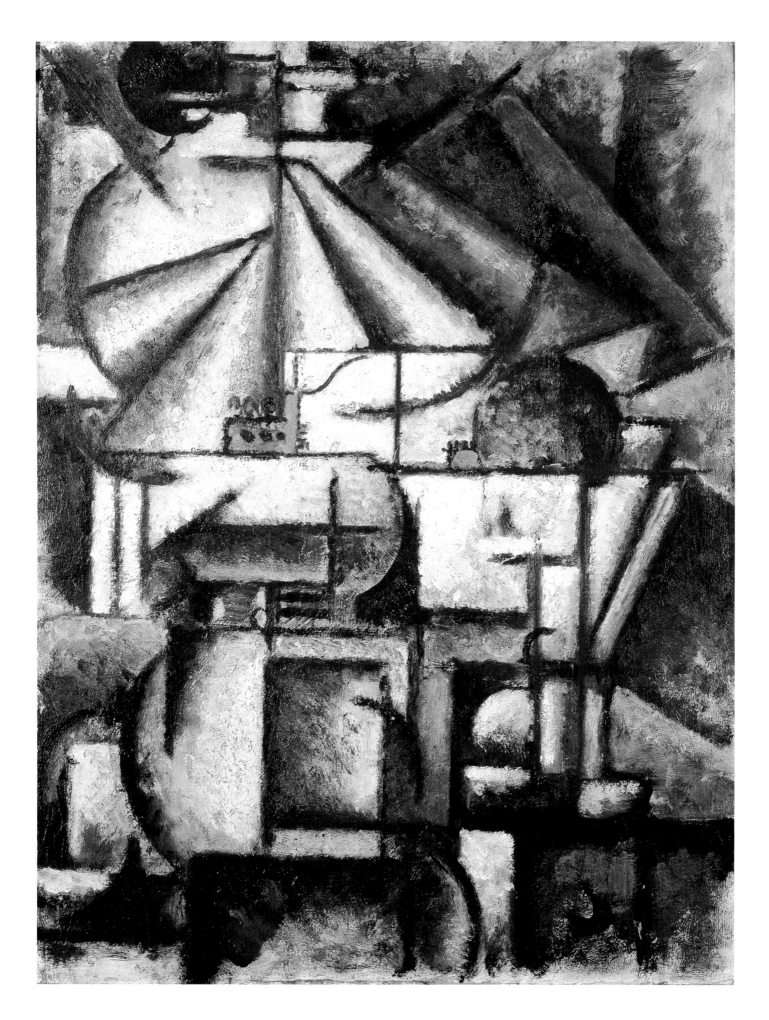

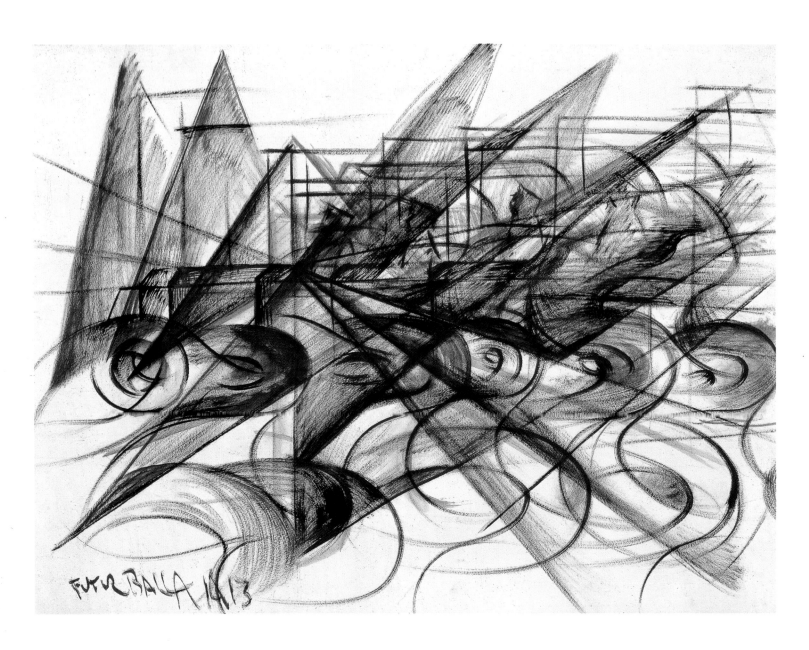

| Giacomo Balla
Automobile Speed
| 1913, oil on cardboard,
| 60 x 98 cm (23 5/8 x 38 9/16 in).
| Civica Galleria d'Arte Moderna, Milan.

eminence, as the metaphor of "universal dynamism." His research was characterized by the notion of a dynamic analogy. The idea was to place on a parallel two or three types of images so as to paint a multiple, simultaneous composition that, liberated from representation, embodied an ideal world shaped merely by the rhythm of abstract forms. In his works like *Dancer = Propeller + Sea*, two realities connected by analogy thus merged to create a single abstract pictorial reality. The play of association and merging brought about a dual dimension of the image: concrete and cosmic.

Balla went on using chronophotography to express in plastic rhythms a linear movement in *Little Girl Running*

on a Balcony, a painting that singularly radicalized the "divided brushstroke" of the first Futurist manner. Then, on the occasion of a stay in Dusseldorf, he discovered an instrument for analyzing colors, called "Lambert's pyramid," that defined the extinction coefficients of the fundamental chromatic values. He borrowed its chart to paint the *Iridescent Compenetrations* (1912-1913), based on the serial juxtaposition of geometric forms and pure colors. These are abstract compositions where the symbolism of the geometrical signs, as well as the tonal gradations going through the mosaic-pattern of the colors, render the dynamism of light as cosmic energy. Whereas Severini used photographs, meaning static images, to

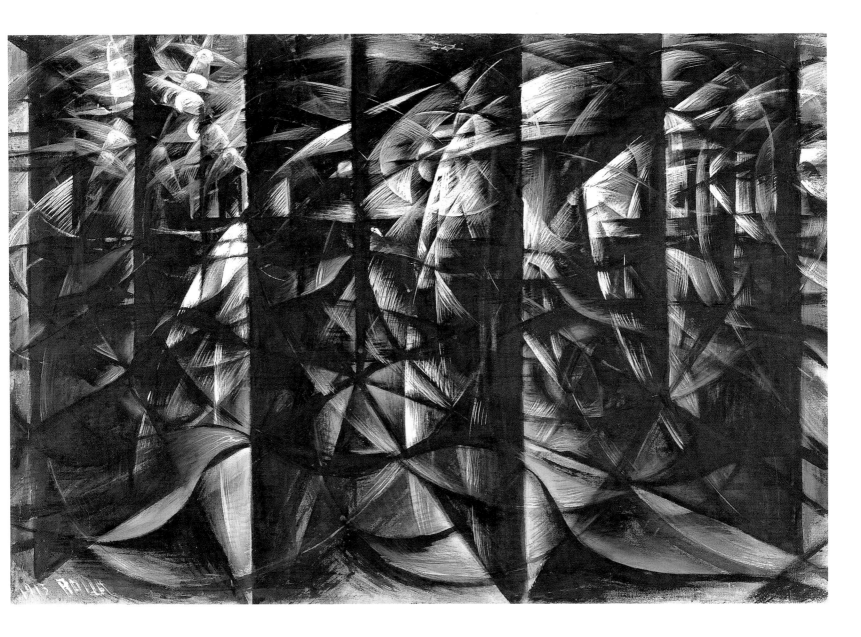

Giacomo Balla |
**AUTOMOBILE SPEED
+ LIGHT + NOISE**
1913, oil on canvas, 87 x 130 cm
(34 1/4 x 51 3/16 in).
Kunsthaus, Zurich.

paint his moving dancers, Balla pursued his analytical investigation by observing real phenomena, using practically a scientific approach. In fact, he would go down in the street to study in detail what happened when speeding cars would go by. Thus he sought to render on the canvas the effects of motion in light, the shiftings of air, the whirling sonorousness of noise, and last, the ephemeral sensation of a space caught up in the accelerated penetration of a moving body. A while later, his painting evolved toward the disappearance of any figuration, thanks to the expressionism of geometric signs. He painted several abstract pictures, such as *Automobile Speed*, consisting solely of close sequences of diagonal lines, sharp angles and tensile stress curves. So many graphic signs whose interpenetration concretized, beyond the materiality of the moving object, the trajectory and secondary effects of actual energy. Concurrently, as in *Automobile Speed + Light + Noise*, he wanted to sonorize painting through monochromes. These works represent the principal contribution of Futurism to European abstract art.

As for Carrà, he tried to go beyond Cubism by using his own syntax, heightening the dynamic vitality of the chromatic form and of the texture of the painting. He painted *The Red Horseman* and launched the manifesto *The Painting of Sounds, Noises, Smells* that called for the

expression, by "abstract plastic equivalencies," such as ellipsoids or curved cones, of the sounds and smells of modern cities. Then he added dynamism to the Cubist collage in *Patriotic Celebration*, where he rendered the uproar of a street demonstration by a swirling proliferation of news clippings. In turn Russolo removed from his painting the slightest influence of Cubist decomposition of the object. Instead, he went on developing the graphic solutions of the first Futurist manner. Thus in *The Solidity of Fog*, he materialized by horizontal strips the waves of the field of energy. The linear networks of his canvas *Interpenetration of Houses + Lights + Sky* evoke the forces that cross the cosmos, giving a fantastic appearance to natural phenomenons. The close-set structuring of his painting *Plastic Synthesis of a Woman's Movements*, where a feminine silhouette appeared to be decomposed in the succession of the stages of a movement, was the expression of his personal approach to Cubo-Futurist. The change from pictorial dynamism to plastic dynamism, focused on a continuous confrontation with Cubism, in Marinetti's case, also led to the shift from free verse to "free words," while Pratella's "absolute polyphony" was replaced by Russolo's "noisism." The latter gave up painting, publishing the manifesto *The Art of Noises* (1913), recommending turning into music the sounds in the city and in nature. New sound materials should enable music to recapture the feeling of life. With his "noise-making" instruments, in 1914 in London, he began an international concert tour, immediately interrupted by the war. The glorification of the noises of life, enacted by Russolo, coincided with Marinetti's manifesto *The Music-Hall* (1913), that set forth a new poetic theory of the theater as *imago urbis*, where the music-hall stage was supposed to reflect the manifold, shifting spectacle of the modern city.

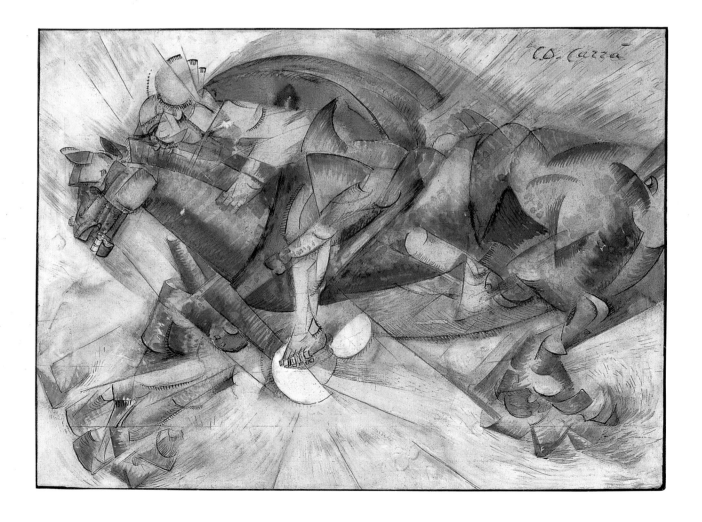

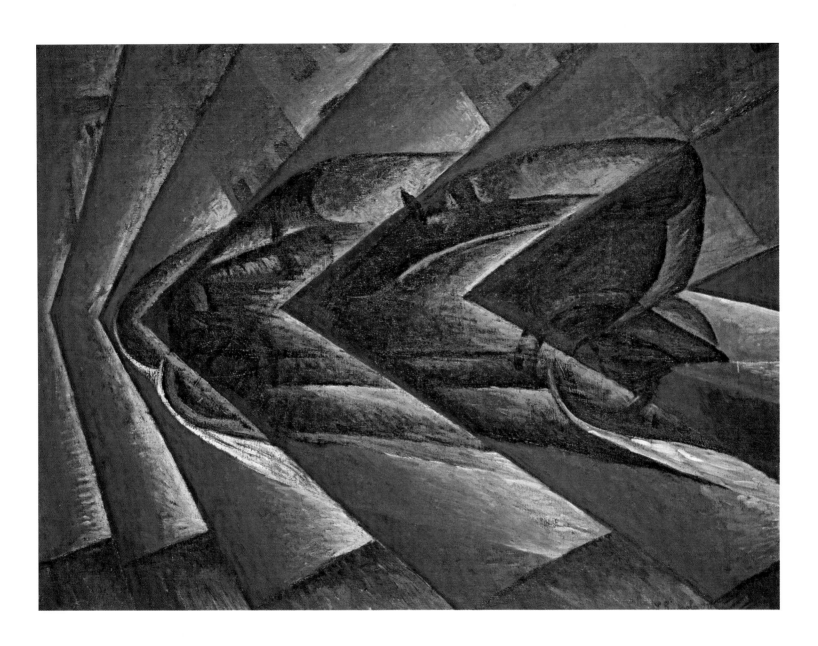

Luigi Russolo |
DYNAMISM OF AN AUTOMOBILE
1912, oil on canvas, 104 x 140 cm
(40 15/16 x 55 1/8 in).
Musée National d'Art Moderne, Paris. |

| Carlo D. Carrà
THE RED HORSEMAN
| 1913, tempera and ink on paper,
| 36 x 26 cm (14 3/16 x 10 1/4 in).
| Civica Galleria d'Arte Moderna, Milan.

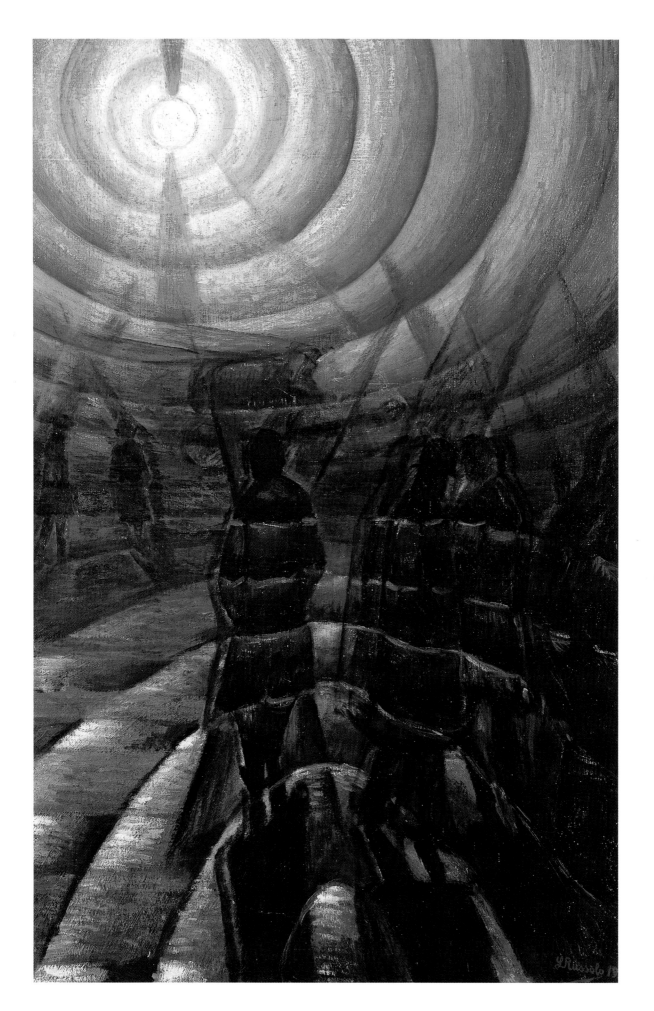

| Luigi Russolo
THE SOLIDITY OF FOG
| 1912, oil on canvas,
100 x 65 cm
(39 3/8 x 25 9/16 in).
Peggy Guggenheim
Collection, Venice.

Carlo D. Carrà |
PATRIOTIC CELEBRATION
1914, tempera
and collage
on cardboard,
38,5 x 30 cm
(15 1/8 x 11 13/16 in).
Peggy Guggenheim Collection,
Venice.

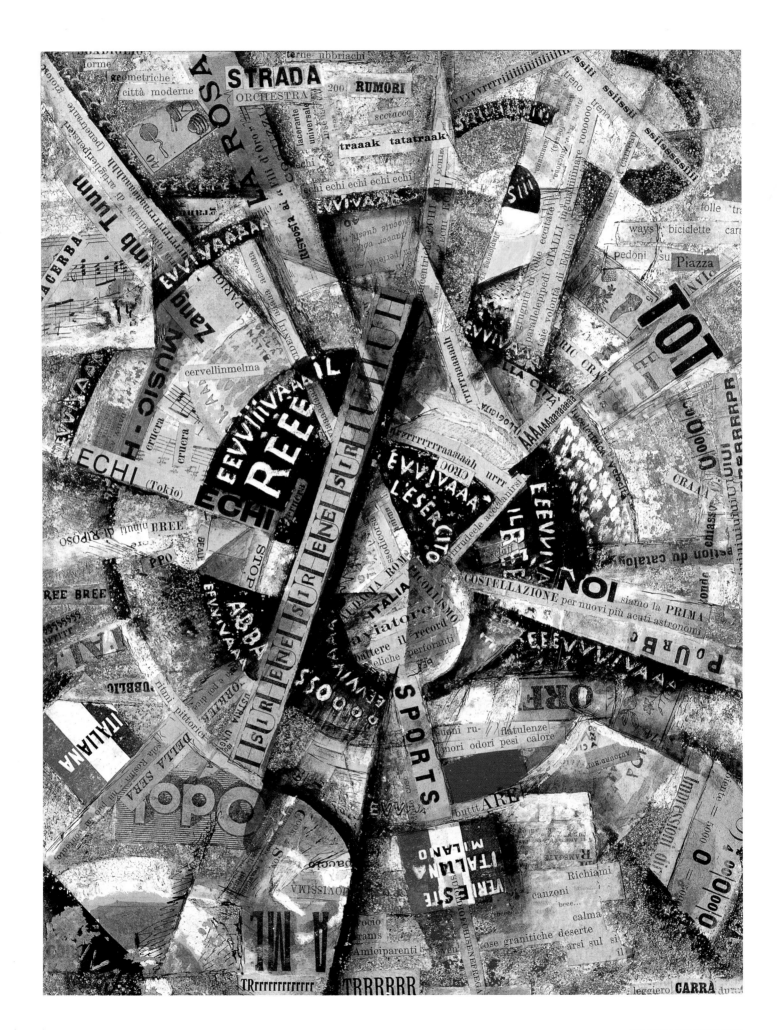

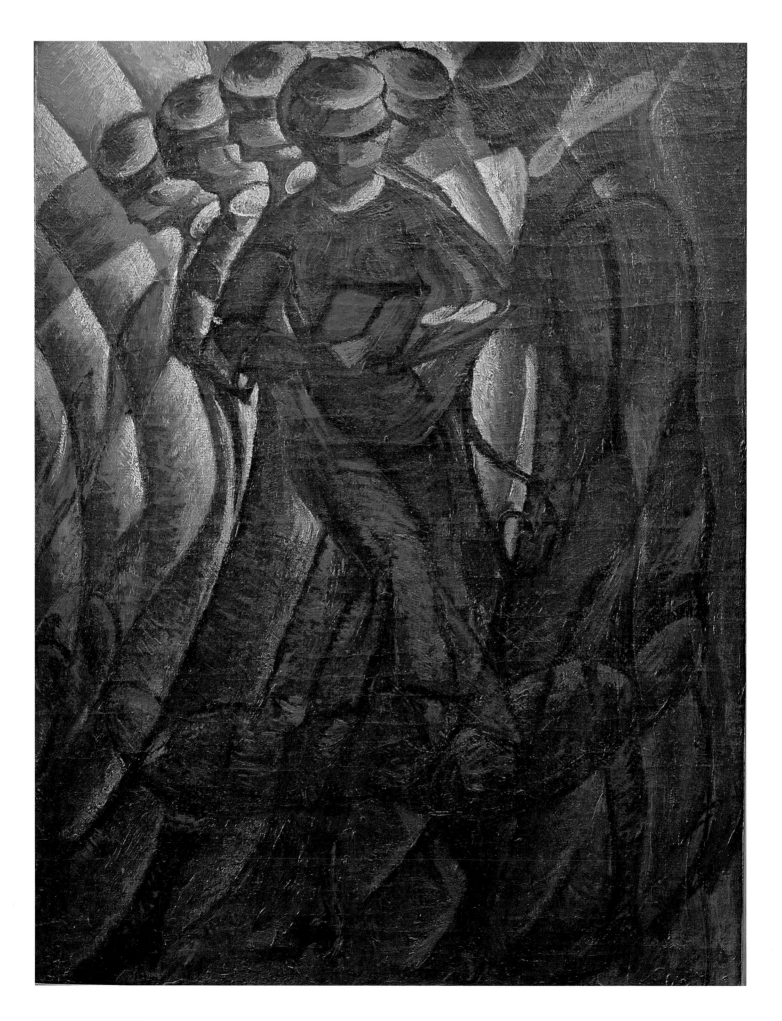

Futurist Reconstruction of the Universe

Futurist art continued to pursue its initial poetics: rendering the dynamism of modern life. Boccioni was still its leading theoretician, but the variety of artistic temperaments forming the Futurist movement created a wholesome situation. The progression of each one's investigative research immediately fed that of the others, causing theories and forms to constantly evolve, investing even architecture, before achieving the creation of assemblages of materials the Futurists called "plastic complexes." Boccioni, pushing his theoretic reflection further, perfected his formal means. In the *Technical Manifesto of Futurist Sculpture* (1912), he reformulated his principles, speaking about the "compenetration of planes," and claiming that from then on Futurist art aimed at "abstract reconstruction, and not the figurative value of planes and

volumes that determine forms." At the time he was working on his first sculptures. By analyzing the constitutive forces of form, he immediately achieved architectural monumentality in *Development of a Bottle in Space*. The spiral became for him a symbolic theme and an analytical instrument suited to the dynamic construction of objects. For the artist, the spiral was an archetypal figure that expressed "the continuity of forms in the midst of universal dynamism," and the indication of constant rhythmic evolution, meaning that vital process of matter that Cubist fragmentation failed to seize. That is how Boccioni thought he could express energy in duration, that is, "the force-form springing from the actual form." He went on to execute *Unique Forms of Continuity in Space*, a sort of mythical image of new man striding toward the future. Instead of decomposing movement

| Luigi Russolo
PLASTIC SYNTHESIS
OF A WOMAN'S MOVEMENTS
| 1912, oil on canvas, 85 x 65 cm
(33 7/16 x 25 9/16 in).
| Musée d'Art Moderne, Grenoble.

Umberto Boccioni |
DEVELOPMENT
OF A BOTTLE IN SPACE
1912, bronze, |
silvered metal patina,
height: 38,1 cm (15 in).
Museum of Modern Art, New York. |

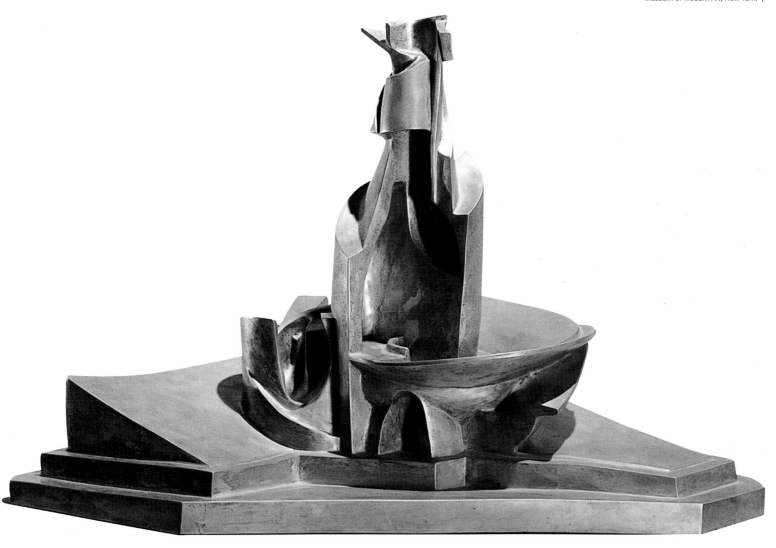

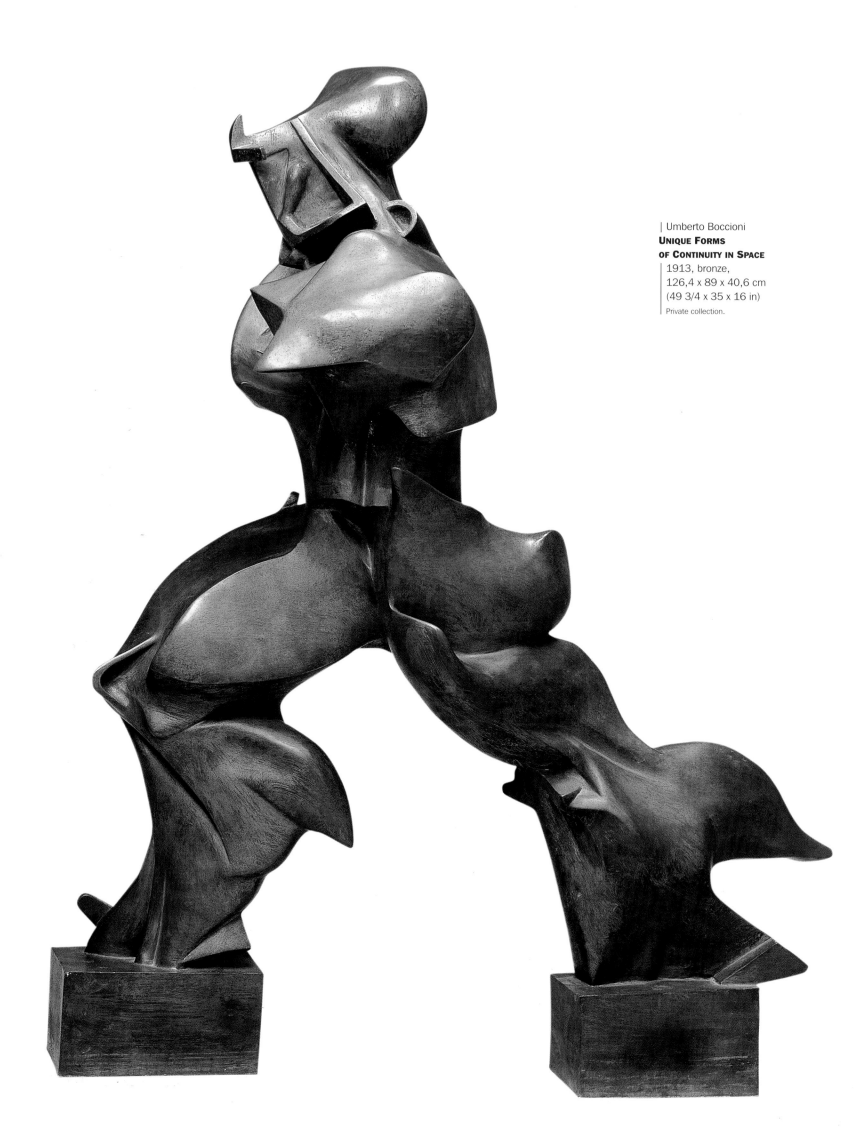

Umberto Boccioni
**UNIQUE FORMS
OF CONTINUITY IN SPACE**
1913, bronze,
126,4 x 89 x 40,6 cm
(49 3/4 x 35 x 16 in)
Private collection.

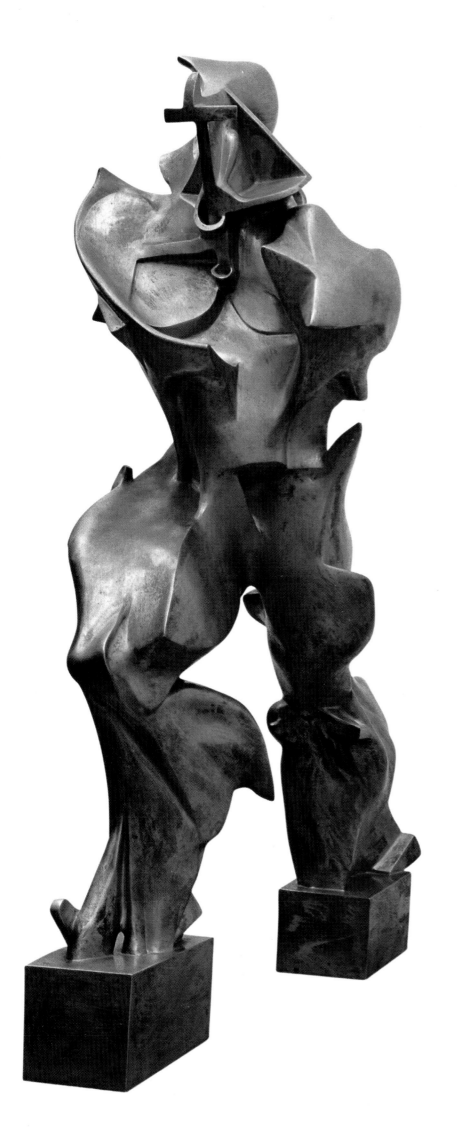
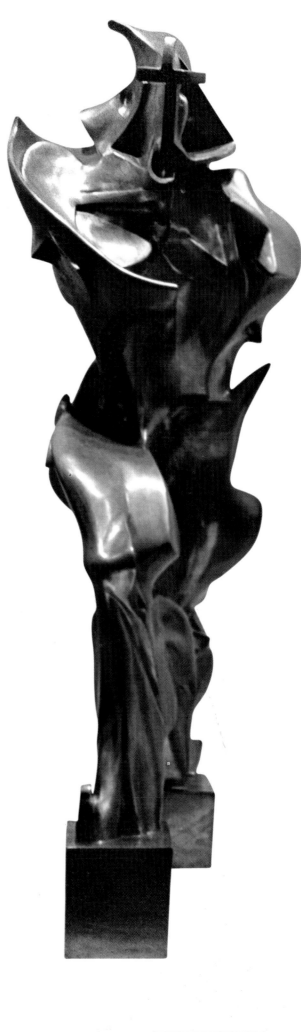

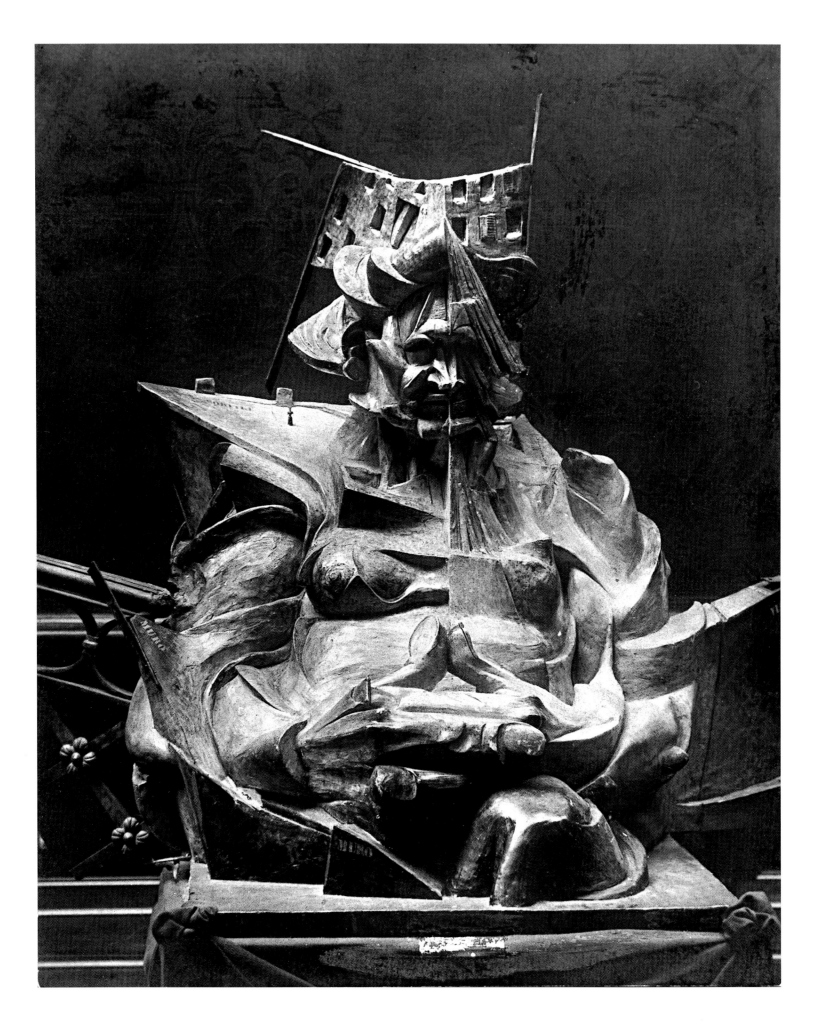

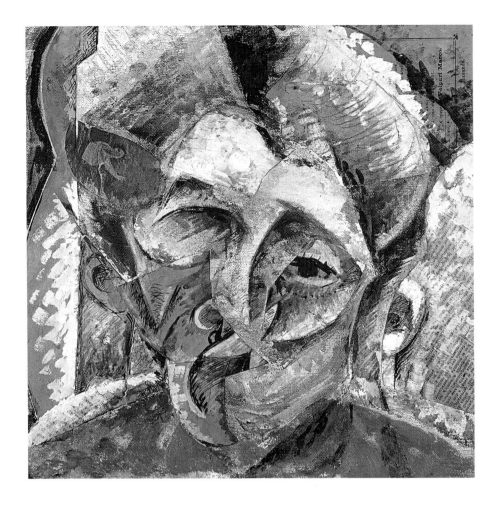

| Umberto Boccioni
DYNAMISM OF A WOMAN'S HEAD
| 1914, pencil, tempera,
pen and collage on canvas,
35,5 x 35,5 cm (14 x 14 in).
Civica Galleria d'Arte Moderna, Milan.

| Page 90
| Umberto Boccioni
HEAD + HOUSE + LIGHT
| 1912, plaster with
assemblage of found
materials, size unknown.
Work destroyed.
Original photograph, private collection.

Antonio Sant'Elia |
ELECTRIC POWER-PLANT
1914, colored inks and pencil |
on paper, 31 x 20,5 cm
(12 3/16 x 8 1/16 in).
Private collection.

into a series of disconnected volumes, he sought to express the displacement of a human body in the indivisibility of time, that is, through the unique and vital totality of the correlations of energy that rule its transition through space.

Boccioni exhibited his sculptures in 1913. In these works, he modeled the fusion "object + environment" in real space, combining found materials. Despite a dynamic emphasis that was sometimes too elaborate, those new works paved the way on the one hand for the conquest of the third dimension, and on the other for the discovery of the expressive capacities of matter itself, two principles that, between 1914 and 1916, were to unleash the Futurists' creativity. Boccioni even introduced collages in his pictures. His *Dynamism of a Woman's Head* is undoubtedly, in the history of avant-garde art, one of the first works in which a pasted-on image appeared. He was also thinking of an architecture that could erect in urban space the "spiraling constuctions" of his plastic dynamism. He wrote a manifesto on the subject, but Balla responded to the text with some reticence. It was at that time that Carrà urged admitting Sant'Elia to the Futurist movement.

| Antonio Sant'Elia
THE NEW CITY
| Building with outside elevators, arcade, covered passageway,
on three street levels (tramway track, street for automobiles,
metal footbridge), lighthouse and wireless telegraphy.
1914, ink and black pencil on yellow paper,
52,5 x 51,5 cm (20 5/8 x 20 1/4 in).
| Musei Civici, Como.

Sant'Elia, a professional architect, had already approa-
ched Futurism in 1913, with the conception of various
designs: factories, warehouses, hydro-electric plants,
called "architectural dynamisms." Along with Chiattone,
Funi, Dudreville and other artists from *Famiglia Artistica*,
he had just founded in Milan the *Nuove Tendenze* group

that claimed, in contrast with Futurism, a more mode-
rate vein of avant-garde research. On joining Marinetti's
movement in 1914, Sant'Elia immediately published his
Manifesto of Futurist Architecture. He claimed that archi-
tecture, henceforth emancipated from "historical styles"
and every tradition, had to adopt exclusively new tech-
niques and new materials, and draw its inspiration
from the dynamism of modern life. Its starting point
would no longer be the individual building, but the
context of large city centers. In his drawings, the city
appeared as a complex, three-dimensional structure,

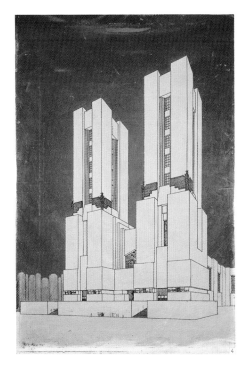

| Mario Chiattone
CATHEDRAL VI
| 1914, India ink, tempera and
pencil on cardboard, 85 x 55,5 cm
(33 7/16 x 21 13/16 in).
Cabinet of Drawings and Prints of the Istituto di Storia
dell'Arte dell'Università, Pisa.

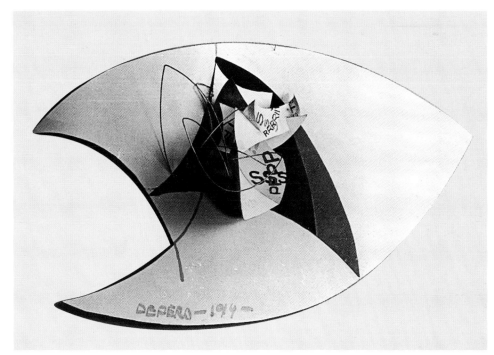

Fortunato Depero |
FORMS-NOISES
1914, assemblage of painted cardboard, |
paper, wire, size unknown. Work destroyed.
Original photograph, Museo d'Arte Moderna
e Contemporanea,
Trento – Rovereto. |

Carlo D. Carrà |
NOISES OF
THE NIGHT CAFÉ
1914, oil, collage |
and assemblage
on cardboard,
30 x 40 cm
(11 13/16 x 15 3/4 in).
Work lost.
Original photograph,
private collection.

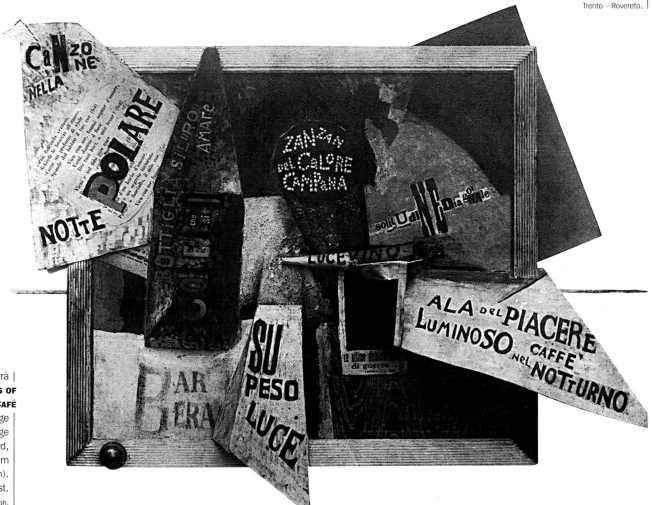

**THE KINETIC-NOISIST ASSEMBLAGE
BY DEPERO**
Reconstruction by the Guillaume studio,
1983, Paris, 50 x 60 x 40 cm
(19 11/16 x 23 5/8 x 15 3/4 in).
Private collection.

Fortunato Depero |
**PLASTIC COLORED SIMULTANEOUS
KINETIC-NOISIST COMPLEX DECOMPOSED
IN STRIPS**
1915, assemblage of wood, painted
cardboard, tin, bellows and metal parts,
size unknown. Work destroyed.
Original photograph, Museo d'Arte Moderna
e Contemporanea, Trento – Rovereto.

| Fortunato Depero
THE TOGA AND THE MOTH
| 1914, cardboard and varnished wood,
| 58 x 54 x 10 cm
| (22 13/16 x 21 1/4 x 3 15/16).
| Museo d'Arte Moderna e Contemporanea, Trento – Rovereto.

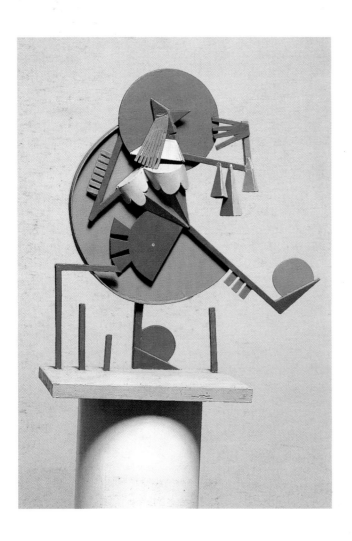

crisscrossed by constantly moving elements. Sant'Elia studied groups of inter-connected buildings, crossed on several levels by the large communication axes of the urban network. Following the Futurist esthetics of the dynamism of the machine, he introduced in the space of the "new city" the most characteristic elements of industrial landscape: elevators climbing up façades, iron bridges and elliptical arcades, towers shaped like plant chimneys, large slanting surfaces similar to the sloping falls of hydro-electric plants, perspectives showing the city aligned on the arrival of the main railroad tracks.

Chiattone also joined up with the Futurists, and in his designs for *Constructions for a Modern Metropolis* pursued the utopia of an architecture conceived on the city scale. Yet he had a preference for colored flat surfaces that gave his sketches a pictorial and poetic feeling, and emphasized the imaginary tension toward the monumental and the huge, while rejecting dynamic elements such as ellipses and oblique planes. Furthermore, a great many of his drawings had to do with the individual building, offering the mass and the volume of a skyscraper, rather than the overall connections of the modern city. With Chiattone's designs, apparently in affinity with Sant'Elia's, Futurist architecture tended toward a new form of monumentalism: the vertical thrust was accentuated and volumes were given a more compact appearance. What in Sant'Elia recalled a leveling of social differences, in Chiattone was more related to mass society, and his images already introduced the alienating dimensions of industrial cities.

Boccioni, in his theoretic writings calling for Futurist sculpture, had explicited the principle of "plurimaterialism," claiming that it was necessary to "fraction the unity of matter into several materials, each one of which could characterize, by its natural diversity, a diversity of weight and of expansion of molecular volumes, in order to obtain a primary dynamic element." He had even wanted to create kinetic sculptures, but never carried out the idea. By 1914, the Futurists seized upon these principles in ways that sometimes were radical and other times playful. The very first "dynamic assemblages of objects," such as *Mademoiselle Flic-Flic, Chiap-Chiap* by Marinetti and Cangiullo, were works with anthropomorphic subjects and meant to be provocative by their humor. Thus Marinetti insisted on his *Selfportrait Running* being hung above the heads of the visitors during a Futurist exhibition that opened in 1914 at the Doré Gallery in London. Using the same approach, right away painters tried to break away from the static, opaque screen of the canvas to introduce the forms and signs of dynamism into real space. Carrà thought of making "plastic constructions" by assemblying several materials. In *Noises of the Night Café*, he extended his pasted-on papers into the third dimension, cutting them into "forms-noises" so as to

Giacomo Balla |
PLASTIC COLORED COMPLEX
OF DIN + DANCE + CHEER
1915, assemblage of mirrors, tinfoil, |
talcum powder, cardboard and wire,
size unknown. Work destroyed. |
Original photograph, private collection. |

| Umberto Boccioni
HORSE + HOUSES:
(DYNAMIC CONSTRUCTION OF A GALLOP)
| 1915, paint and assemblage of wood, cardboard,
metal, 60 x 122 cm (23 5/8 x 48 in).
| Peggy Guggenheim Collection, Venice.

| Enrico Prampolini
**SETS FOR THE MOTION-
PICTURE *THAÏS* BY ANTON
GIULIO BRAGAGLIA**
| 1916, Rome.
Private Collection.

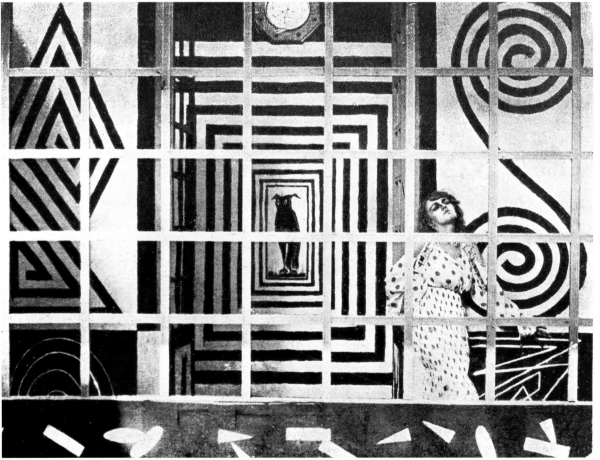

Fortunato Depero |
DEPERO IS A GENIUS
Mail art and Futurist
photo-performance:
message addressed
to Carrà on the back
of the three
states-of-mind self-
portraits, March
1915, tempera and
photographic collage
on paper,
11,1 x 9,3 cm
each portrait
(4 3/8 x 3 5/8 in).
Private collection.

aggressively involve the viewer. Balla discovered materials like tin and tinfoil that he put in his works, as being best-suited to express the sensation of city noises. By twisting them, or laying them on uneven surfaces, he obtained refracting planes with shifting, fleeting luminous reflections, their capacity to vibrate even producing a furtive rustling. Sensorial event becomes then the object of a true performance. Futurist plastic creation was then to reach a yet further stage, marked by plurimaterialism and real kinetism.

Young Depero, the true theorist of a "kinetico-noisist" art, would be the one to best interpret those experiments. The creator of the Futurist photo-performance, he was also the author of constructions producing unexpected noisist and kinetic effects. He signed along with Balla the manifesto *Futurist Reconstruction of the Universe* (1915), that launched "plastic complexes," a new form of the art of Futurist plastic dynamism. These were assemblages of materials called "complexes," according to the language of the *Gestalttheorie*, in order to emphasize the fact of the indissociable nature of the play of forms of the built ensemble. Indeed, within the Italian avant-garde, these combinations meant evolving from an art of representation to an abstract art creating playful, plurisensorial emotions: auditive, olfactory, tactile, and so on, thus assuming a global perception involving the viewer's whole body. Even the titles of these constructions of materials, such as Balla's *Plastic Colored Complex of Din + Dance + Cheer* (1915), expressed a conception of the work as being a detonator of vital energy.

Joining in these experiments, young Prampolini made mobile metal structures and published a manifesto advocating hanging sculptures. In turn Severini executed the kinetic object-painting *Articulated Dancer* that required the viewer's active, playful participation. Even Boccioni carried his own ideas further, making one of his most meaningful sculptures, the combination *Horse + Houses: Dynamic Construction of a Gallop*, that embodied dynamic sensation by juxtaposing volumes and contrasting the tactile qualities of the textures. On the other hand, some of Depero's "kinetico-noisist plastic complexes," that the viewer set in motion with bellows, were decomposed by off-centered movements, while producing noises, sounds, smoke, rays of light, spurts of multicolored liquids. These assemblages, full of fun and inspired by the world of fairs, were seen as an esthetic metaphor of city space and as total theater. The logics of that type of research could but lead to the theater. Balla, in his scenography for *Fireworks* (1917), on a project by Diaghilev, suggested a plastic structuring of the physical space of the stage: an ensemble of built volumes, like an architecture of abstract forms, lit by plays of colored lights. The performance proceeded entirely without the least human presence. As for Prampolini, he thought up a stage where mobile

Giacomo Balla|
**PLASTIC, ABSTRACT AND
CHROMO-LUMINOUS
SET FOR *FIREWORKS*
BY STRAVINSKY**
1916-1917, tempera
on paper sketch,
48,5 x 33 cm
(19 1/16 x 13 in).
Museo teatrale alla Scala, Milan.

| Virgilio Marchi
FUTURIST CITY
1919, tempera on paper,
180 x 145 cm
(70 7/8 x 57 1/16 in).
Private collection.

structures would replace the actors' performing, while Depero created "kinetico-noisist costumes," wherein the suddenly changing plastic forms produced impressions of amazement and magic.

Realities of the War

Italy's joining in the war, in May 1915, set fire to the Futurists' patriotic ideals. At that point, the political stands of Futurism embraced Marinetti's personal convictions, since he had always wanted to involve the Futurists in the country's political destiny. Actually, Futurists were driven by a lyrical, playful form of patriotism, ironic and modern, expressed among other things by a constant glorification of the colors of the national flag. They had claimed the flag of the new Italy should be republican, that is, should disregard the king's colors, and that the red stripe should be much wider than the white and green ones. They had put out an asymmetrical tricolor postcard, where the predominance of red represented the daring and dynamic impulse of Futurist Italy. They then had proclaimed that watermelon should become the Italian national fruit, since its red pulp largely prevailed over the white and the green of the rind: that was the meaning of the still lifes with watermelons that Boccioni, Balla, Soffici, Baldessari and other Futurists painted. Later on they were to organize a city happening by hanging on the top of the Galleria Vittorio Emanuele II, in Milan, "the biggest flag in the world": a Futurist, republican flag measuring several hundred square meters. They even succeeded in creating the fashion, for Italian women, of tricolor nail polish.

The outbreak of the war created an effervescent atmosphere throughout Italy. A large number of Italians, even in left-wing socialist circles, believed the country should take part in the conflict to complete the national unity born of the *Risorgimento*. Several Futurists declared they were favorable to the war. But, for them, the war against the Austro-Hungarian empire was merely the final step toward national reunification. So there was quite a difference between Marinetti's bellicism, glorifying war as an absolute, and the far more circumstantial views of a great many Futurists. Yet these differences disappeared in the face of the urgency of action. In December 1914, the Futurist group held a street demonstration in front of the university of Rome in favor of military intervention. For the occasion Cangiullo was wearing a tricolor Futurist suit Balla had designed, with a hat crowned by a silver star, the famous star of Italy, the very symbol of the national *Risorgimento*. When, a few months later, Italy joined in the war, a number of Futurists were volunteers, stirred by their shared romantic idealism.

For Boccioni, the experience of war brought about a turning point that would lead him to a greater degree of lucidity regarding his own militancy. That experience, at last lived out, turned out to be nothing but a dull routine that even barred self-determination, the ecstasy of the heroic overcoming of life itself. So he saw art as being the only possible value. On August 12, 1916, five days before his death, he wrote his friend, the pianist and composer Ferruccio Busoni: "I shall shed this kind of life feeling a deep contempt for everything that is not art. All I am seeing now is mere play compared to a good brushstroke, to a balanced verse, to a well-placed chord. All the rest, compared to creation, is nothing but a question of mechanics, of habit, of patience, of memory. So all we have is art, with its fathomless pulse beat, its unplumbed depths.

Everything else is within reach if you just bother to try." Sant'Elia took part in the fighting to take Dosso Cassina. In July 1916, in Montefalcone, he built for his own brigade the cemetery where he would be buried three months later, killed by a bullet in the head. In August, Boccioni fell off his horse: he died in the hospital in Verona, his chest having been crushed by the horse's hooves. In June 1917, Marinetti suffered leg injuries on the Isonzo front. In August of the same year, Soffici received head wounds on the occasion of the assault of mount Kobilek. Four months later, in December, during an assault on mount Grappa, Russolo suffered serious head wounds. He underwent trepanation that would limit his physical capacities for several years. Younger Futurists, like Tommei and Erba, were killed in combat.

| Giacomo Balla
WAR TRAPS
| 1915, oil on canvas, 115 x 175 cm
(45 1/4 x 68 7/8 in).
| Private collection.

Mario Sironi |
THE BOMB
1918-1919, tempera and |
collage on paper, 64 x 47 cm
(25 3/16 x 18 1/2 in). |
Private collection. |

Words-in-Freedom

Since the Futurist poet was supposed to express himself in terms of the modern world, Marinetti transposed in literature the pictorial principle of the dynamic disarticulation of the object. He launched the *Technical Manifesto of Futurist Literature* (1912), proclaiming words should be set free by abolishing rules of grammar and punctuation. Poetry was composed by "wireless imagination," that is, by intuitive, immediate analogical associations, without comparative explanations. Thus an uninterrupted network of sensations and images should seize the primal state of language, prior to any logical structuring or rational finality. After the fashion of Futurist sculpture's assemblages of materials, Marinetti called for the introduction of onomatopoeic noise, a real fragment of sound matter, among the new elements of Futurist poetry. Free-wording experiments led to the obliteration of the linear model: lines of writing became slanting, vertical, circular, unfolding over the space of the page according to a psychic meaning. These "free-wording compositions" led to the plastic disarticulation of letters, that floated about freely, obeying the most hidden and varied magnetisms. A "materialistic" poetry, imposing the physical presence and the plastic beauty of typographical characters, immediately sprung from the free use of signs according to this "new conception of the typographically pictorial page." Last of all, the book itself was outdistanced: manuscript object-books, then "free-word plates," authentic plastic works of art stemming from writing, appeared.

Dinamo Correnti |
PATRIOTIC DAY
1915, freewordist object-book, collage,
string and colored inks on paper,
41 x 13 cm (16 1/8 x 5 1/8 in).
Private collection.

FRANCESCO CANGIULLO
FUTURISTA

PIEDIGROTTA

col Manifesto sulla declamazi one dinamica sinottica di MARINETTI Edizioni futu riste di Poesia Corso Venezia 61 MILANO 1916

Copertina di CANGIULLO

| Francesco Cangiullo
PIEDIGROTTA
| 1916, freewordist book, cover,
26,5 x 19 cm (10 7/16 x 7 1/2 in).
Private collection.

| Sebastiano Carta
and Augusto Favalli
THE AIRCRAFT GOES BY
1933, inks on paper,
14 x 9,5 cm (5 1/2 x 3 3/4 in).
Private collection.

| Ardengo Soffici
**BIF & ZF = 18, SIMULTANEITY
AND LYRICAL CHEMISTRIES**
1915, freewordist object-book
with newspaper format, collage
for the cover, 45,8 x 34,8 cm
(18 x 13 11/16 in).
Private collection.

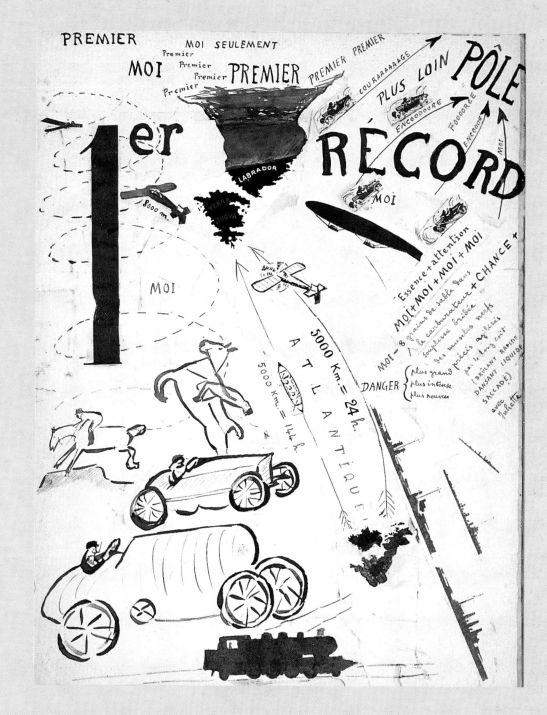

Filippo Tommaso Marinetti |
**TRIBUTE TO THE ITALIAN GUIDO GUIDI WHO,
ON AN ITALIAN AIRCRAFT, BEAT THE WORLD
HEIGHT RECORD (7,950 M)**
1916, watercolor, collage and India ink on
paper, 35 x 26, 5 cm (13 3/4 x 10 7/16 in).
Private collection.

Painters took part in this research,
contributing their own formal means,
such as graphisms, colors and collages.
The "mural poetry" plates led to
"poem-paintings," major works of this
new expressive category of Futurist art.
The Futurists, by ever pressing forward their
experiments with the visual, graphic and
typographical components of free-wording,
thus made the act of writing become
a corporeal pleasure. ■

The war years were also those during which Severini, Carrà, Soffici and many others abandoned Futurism. Indeed, several artists felt that the avant-garde was no longer justified. Confronted with the horrors of the war, art ought to return to a more directly humanist reference. Nonetheless, Futurist investigations would be renovated by countless young artists, including Depero, Sironi, Prampolini, Ginna and Corra who, up to then had been left on the sidelines of the Futurist movement because of Boccioni and his ideological intransigence. With the collaboration of Marinetti and Balla, in 1916 Ginna made the film *Futurist Life*, a true staging, complete with self-irony, of the behavior patterns of the new man born of the Futurist revolution. That was the first film-performance in the history of motion pictures, as well as being the most accomplished expression of Corra and Settimelli's Cerebrist artistic theory. The two, in the framework of Futurism, called for the "a-logical" assembling of materials along the same lines as the Russian Cubo-Futurists. That same year, Prampolini created the sets, built on the scale of the imagination, for Bragaglia's film *Thaïs*. Depero created the major works of the assemblages that represented the new Futurist sculpture. In architecture, Marchi guaranteed continuity. His designs

visualized city space as the center of a vitalist excitement materialized by "the dizziness of heights, the strangeness of volumes, the playful voluptuousness of danger." Therein the plastic movement of volumes reached a baroque paroxysm intended as such. His aim was the "scenic play" of an architecture that, through its actual morphology, had to take part in the phastasmagoria of the modern city. After the war, Marchi called for a renewal of Futurist architecture in accordance with a highly lyrical dynamism. In his city views, steeped in a visionary expressionism, the masses of the buildings, rendered by "formal exaltations" and "sculptural abstractions," seemed to interpenetrate in a dynamic complex producing exclusively scenographic compositions.

Right after Boccioni's death, quite naturally Balla became the leader of Futurist art. Furthermore, he was the only one of the five founders to continue the avant-garde struggle. Giving up the analysis of kinetism and of the modulated, abrupt or shattered emissions of energy, his painting intensified the psychological qualification of abstract forms, lines and colors. In works like *War Traps*, he developed a symbolic idiom of an intuitive nature, founded on correspondences between colors and formal rhythms. Those works are charged with imagination,

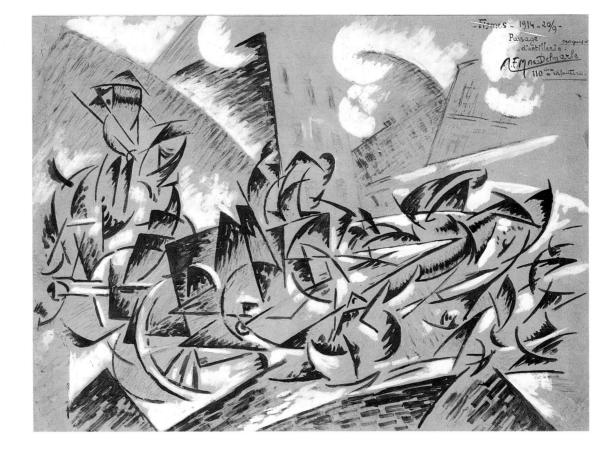

| Enrico Beltrami
SYNTHESIS OF THE WORLD WAR
| September 1918, after a
manifesto published in 1915
with a text by Marinetti
and graphic composition
by Carrà, width 25 cm
(9 13/16 in).
Private collection.

Aimé Félix Delmarle |
THE ARTILLERY PASSES BY
1914, oil, gouache and ink on
brown cardboard, 48 x 64,5 cm
(18 7/8 x 25 3/8 in).
Private collection. |

steeped in sensuality and lyricism. Thus freeing painting from the appearances of the tangible world, Balla made the most vigorous contribution to Futurist theory since Boccioni's plastic dynamism. At the end of the war, he painted a series of allegorical pictures, including *Mutilated Trees* and *The Awakening of Spring* (1918). These images, laden with symbolism, expressed his feelings about the recent events. Balla believed that the war that had just ended should be seen as a sacrificial event that would lead to a national regeneration. Expressing the necessity and the means of this renewal, he exhibited several of these paintings in Rome, at the *Casa d'Arte Bragaglia*. In the exhibition catalogue, he returned to the emblematic motif of the star of Italy in a graphic composition where he wrote: "A new Italy, a Futurist Italy."

Worldwide Avant-Garde

Futurism had gone international in the very first years of its existence. Marinetti had sent the Futurist manifestos all over the world, addressing them to the press, to intellectual and artistic magazines, to writers and artists. The lectures he held in London and Berlin, in Paris and Moscow, were a sort of apostolate. This was not in the least cultural imperialism, since he never intended to

export the specific traits of Italian Futurism. Marinetti did not ask for a passive embracing of his Futurist ideas. On the contrary, he wrote a *Proclama futurista a los Españoles* (1910), or a *Futurist Speech to the English* (1910), to urge each nation to break free from its own backward-looking proneness, so as to attain the active vision of the world and the human condition that the Futurist revolution meant to him. The values of modernism, in his opinion, could only lead to the birth of the *Homo novus*, a universal man. Having inherited the myths of Mazzini's "religion of the future," Marinetti wished Italy to once again follow its historical vocation, becoming the model for a new international culture. Dubbed "Europe's caffeine," he would keep on stimulating spirits by his enthusiasm and his revolutionary proclamations. And that is how the Futurist impulsion was to spread throughout Europe and the world.

In France, as of 1910 Futurist theories contributed to the evolution of the work of Delaunay, Kupka, Villon, Léger, Duchamp, Picabia toward a "Cubo-Futurism" that, ridding painting of studio subjects, combined the motion, the energetic vibration, the lines of force, the compression of space and the dynamic shattering of the object, with the purely intellectual investigations Picasso and

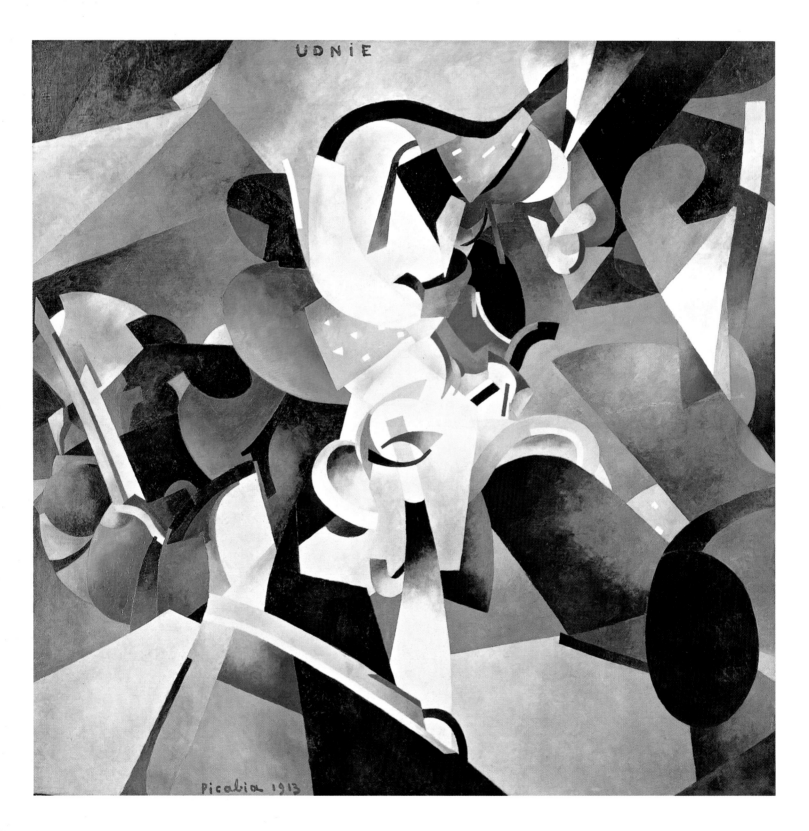

| Francis Picabia
UDNIE (YOUNG AMERICAN GIRL DANCING)
| 1913, oil on canvas,
| 300 x 300 cm (47 1/8 x 47 1/8 in).
| Musée National d'Art Moderne, Paris.

Raymond Duchamp-Villon |
HORSE
1914, original plaster, |
45 x 40 x 24 cm
(17 11/16 x 15 3/4 x 9 7/16 in).
Musée d'Art Moderne, Grenoble. |

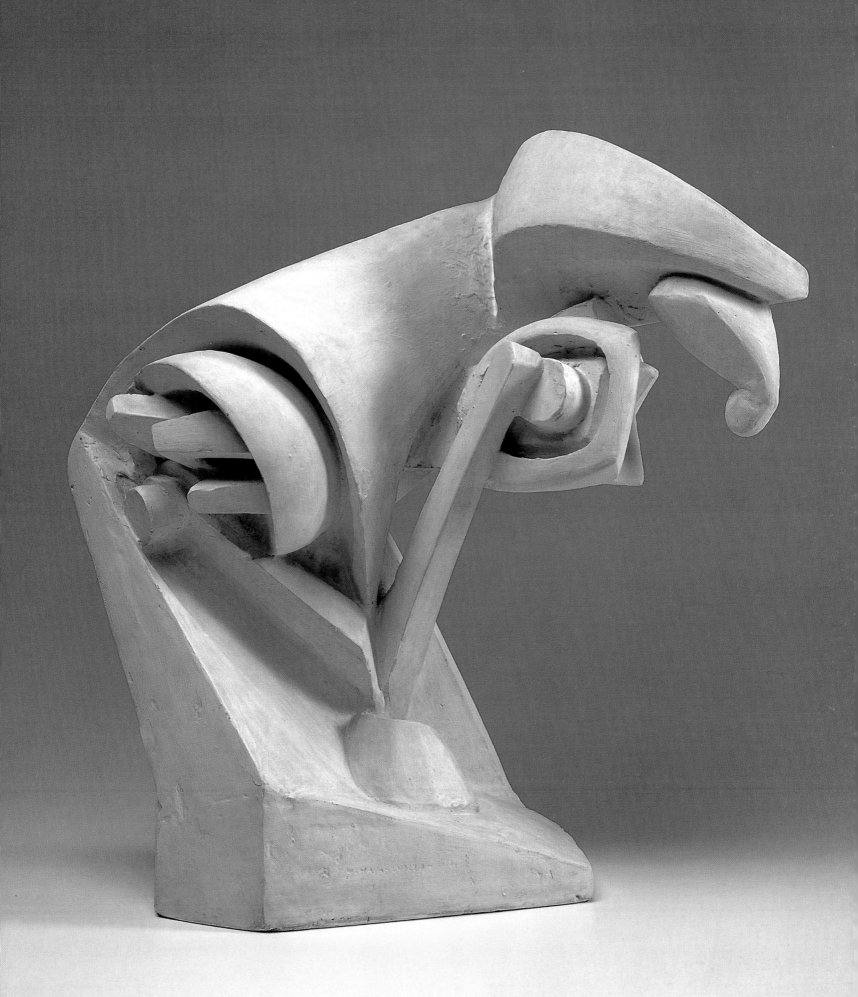

| Kazimir Malevich

THE REAPER

| 1912, oil on canvas, 113,5 x 66,5 cm
(44 11/16 x 26 3/16 in).

National Art Museum, Nijni-Novgorod.

Jacques Villon |

MARCHING SOLDIERS

1913, oil on canvas, 65 x 92 cm |
(25 9/16 x 36 3/16 in). |

Musée National d'Art Moderne, Paris. |

Braque had begun. Gathered in the "Puteaux group," some of these artists continued to associate Cubism and Futurism according to a program expressed in major works like *Udnie* (*Young American Girl Dancing*) by Picabia, or *Marching Soldiers* by Jacques Villon.

An original application of Futurist principles lay behind many other works along those lines, from the sculpture *Horse* by Raymond Duchamp-Villon, where the machine became a formal metaphor, to *Velodrome* (1914) by Jean Metzinger, where movement made the bodies transparent. Marinetti's strategy of cultural agitation appealed to the painter Aimé Félix Delmarle, who launched a *Futurist Manifesto of Montmartre* (1913). Using original graphic solutions, his painting revisited the Futurist themes of the musical gesture, dance, the city and sports. Blaise Cendrars, Pierre Albert-Birot and Jean Azaïs were drawn to Futurism, too. Albert-Birot made overtures to Severini, but later preferred to launch "Nunism" from the Greek word *nun*, meaning now. That determination to keep a distance from the Italian movement would appear in several countries.

Alexandra Exter, having shared Soffici's studio in Paris, introduced the word "Cubo-Futurism" in Russia. She formulated the first concepts of Russian Cubo-Futurist painting based on the ideas of Roger Allard, the critic of the Puteaux group. He had just made an analysis of "divergence of plastic forces" and Delaunay's and Léger's ways of applying Futurist theories in their paintings. At the same time, the impact of Boccioni's manifestos led Goncharova, Popova, Larionov, and many others to directly borrow Futurist principles in their works. The impulsion Italian Futurism had provided was soon surpassed by the evolution and the diversifying of experiments. Larionov opposed Marinetti for the sake of Rayonism, whereas Malevich carried Cubo-Futurism to its ultimate consequence, abstraction, allowing him to found Suprematism. What would profoundly alter the physiognomy of the Russian avant-garde was the October Revolution. From then on, Productivism pursued the myth of the social usefulness of art, whereas Constructivism was meant to be an overall theory of the new artistic language.

In Belgium, Jules Schmalzigaug painted the dynamic image of speeding cars, in order to study the disintegration of form. His city visions made the canvas become a puzzle of colorful elements. Peeters and Servranckx were drawn to Futurist theories, just as Gaillard, Flouquet and young Magritte were. As for Prosper de Troyer, he developed a more personal form of Futurism. In works like *Lively Toilette* or *Woman sewing*, he built circular movements, hollowing the center of the canvas by the use of

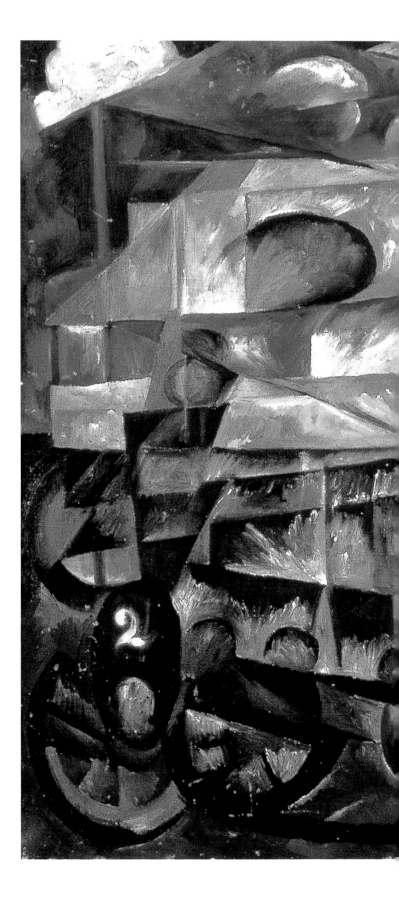

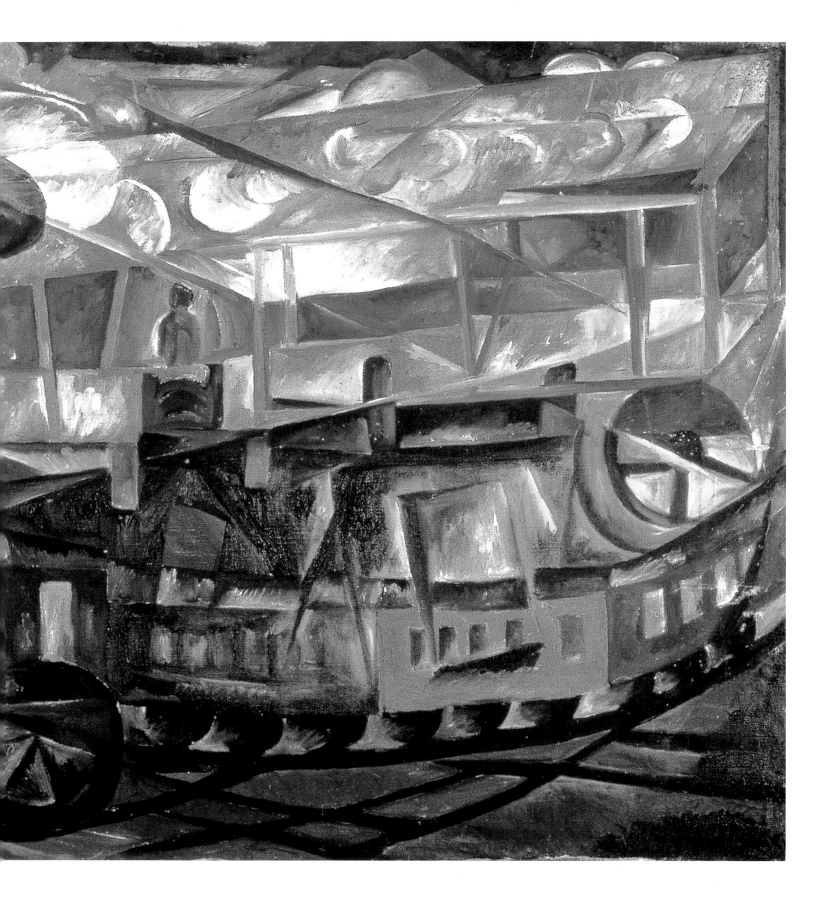

Natalia Goncharova |
AIRCRAFT OVER A TRAIN
1913, oil on canvas,
55,7 x 83,8 cm (21 13/16 x 33 in).
Fine Arts Museum of the Republic of Tatarstan.

David Bomberg |
THE DANCER
1913-1914, pastel, watercolor and |
gouache on paper, 67,5 x 55,5 cm |
(26 9/16 x 21 13/16 in). |
Anthony d'Offay Gallery, London. |

| Jais Nielsen
EXIT!
| 1918, oil on canvas, 120 x 101 cm
(47 1/4 x 39 3/4 in).
Lolland-Falsters Kunstmuseum, Maribo.

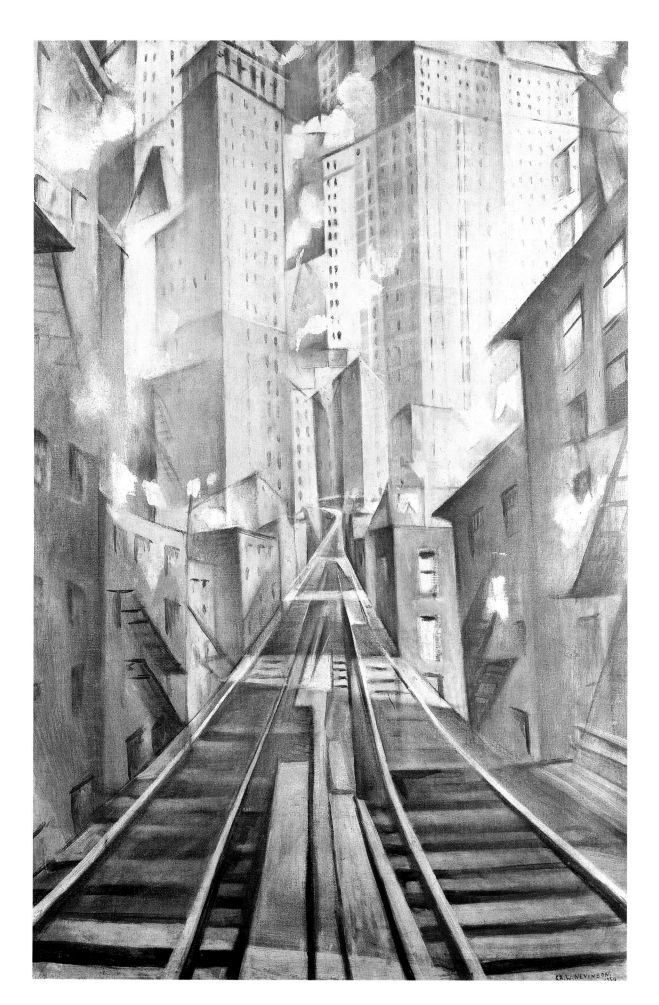

Page 116
Wyndham Lewis
THE VORTICIST

1912, ink, chalk and
gouache on paper,
41,4 x 29,4 cm
(16 5/16
x 11 9/16 in).

City Art Gallery,
Southampton.

Christopher
R. W. Nevinson
**RAILWAY AND
SKYSCRAPER**

1914, oil on canvas,
76 x 53 cm (29 7/8
x 20 7/8 in).

Private collection.

white flats. At Antwerp, Paul Joostens painted scenes of dance-halls. Up North, the paintings of the Dane Jaïs Nielsen and the Swede Gosta Adrian-Nilson expressed the Futurist vision of the city and modernism.

In Great Britain, Marinetti received the support of the poet Harold Munro. Then the Scottish painter Stanley Cursiter and the English painter C.R.W. Nevinson became his ardent disciples. Nevinson, who was a member of the Rebel Art Center, founded by Wyndham Lewis in London, published with Marinetti the manifesto *Vital English Art* (1914). The same year, the magazine *Blast* was born, marking the launching of Vorticism, that embraced Marinetti's slogans against the ascendancy of the past and for the glorification of the energy of the modern world. Ezra Pound, who defended its cause alongside artists like Jessica Dismorr, Helen Saunders, Edward Wadsworth, David Bomberg, Alvin Labgdon Coburn and Jacob Epstein, wrote: "The vortex is the maximal point of energy. In mechanics it represents the greatest efficiency." The magazine sought the theoretic formulation of an art that could express the world of machines, yet excluding all vitalist excess: the whirling force of the vortex is crystallized by the geometry of plastic rhythms. The movement meant to mark its difference from Italian Futurism; but Pound would continue to consider Marinetti one of the founding fathers of modern art.

In Germany, Herwarth Walden exhibited Futurist paintings in his gallery Der Sturm in Berlin. For the occasion, Marinetti had the city streets plastered with posters of Futurist tracts, then rented a taxi and roamed about the streets, shouting his revolutionary slogans. The painters of German Expressionism were sometimes very close to the formal expressions of the Italian Futurists, but they differed in sensibility. They used the dynamic deformations of Futurism to express their anguish in facing the contemporary world, or even to denounce the horrors of war. Direct echos of Futurism can be found in Ludwig Meidner, in his vitalist images of modern streets and cities. Lyonel Feininger, Franz Marc, August Macke had a positive appreciation of Italian Futurism, whose ideas and works also influenced paintings by Otto Dix and George Grosz. Before turning to Dadaism, Max Ernst and Christian Schad painted Futurist paintings.

In Switzerland, Otto Morach, Jean Crotti, Alice Bailly, Gustave Buchet, Johannes Itten, Oscar Lüthy expressed several variants of the Cubo-Futurist style. When Tzara attempted to replace Futurism with Dadaism, he showed himself above all to be the spiritual son of Marinetti himself. Richard Huelsenbeck and Hans Richter did not neglect to mention Dada's debt toward Futurism on many occasions: noisism, the simultaneous poem, the typographical revolution, the use of new materials, the strategy of tracts and manifestos, the confrontation with the audience during the *soirées*, the very idea of a movement that would give a political meaning to artists' collective work.

Lajos Kassak, the leader of the Hungarian avant-garde, experienced an authentic illumination on seeing the paintings of the Italian Futurists exhibited in Budapest. The dynamic visions of Futurism also struck painters like Béla Uitz, Sándor Galiberti, János Mattis-Teutsh, Sándor Bortnyk, Pór Bertalan, Lajos Gulácsy. Their paintings occasionally combined Expressionist excess with Futurist vitalism. Activism, that later on would become the Hungarian avant-garde's specific mode of expression, borrowed the principles of Futurism, first of all Marinetti's myth of the artist's "direct action," but in this case it was in keeping with a left-wing, socialist and anti-militarist political radicalism. In Poland, the first to represent Futurist ideas was Jerzy Jankowsky. Then the poets Stern and Wat founded in Warsaw a group claiming to follow Futurism, while in Cracovy Futurist theories would challenge Chwistek's Formism. In Romania, the painters Arthur Segal, Darascu, Sirato and Theodorescu-Sion introduced Futurism in their paintings by curvilinear rhythms and violent colors. In Czechoslovakia, Rougena Zátkova joined the Futurist movement, that equally fascinated other artists, including Kroha and Neumann. Last of all, in Bulgaria Geo Milev embodied Futurist ideas, or else in Yougoslavia Mitzitch revisited them in Zenithism.

Ramón Gómez de la Serna presented Marinetti's precepts in Spain, whereas the painter Rafael Pérez Barradas introduced Futurism in Barcelona. Poets and artists like Junoy, Sánchez-Juan, Torres-García drew closer to the Italian avant-garde. Salvat-Papasseit, dubbed "the Catalan Marinetti," published Futurist manifestos. Nonetheless, Spanish Futurism soon chose to call itself "Ultraism." A like situation occurred in nearly all the Latin American countries. Futurism confronted the Stridentism of Manuel Maples Arce and Germán Cueto in Mexico, was challenged by the Creationism of Vicente Huidobro in Chile and the Ultraism of Jorge Luis Borges in Argentina. These movements however owed their very existence to the impulse of Futurism. On the other hand, the 'brand'-name of Futurism was called upon as such in Peru, with Alberto Hidalgo, in Uruguay, with Parra del Riego, and especially in Portugal, with the group that brought together Almada-Negreiros, Sá-Carneiro, Santa-Rita Pintor, Amadeo de Souza-Cardoso, and Alvaro de Campos, the Futurist pseudonym of Fernando Pessõa.

In Italy as well, other avant-garde trends, such as Cerebrism, Imaginism, Newism, Liberism, Presentism sought to create alternatives to Futurism, disagreeing with some of its positions. But they drew their very strength from that opposition that bound them dialectically to Marinetti's movement, if they were not actually finding their own theories in the Futurist manifestos.

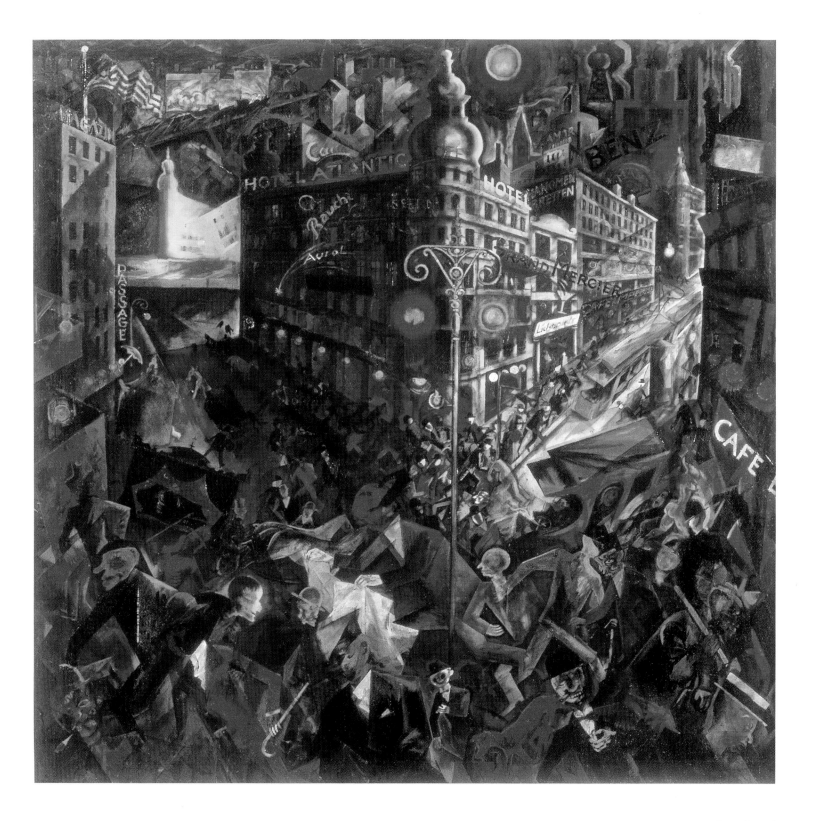

Georg Grosz |
METROPOLIS
1916-1917, oil on canvas,
100 x 102 cm (39 1/4 x 40 1/8 in).
Museo Thyssen-Bornemisza, Madrid.

Besides, there was an Egofuturism in Russia and an Ultrafuturism in Argentina, further confirmations that Futurism was the crucible of the new ideas. Indeed, if the English Futurists called themselves "Vorticists," Balla had already painted the vortex as an emblematic image of dynamism; if the Russian artists saw themselves as "Tomorrowans," Italian Futurists had already claimed to be "Tomorrowists"; if the German artists claimed to be "Vibrists" and the Spanish artists "Vibrationists," in their manifestos the Italian Futurists had already spoken of the "universal vibration" that seizes all things. These were actually the common stock of Futurist values that had marked the entire period.

Futurism also appeared in China, where Marinetti's proclamations were repeated by Hu Shih, Kuo-Mo-Jo and the poets of the magazine *Hsin ch'ing*, while in Japan the Italian manifestos stimulated the artists of the magazine *Nihon mirai-ha*, but also Tetsugoro, Taï Kambara, Yanase, Murayama and Seiji Togo, the latter painting city figures decomposed by light.

In the United States, the first Futurists were Athos Casarini, James Henry Daugherty, and Joseph Stella, who painted the typical sites of New York modernism, such as the streets of Coney Island or the hugeness of the Brooklyn Bridge, before executing compositions with explosive forms and colors. The Armory Show exhibition, held in New York in 1913, gave Americans the chance to discover Duchamp's and Picabia's Cubo-Futurist works. The Futurist themes of the machine and the city cosmos immediately inspired the paintings of Arthur Dove, Konrad Kramer, Charles Demuth. In 1915, Balla, Russolo, Carrà, Boccioni and Severini exhibited fifty works in a room reserved for them in the Panama Pacific Exhibition of San Francisco, where Max Weber's Futurist paintings were presented as well. The critic Christian Brinton pointed out that: "Everything we see, think, feel or remember can be found in a Futurist painting." Futurism influenced the painting of Mardsen Hartley, Frances Stevens, John Marin, while Stieglitz' Gallery 291 in New York organized Severini's one-man show in 1917.

Joseph Stella |
FUTURIST COMPOSITION
1914, pastel and pencil
on paper, 41,5 x 55,3 cm
(13 5/16 x 21 3/4 in).
Private collection.

American critics at the time spoke of "Futurism" to qualify most of modern art. That approach was true in several countries, where the word was used as simply meaning "avant-garde," and even to describe any sort of innovatory, anti-traditional work of art. That was the case, for instance, in Brazil and in Romania. This was not due to a confusion, but instead to the clear awareness that Futurism, considered as a world-view, was the embodiment of the most profound spirit of the avant-garde. Apollinaire himself felt it to be so, claiming that Futurism was the word "best-suited for new experiments."

In that sense, Apollinaire understood Marinetti's Futurism better than anyone else. The poet of *Alcools* knew that the idea of Futurism could not be expressed merely by its most contextual slogans, such as the glorification of the machine or the determination to set fire to museums. He perceived that it was just as radical a notion of the future as an act of faith, an overall philosophy of becoming seen as the very essence of being. In his manifesto *The Futurist Antitradition*, Apollinaire made Futurism the synonym of the very concept of the avant-garde. In fact he placed as an epigraph to his text a date, a place and an imaginary altitude: "Paris, June 29, 1913,

date of the Grand Prix, 65 meters above the Boulevard Saint-Germain." By that playful paraphrase of the note Nietzsche had written when he had the intuition of the "eternal return" of all things, Apollinaire provided the key to his manifesto: Futurism reveals the implicit doctrine of every avant-garde, expresses the fatality of every regeneration, is the eternal return of that impulse toward renewal which is an abiding feature of the human spirit. It was with that same idea in mind that Marinetti launched his manifesto *Worldwide Futurism*. The text in fact expressed his characteristic determination to spread the name of Futurism to the art of innovators, artists and poets, all over the world. That manifesto, the first planetary inventory of avant-garde movements, named all those who from Tokyo to Moscow, from Chicago to Warsaw, were working toward the advent of modernism. Marinetti called them "Unknowing or declared Futurists." And, in his role as historical founder of the avant-garde spirit, he claimed: "Together let us open new breaches onto the future, let us create with an utter faith in the everlasting genius of the Earth." That initial determination to forever be the catalyst of new energies is probably the most appealing aspect of his personality.

| Rafael Barradas
AT THE CAFÉ
1918, watercolor and gouache
on paper, 47,7 x 62 cm
(18 3/4 x 24 3/8 in).
Private collection.

Seiji Togo |
ALL FOR HER
1917, oil on canvas, 103,5 x 104,5 cm
(40 3/4 x 41 1/4 in).
Kagoshima Municipal Museum of Art, Kagoshima.

3

The Machine as Model, or the Twenties

Fortunato Depero
New-York-1930

Pages 126-127
Fortunato Depero
**MECHANICAL-KINETIC
SET FOR THE BALLET *NEW YORK
NEW BABEL* BY DEPERO
AND LEONIDE MASSINE**
1930, tempera on paper sketch.
68 x 102 cm
(26 3/4 x 40 1/8 in).
Museo d'Arte Moderna e Contemporanea,
Trento-Rovereto.

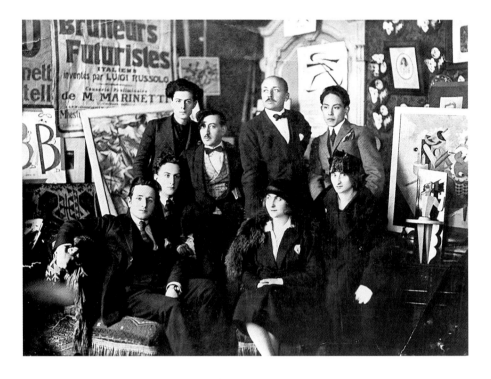

As soon as the war ended, Marinetti felt the need to bring about changes in his movement. So in 1919 he organized in Milan the first *Grande Esposizione Nazionale Futurista*. The exhibition, featuring over 460 works of painting, sculpture, freewording, decorative arts and architecture, allowed several young Futurists to make their début. It brought to light an essential aspect of post-war Futurism: although Marinetti's personality still prevailed, the movement was inspiring a great number of vocations and generating countless trends. Even Marinetti diversified his own research, soon launching Tactilism, meaning the art of touch, being the latest development of Futurist experiments with materials.

Post-war industrial reconstruction, like the utopia of a proletarian revolution, obliged nonetheless most of the Futurists to undertake investigations focusing on "mechanical art," that produced a substantial shifting in the point of view of Futurist art. The machine, that Marinetti had celebrated as a metaphor of vital energy, was superseded by factory machines, by mechanics considered as a productive tool.

The diffusion of mechanical art in the Italy of the twenties came about through contacts with other trends of the European avant garde. Fiozzi, Prampolini, Pannaggi, Diulgheroff were in touch with De Stijl and Bauhaus artists, whereas Fillia and Paladini were looking to Léger and the group of *Esprit Nouveau*. The influence of Dadaist photomontages and Russian Constructivism was obvious in Pannaggi's and Paladini's work. Fillia, Prampolini, Sartoris and Russolo joined the *Cercle et Carré* group, presided by Seuphor in Paris in 1930. The following year, Prampolini founded with Arp, Vantongerloo and Herbin the *Abstraction-Création* group. Italy's exchanges with European culture were undoubtedly the most significant aspect of Futurism at that time, far moreso than its rallying to Fascism.

From those years forward, Marinetti would occasionally use the expression "the first Futurists" to designate those artists who had been the founders of the movement and whose research had focused on plastic dynamism. His intention in so doing was to emphasize the continuity of Futurism, in spite of the novelty of the experiments the post-war generations had undertaken. In turn, Evola would refer to a "second Futurist period" beginning around 1916, with Balla's abstract painting coming after Boccioni's "lines of force." Actually, the only significant break warranting the expression "second Futurism" was the movement's political neutralization, which Marinetti had determined and history would sanction, and that from 1922 on was to lead to profound mutations in both the ideology of the Futurist avant-garde and its role in Italian society.

Art and Revolution

With the end of the war, Marinetti's political commitment would become more clearly outlined, when in 1918 he published a *Manifesto of the Futurist Political Party*, where he suggested applying the avant-garde's permanent revolution to political institutions. In 1919, he took part in the founding of *Fasci di Combattimento* (Fighting

Fortunato Depero |
DANCERS' MECHANISM
1917, oil on canvas, 75 x 71,3 cm |
(29 1/2 x 28 1/16 in).
Museo d'Arte Moderna e Contemporanea,
Trento – Rovereto.

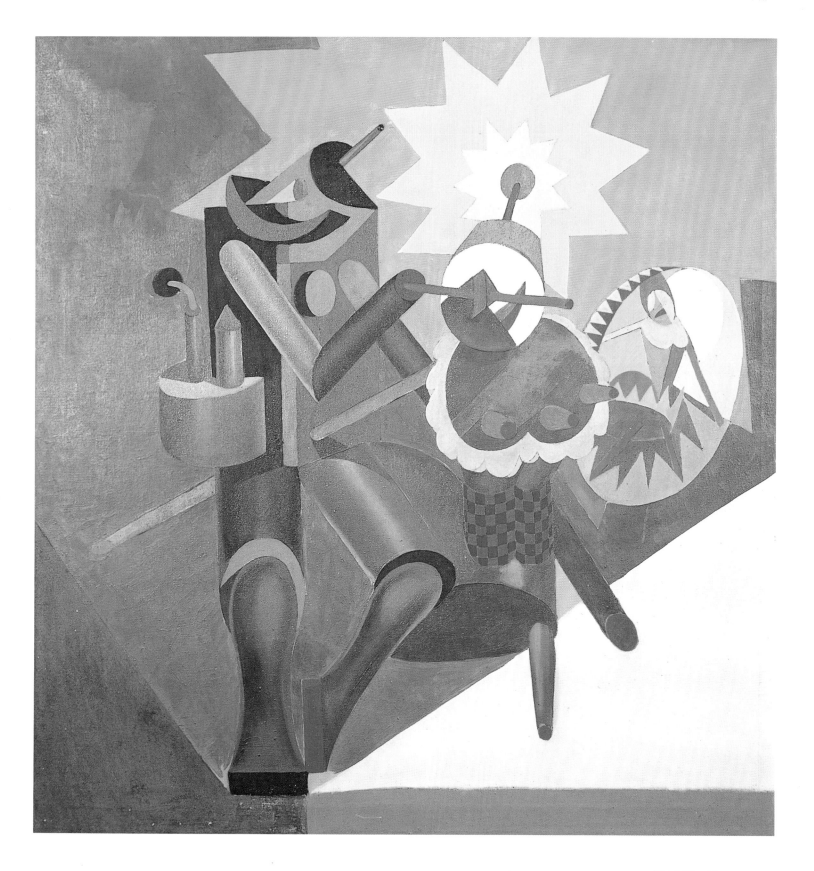

Fasces) thus joining forces, alongside the revolutionary syndicalists, with the first program introduced by Mussolini, a runaway from Socialism. But, a year later, he rejected that alliance, reasserting his anti-clericalism and his republican convictions, before turning to Malatesta and the Anarchists. Then Marinetti went to Fiume (the city in Yougoslavia, claimed by Italy, was occupied by D'Annunzio and his followers) and launched an inflamed proclamation about "handing power over to artists." A while later, the echos of the October Revolution caused Italian Futurism to shift toward a political stance inspired by the Russian avant-garde.

Up to then, Italian left-wing Socialism was used to referring to Tolstoy and Nordau in rejecting avant-garde art and calling for realism or a return to the "pure sources of popular art."

Instead, in 1920, in Moscow, at the Third Congress of the Communist International, Lunacharsky called Marinetti a "revolutionary intellectual," and Zinoviev added, for the benefit of the Italian delegation: "In times of revolution, we need revolutionaries." Even Gramsci wrote about Marinetti and about the vital role of innovatory protest Futurism played within bourgeois culture.

At that point, several young Italian intellectuals, militants in the revolutionary left, discovered the avant-garde. In 1922, in Turin, the Institute of Proletarian Culture published the anthology *1 + 1 + 1 = Dynamite, Proletarian Poems*, with the collaboration of Fillia, while Remondino, Rampa-Rossi, Frassinelli and other Futurists connected with Gramsci's magazine *Ordine Nuovo* (New Order) organized an *Esposizione Futurista Internazionale*. Marinetti contributed by presenting to the workers the paintings on exhibit. Those encounters were followed by an ideological discussion on the role of the artistic avant-garde within the social revolution. But Marinetti did not let himself be carried away. Just as his republican beliefs and his anti-clericalism had impelled him to move away from budding Fascism, his nationalism, more a gut feeling than ideological, prevented him from identifying with Communist internationalism.

In so doing, Marinetti became utterly isolated, unable to pursue his dream of a Futurist Italy that the "artists risen to power" were to have brought about. So it was on observing the pointlessness of art as a revolutionary force that his political experience came to an end. He then wrote *The Fire Drum* in which, in an allegorical style and with great lucidity, he drew to a close the myth of "action-art." Indeed it was at that time that Futurism entered another historical phase.

And yet in 1922, the very year the staging of *The Fire Drum* marked the end of the Futurist utopia, Paladini was to take a stand as the theoretician of a new political commitment of the artist joining forces with the revolutionary proletariat. In the magazine *Avanguardia*, pub-

lished in Rome by the *Federazione Giovanile Comunista d'Italia*, he published three Futurist manifestos: *Intellectual Revolt, Communist Art* and *Appeal to the Intellectuals*, that were also to constitute the first theoretic expression of a "mechanical art." These texts were the last historical opportunity for the birth of a common front associating the political left and the artistic left in Italy. A few months later, the March on Rome brutally put an end to these initiatives. Nonetheless, several Futurists reacted, radicalizing their political commitment. Johannis painted the work *The October Revolution* (1924), while Paladini published new manifestos, including *Proletarians and Intellectuals* (1925), claiming once again the necessity to involve avant-garde artists in social conflicts.

After the dictatorial regime was put in place, in 1925 a long period of uncertainty began, during which the consolidation of the Fascist party's rise to power coincided with attempts to resist on behalf of a certain number of Futurists, who would choose exile, alignment on anarchist positions, or even silence. It was not until toward the end of the twenties that several of them, in order to survive, resigned themselves to compromising with the established regime. Others, instead, followed Marinetti in his new determination to make Futurism the official art of the Italy that was to be born, it was believed, from the

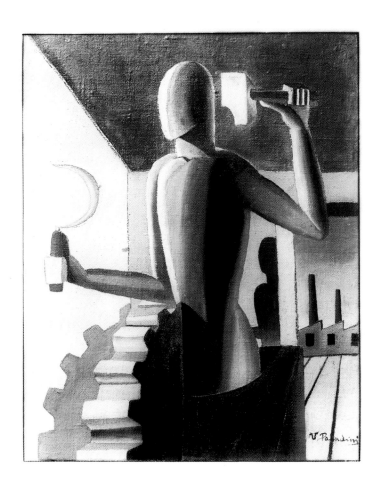

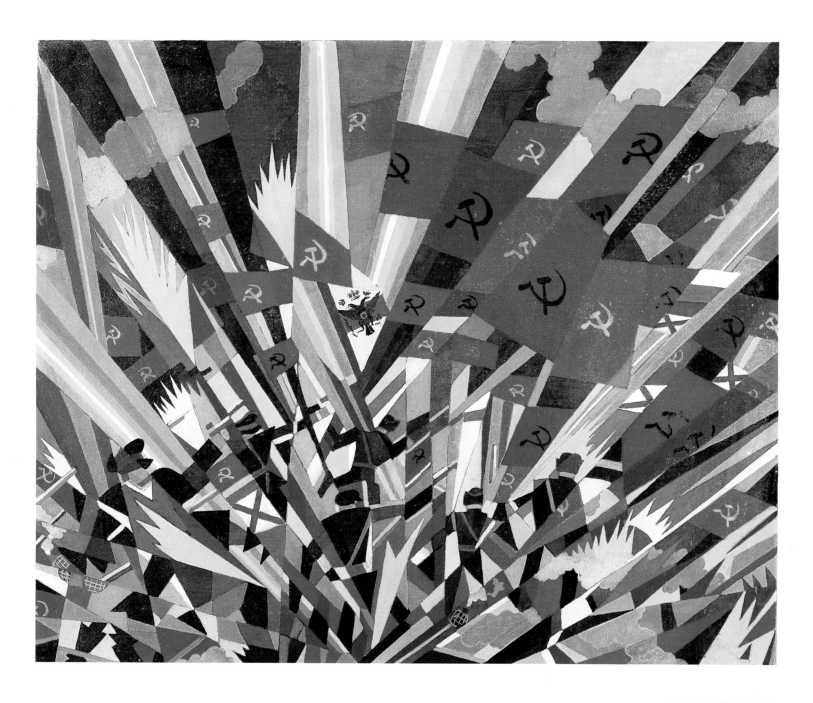

Luigi Rapuzzi Johannis |
THE OCTOBER REVOLUTION
1924, tempera and
lacquer on paper,
121 x 132 cm
(47 5/8 x 51 15/16 in).
Private collection.

| Vinicio Paladini
THE NINTH HOUR
1922, oil on canvas,
size unknown.
Work lost.
Original photograph, private collection.

so-called Fascist revolution. So Fillia's activism and Turinese Futurism were all that was left of the ideological discussion on the avant-garde the Communist militants of *Ordine Nuovo* (New Order) had sought.

During those same years, after announcing his movement's political neutrality, Marinetti claimed the primacy of Futurist art within the cultural action controlled by Fascism. That was why, in 1924, the Futurist Congress of Milan backed the government, that the assassination of Matteotti had brought to a crisis. The following year, the Futurists were invited to the second *Biennale Romana*. From then on, they would take part in the main cultural events of the Fascist regime. But in fact, Futurism was just barely tolerated by Fascism, that instead, to enhance its image as a powerful party, counted far more on the classicist restoration promoted by the *Novecento* movement, founded by Margherita Sarfatti, the Duce's egeria. Faced with the hostility of Mussolini's regime, Marinetti strived on the other hand to eradicate from Futurism any kind of semblance of being a structured association susceptible to resisting Fascist norms.

On the threshold of the thirties, that obstination of Marinetti's to keep the flame of the avant-garde alive seemed to have achieved its aim: to become the official art of Fascist Italy. But Marinetti's aspiration would only be fulfilled in an illusory way: actually, it was Fascism that would seek to use the Futurist avant-garde to its own ends. Orchestrated by Marinetti, this extreme compromising of Futurism would in fact lead to a series of failures. Manoeuvers to marginalize it, virulent attacks, and even episodes of censorship, would be inflicted on the movement all the way up to its founder's death.

Machine Art

At the beginning of Futurism, Marinetti had already elaborated the theoretic foundations of mechanical art. Marinetti's imaginary projection of the machine-man had been illustrated at the time by Boccioni's sculptures, and then by Balla's *Type-Setting Machine* and Severini's paintings on the theme of the tango, last of all by the plastic puppets and the canvases by Depero. In the post-war period, young Futurists, like Paladini and Pannaggi, viewed those positions as a thing of the past: their investigations sought a mechanical art conceived as a testimony of social conflicts, that made the "proletarian of steel and coal" the man of the future. Those new ideological stances, implying the shifting from the Dionysian model of the "roaring automobile" to the Apollonian model of the machine regulating the gesture of labor, were expressed by Paladini: "Teeth and gears, cogs and dynamos, the magnificent architectures of cranes and iron bridges, blast furnaces, gas generators and towers with their dizzying mechanics will replace the slimy, wan old landscape, the romantic subject and the moonlight,

all that pathetic, worm-ridden literature the bourgeois so dote on. The straight line, firm and aristocratic, versus nebulous, impressionist vagueness. Pure steel and three-dimensional forms of nuts and bolts of the factory world, the source of our modern life and of our great revolt." The paradigm of mastery and formal rigor, the machine inspired new values of clarity, synthesis, organization and construction that allowed Futurist painting to rediscover, after dynamic dislocations and kinetic vibrations, a new objectivity and a greater "plastic solidity."

The first mechanical art works Paladini painted in 1922, among which *The Proletarian of the III International*, were dedicated to revolutionary themes. But the rise to power of Fascism would immediately deprive mechanical art of any kind of symbolism connecting it with the world of labor. Even in its playful, technological or spiritualistic versions, mechanical esthetics would be harshly countered by Fascism as being a reflection of the socio-economic realities of the urban proletariat. Indeed, Fascism's cultural policies would privilege the social myths and ethical values of the rural world, far easier for a totalitarian regime to control.

Thus, the common denominator of these experiments was nothing but an idealism sprung from the deep crisis the entire Futurist avant-garde was going through, henceforth deprived of the revolutionary activism that had sustained it. The spiritualism inherent to the post-war cultural mood was what would fill the vacuum left behind by the loss of political commitment. Paladini, for instance, for his painting *The Ninth Hour* (1922), that dealt with women workers' demands that their working hours be reduced, sought in De Chirico the secret of a magical painting, based on the crystal clarity of forms and their isolation in space.

Futurist painters were then drawn to the severe beauty of machine gears and the standardized volumes of the metropolis. Those preferences were expressed in their paintings by rigorous formalizations that only occasionally led to abstraction. Prampolini's nearly abstract pictures, like *Dance of the Tarantella - Rhythm of Space*, were mostly significant as an initiation to the new formal vocabulary inspired by the machine. Several other works, like Pannaggi's *Speeding Train*, also illustrated this transition stage.

Once the initial fumblings were over, mechanomorphic analogies, geometric forms and the very theme of the machine would become a playful invention for Balla, an ironic figuration for Diulgheroff, a grotesque or naïve stylization for Depero. The severity and the repetitive logic of mechanical rhythms always appeared in their works as though decomposed by the irruption of a liberating imagination. Thus, in *The Two Sisters*, Diulgheroff staged with a sense of humor and tenderness the complicity of his wife and sister-in-law, whose endless con-

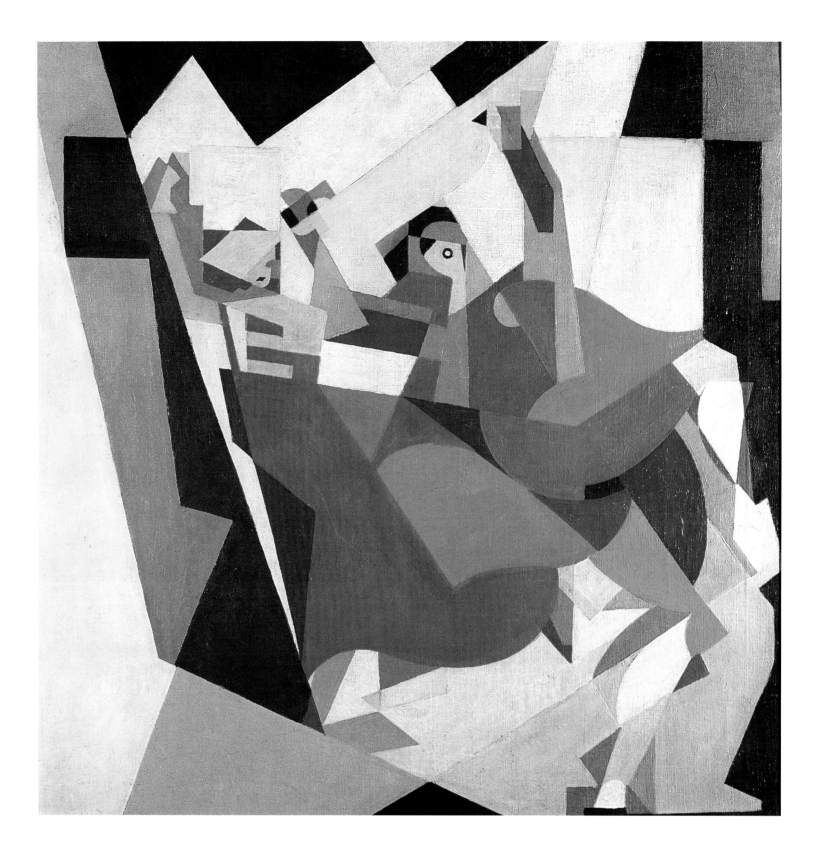

Enrico Prampolini |
**DANCE OF THE TARANTELLA-
RHYTHM OF SPACE**
1922, oil on canvas,
80 x 80 cm
(31 1/2 x 31 1/2 in).
Narodowe Museum, Warsaw.

versations ran on like a perfect mechanism. Depero painted a festive atmosphere in his *Composition with a Locomotive*. As for Paladini, he claimed: "I gave up the old research for movement and spatial expansion, that had given rise to the technical system of the interpenetration of planes, for other constructive, architectural investigations. If the technique is similar to that of the Russian Suprematists, the spirit is entirely different. In my painting *Equilibrisms* there is no Suprematist abstraction at all. On the contrary, I tried to project in it elements that belong to the light, witty world of humor, to express feelings like surprise and the childish delight circus performances give us, entirely real feelings and of a highly psychological nature." That rejection of a purely formalist approach of mechanical esthetics was typical of the research of a number of other Futurists.

Likewise, Dottori used the formal idiom of mechanical esthetics to geometrize the night vision of flames in his *Fire in the City* (1925-1926). Fillia sought an orthodox interpretation of mechanical art, for instance in his painting *Steam Engine = Relationship of Forms*, while Diulgheroff confirmed his ironic approach in *Rational Man*. As for Marasco, he worked at the reducing of forms in his *Skyscraper Logarithm*. Mechanical art was far from being a codified expression, each Futurist displayed therein his personal sensibility.

Actually, the Futurists' attitude toward the machine was far from being univocal. Often, "mechanical" reality was only approached, in their works, through its multiple, conflictual connections with human nature. Either jubilating, or anguished, that issue of the identification of man and machine ran through all of Futurism. Their

| Fillia
STEAM ENGINE = RELATIONSHIP OF FORMS
1926-1927, oil on cardboard,
46,5 x 64,5 cm (18 5/16 x 25 3/8 in).
Private collection.

Ivo Pannaggi |
SPEEDING TRAIN
1922, oil on canvas, 100 x 120 cm
(39 1/4 x 47 1/4 in).
Cassa di Risparmio, Macerata.

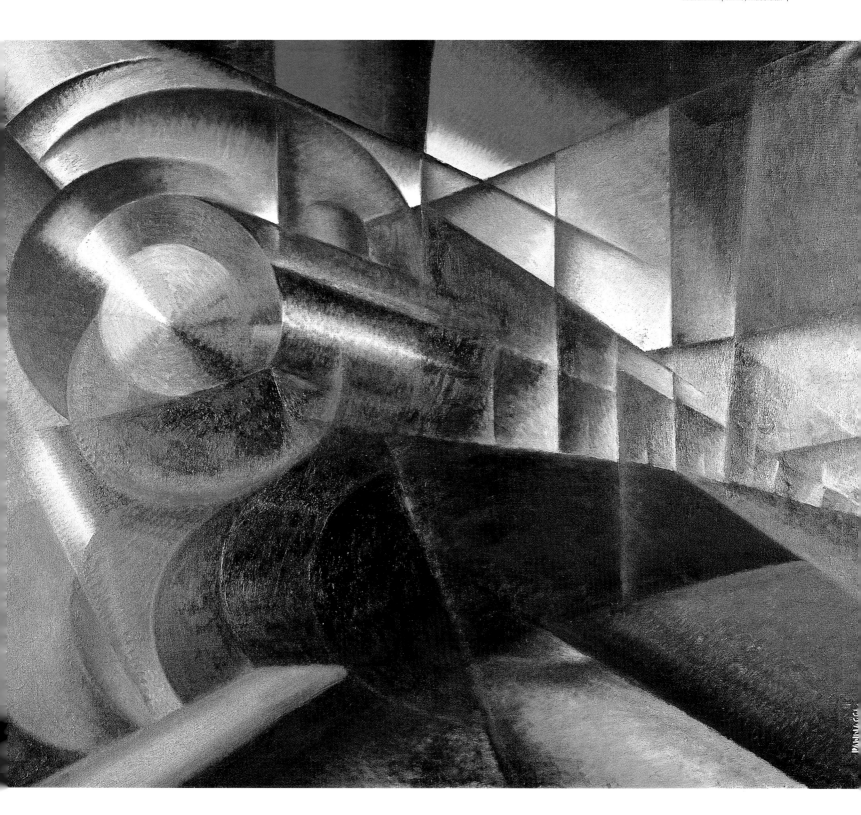

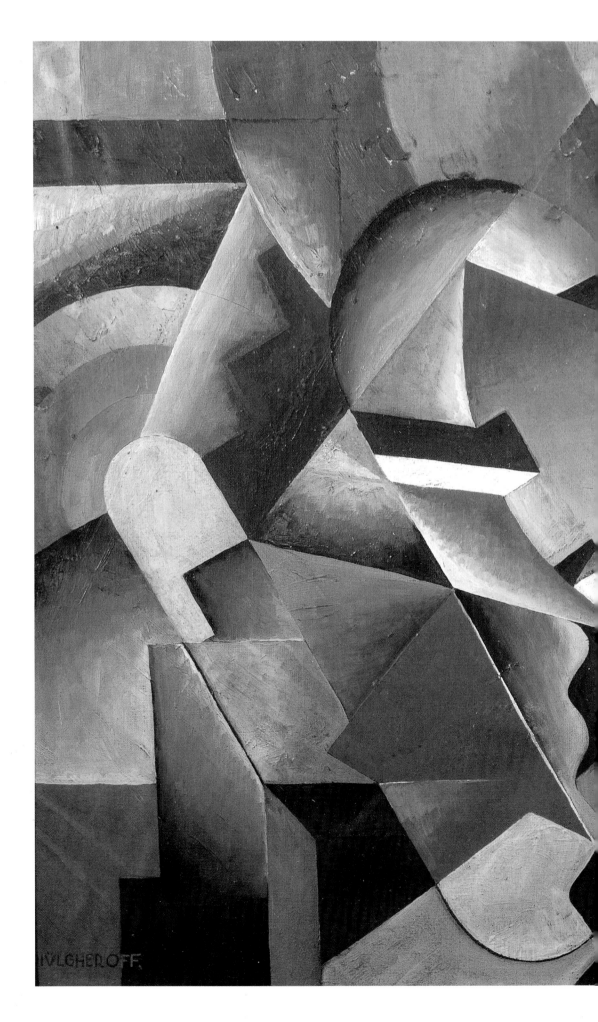

Nicolay Diulgheroff |
THE TWO SISTERS
1922, oil on cardboard,
49,5 x 74 cm
(19 1/2 x 29 1/8 in).
Galleria Nazionale d'Arte Moderna, Rome.

Page 138 |
Nicolay Diulgheroff |
RATIONAL MAN
1928, oil on canvas,
99 x 113,5 cm
(39 x 44 11/16 in).
Private collection.

Page 139 |
Nicolay Diulgheroff |
THE PROFESSOR
OF RATIONAL MECHANICS
1930, oil on canvas,
94 x 74 cm (37 x 29 1/8 in).
Private collection

Page 140 |
Fillia |
FOURTH DIMENSION
OF THE HEART
1926, tempera on
cardboard, 25,6 x 23 cm
(10 1/16 x 9 1/16 in).
Private collection.

Page 141 |
Fillia |
THE BUILDER
1928, oil on masonite,
70 x 50 cm
(27 9/16 x 19 11/16).
Private collection.

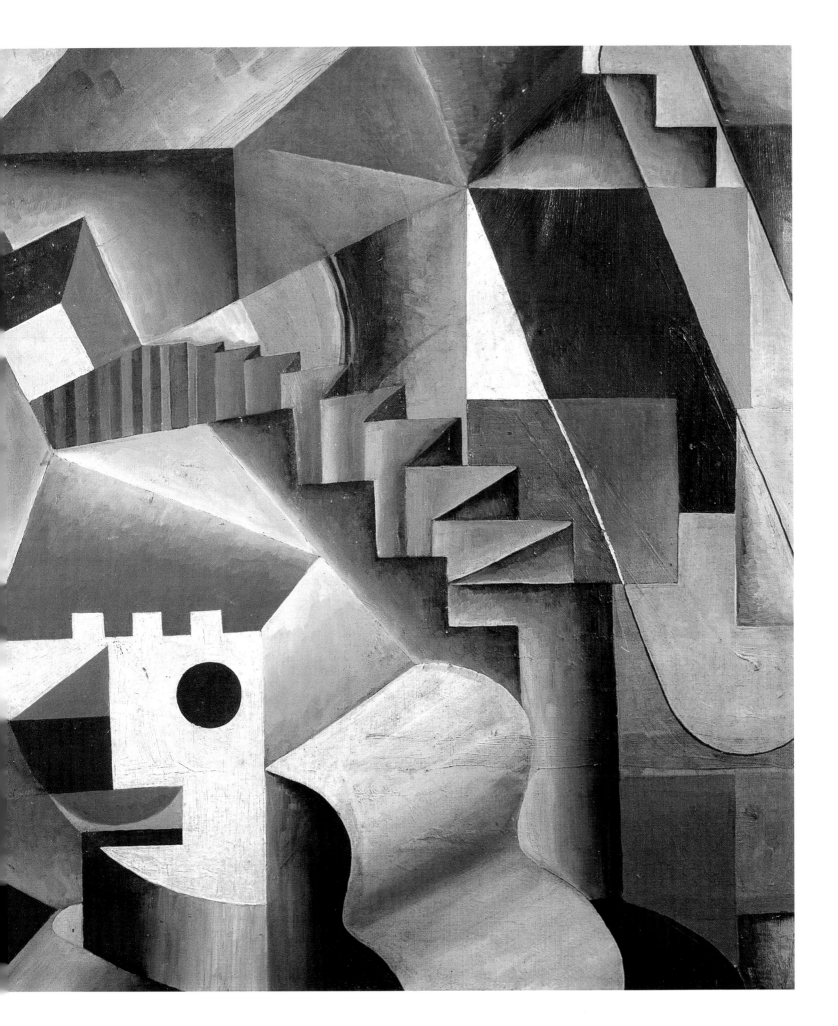

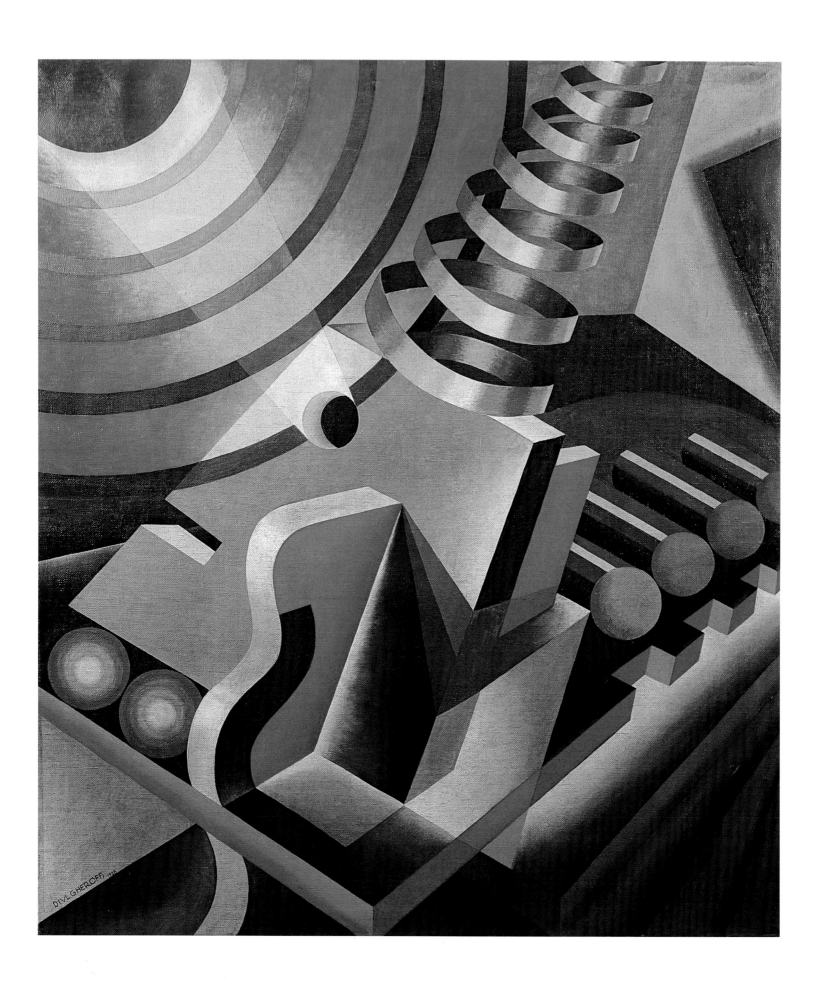

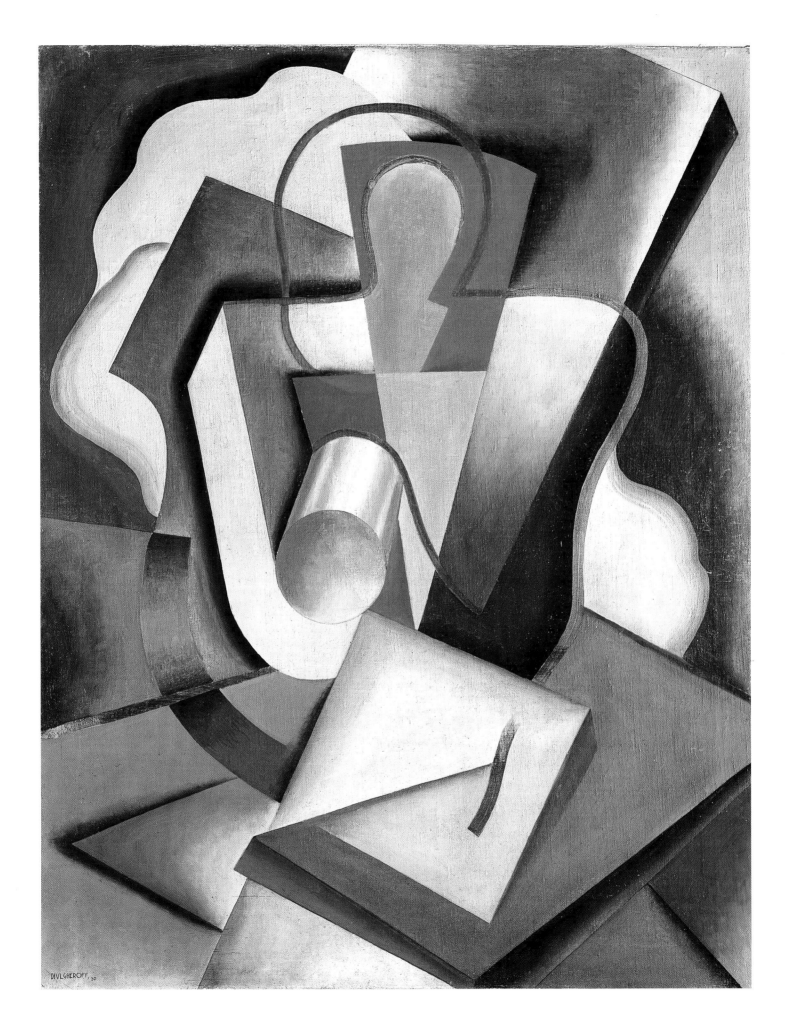

DIVLGHEROFF, 20

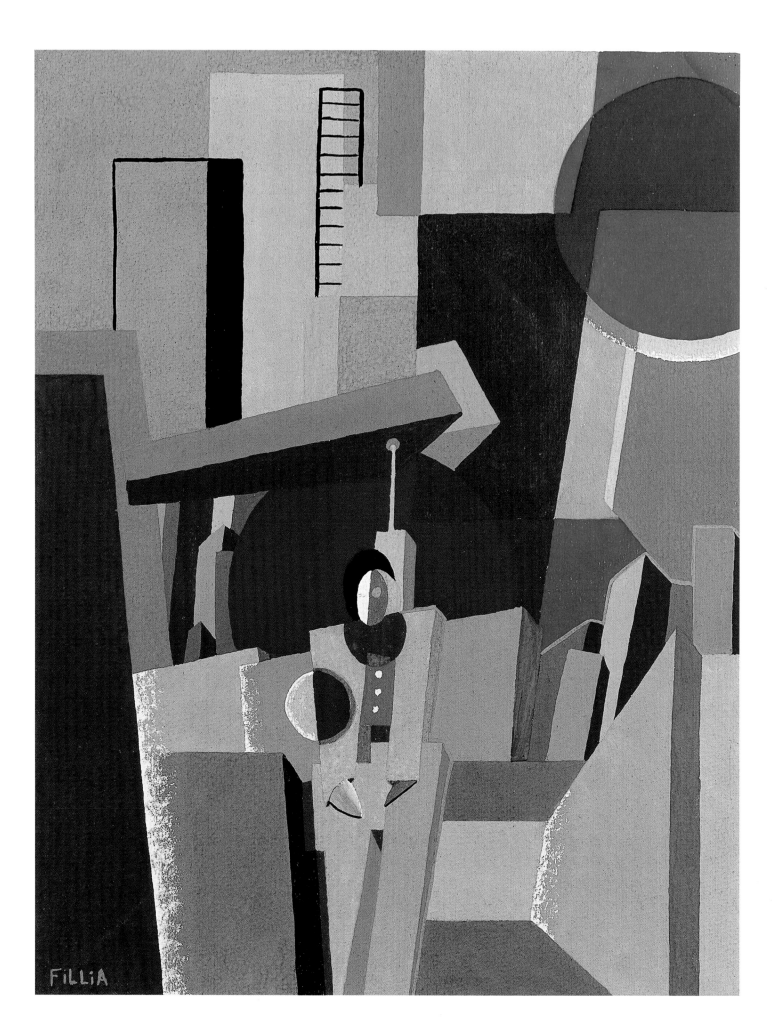

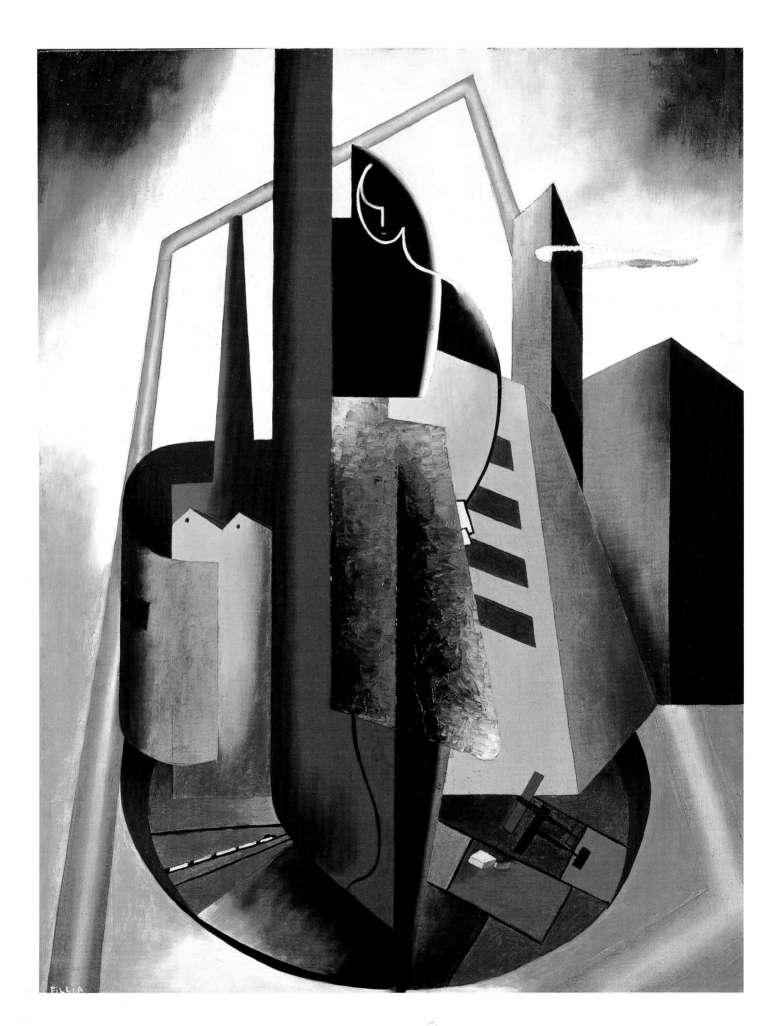

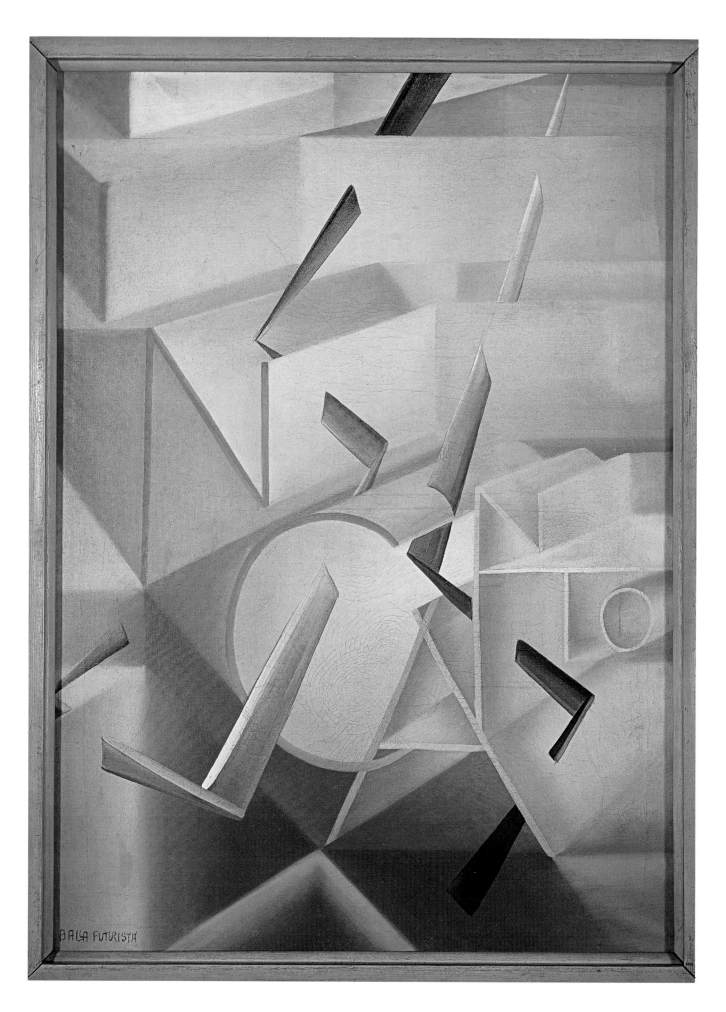

confrontation being unavoidable, the Futurists saw in that conflict the possibility of creating an entirely new art, focused on the wonders of the industrial world. But, beyond the theories the countless manifestos of the movement proclaimed, Futurism was not in the least a mere celebration of the machine and its esthetics. In fact, the Futurist glorification of modernism would never forget the Humanism that nurtures Italian culture in its very roots. That is why vitalist spontaneity always prevailed: Futurism was refractory to some of the ideological projections of Constructivism, that very concretely envisioned "modeling the spirit" of modern man, pursuing his political education. Futurist mechanical art was above all determined by a Dionysian approach to the metropolis. And it always would plead the cause of humanity, of its primacy over the machine itself, even by merely producing a dissonant, amused gaze that made man become a factor of resistance to the mechanization of lifestyles generated by industrial civilization.

Around the mid-twenties, Prampolini and Benedetta, Marinetti's wife, seeking a theoretic clarification, clashed with Dottori, who spoke of a new "subject" in referring to mechanical art. Benedetta replied to him that it was out of the question to directly paint machine parts, the point being to reach the laws of construction and the formal values of which the machine is the model: "It is the Futurist painting, precisely because it is the result of our mechanical sensibility, that will be constructed like a machine." Several canvases by Pannaggi, Marasco, Prampolini, Diulgheroff, just as Depero's type-setting experiments, belong to that tendency focused on contrasts of flat tints and structured volumes, or on the principle of orthogonality allowing a page layout with jerky rhythms.

Agreement on principles did not exclude divergence of applications. Fillia and Prampolini gave a spiritualist character to mechanical art. Bot's mechanical assemblages, Thayaht's chromium-plated metal sculptures, and some of Pirrone's and Azari's photographs belonged to a more radical artistic theory, directly open onto the world of technology. Paladini's and Pannaggi's photomontages used the language of mechanical forms. In the Surrealist-style photographic double exposures by Tato and Parisio, the machine was merely a metaphor. Balla developed mechanical art based on a playful lettrism: in *The Big T*, he referred to Henry Ford's model T race cars, while in *The Spell is Broken* color came to confirm the meaning of the words.

Depero used that same lettrism in architectural research. In 1927, for the Monza *Biennale Internazionale delle Arti Decorative*, he built a white and blueish-white Book Pavilion, where the book and the volumes of gigantic typographical letters were turned into architectural elements. It was one of the most successful achievements of

Antonio Marasco |
SKYSCRAPER LOGARITHM
1929, oil on canvas,
87 x 50 cm
(34 1/4 x 19 11/16 in).
Private collection.

| Giacomo Balla
THE SPELL IS BROKEN
| 1922-1923, oil on canvas,
106 x 76 cm (41 3/4 x 29 7/8 in).
Private collection.

| Fortunato Depero
BOOK PAVILION BUILT IN THE PARK OF MONZA, FOR THE IIIRD BIENNALE INTERNAZIONALE DELLE ARTI DECORATIVE
| May 1927. Work destroyed.
Original photograph, Museo d'Arte Moderna e Contemporanea, Trento – Rovereto.

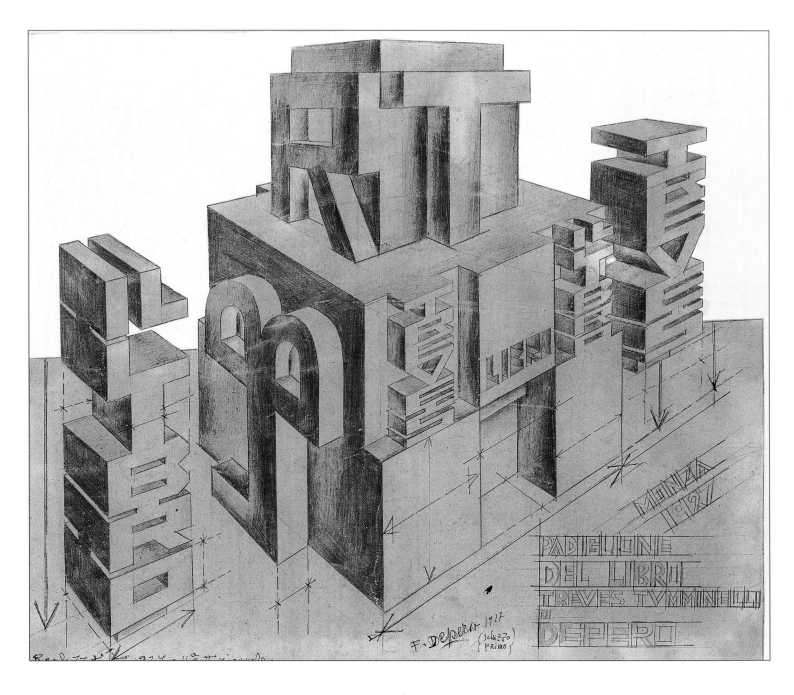

the Futurist architecture of the time. Yet even in that field the diversity of tendencies prevailed. Visions of a totalitarian society began to haunt Marchi. His designs then modeled the Futurist city as a huge machine overwhelming space and perpetually striving toward the heights of a monumental verticalism. Instead, the rigor of functionality and the bare geometries that made the machine the model for a new social ethics were to be found in the architectural designs by Sartoris and Diulgheroff, while the Cubist codifications of the "steamer style" attracted Paladini and Prampolini. The latter built the Futurist pavilion for the *Esposizione Internazionale* that was held for the tenth Victory anniversary at the Valentino Park of Turin in 1928.

Mechanical Ballets

It was especially in "mechanical ballets," created during those post-war years, that the Futurists dealt with the issue of the machine-body. They even made it the very emblem of the culture arisen from technology and big industry. On the stage, the machine-body was not merely the stakes of a new esthetic; it was also the most striking illustration of the need to redefine man within the industrial world. Authors like Marx or Bergson had implicitly brought up that necessary redefinition of human nature when they sought to grasp that novel thing: the "mechanized being." The former by studying, in *Das Kapital*, the consequences of "machinism," the latter by referring to the disappearance of tragedy in *Laughter*. So the Futurists' machine-body expressed the new anthropological condition inherent to modern man. In all its complexity, it pointed to the necessary rediscov-

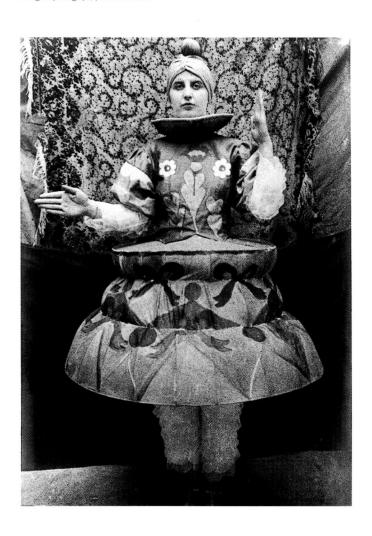

ZDENKA PODHAJSKÁ IN *DOLL DANCE* ON MUSIC BY TCHAÏKOVSKY
August 1924, Theater
of Thonon-les-Bains.
Original photograph, private collection.

ery of the specificity of man confronted with the machine. Thus mechanical ballets turned the machine-body into the flickering projection of a dream of power, immediately contradicted by the burst of laughter of a profoundly humanist intelligence. In other words, the image of the automat appeared in the Futurists' works either as the reflection of an anxiety overcome, or as the triumphant objectivation of an over-determined will. So the anthropomorphic machine was at once a puppet and an overman. In both cases, the automat revealed the mechanical aspect in man: it was proof of the fact that modern man could no longer get along without the machine, because henceforth it crystallized an awareness, both traumatizing and rejoicing, of his own flesh and muscle body. Mechanical ballets, with their robot costumes made of thick cardboard and tinfoil, thus composed a mode of expression that was influenced by the world of machines as well as by the clownish spirit of music-halls and Commedia dell'Arte.

The emblematic, ambiguous status of the machine-body was illustrated in 1922 by the *Futurist Mechanical Ballet* by Paladini and Pannaggi, performed at the Casa d'Arte Bragaglia in Rome. The leading character of the ballet, the Proletarian – a worker in big industry –, is torn between two poles of attraction: the Machine, represented by a robot-dancer, and Woman. The feminine being the human element *par excellence*, the Proletarian is shown as being perpetually trapped between those two opposing realities: the human and the mechanical, opposed to one another both as antagonist and as complementary. Part-man, part-machine, the Proletarian expresses that play of attraction and of repulsion by paced geometric gestures, moving about under the projectors on the noisist rhythm of two motorbike engines. He embodies the being of the future, that is, a forceful, ambivalent subject, capable of humanizing "machinic" reality as well as of subverting the human dimension to identify it with the incorruptible splendor of the machine.

Later on, the mechanization of human nature would produce its humorous counterpart with the mechanical ballets *Enicham of 3000, The Dance of the Propellor, Psychology of Machines*, conceived in 1923 and 1924 by Depero, Casavola, Pocarini, Mix and Prampolini. Mechanical gestures and three-dimensional structuring of the costumes were again combined in other ballets, like *Contrast of Relativity* and *Construction SR* by Mix and Marasco. Then new and contradictory metamorphoses of the machine-body were brought to the stage with *The Anguish of Machines* by Ruggero Vasari and Prampolini's *Ballets of the Futurist Pantomime*. The disturbing mythology of the machine as a model interiorized by man alternated with the liberating jubilation of the body abandoned to the frenzied dynamism of the big city: the

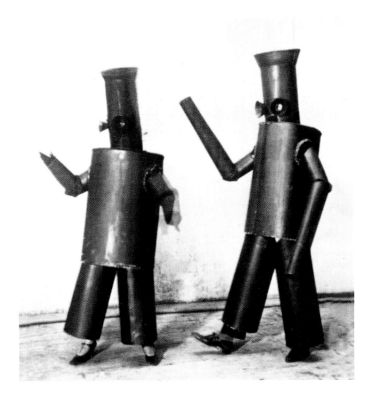

| Ivo Pannaggi
MECHANICAL BALLET
| Composition after a stage photograph
of the Proletarian's costume.
1924, photomontage, size unknown.
Work destroyed.
Original photograph, private collection.

Fortunato Depero |
MECHANICAL BALLET *ENICHAM OF 3000*
BY DEPERO AND CASAVOLA, BILLBOARD
1923, lithographic print, 140 x 100 cm
(55 1/8 x 39 3/8 in).
Museo d'Arte Moderna e Contemporanea,
Trento – Rovereto.

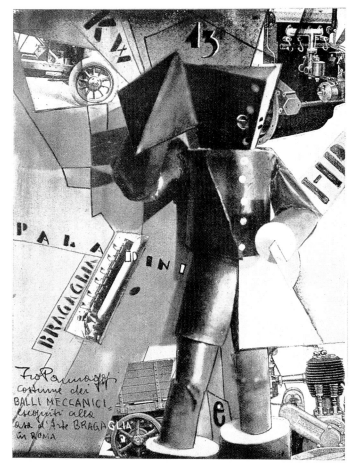

| Fortunato Depero
COSTUMES OF THE MECHANICAL
BALLET *ENICHAM OF 3000*
January 1924.
Trianon Theater, Milan.
Original photograph, private collection.

machine as a necromorphic force or as a vital alternative. Turning the machine-dancer into a puppet would eventually lead to the total mechanization of the stage. In 1929, for his design for the ballet *New York New Babel*, Depero saw the entire stage as a machine containing volumes with scheduled movements.

That grotesque, playful or even humorous vein of those mechanical dances coincided with the predilection for American jazz expressed by the new Futurists Casavola and Mix. Russolo, on the other hand, resumed his noisist experiments, creating a new instrument, the Rumorharmonium, the ancestor of Cage's "prepared piano" and the synthesizer. Playing the part of a noisist musician, he took part in the projections of the film *The March of Machines* presented by Deslaw in Paris. In the cinema, Viola and De Marzi revisited in 1934 the humorous component of mechanical art in the short film *Eve the Machine*, that challenged the morals of the times. Thanks to the extremely rapid editing of the images, the film turned the motorcyclist's contact with his machine into the equivalent of the carnal union of man and woman. In literature, where creations of the imagination do not benefit by the visual immediacy specific to the plastic arts, the "return to human nature" was openly discussed. Vasari, Fillia, Trimarco, Marasco, Tordi wrote plays where a negative image of human robotization was offered in counterpoint to the most incisive expressions of mechanical esthetics.

The Avant-Garde of Everyday Life

At that time, Marinetti's attempt to provide an institutional framework for Futurist art led to the multiplication of *Case d'Arte* (Houses of Art), exhibition spaces and arts and crafts shops, whereby the Futurists sought to make avant-garde esthetics become popular. In a way it was Balla's turn to win out: opposed to Marinetti's activism and revolutionary romanticism, he called for a spreading of the new forms to everyday life, that is, a concrete action that, based on the production of useful articles and decorative stylization, would model the sensibility of all of modern society. A first example of that spirit, the *Casa d'Arte Bragaglia*, opened on via Condotti, in Rome, in 1918, followed several months later by a number of other ones, set up in Palermo, Milan, Bologna, Turin, and so on. By 1925 the *Manifattura Ceramiche d'Arte* Mazzotti at Albisola began manufacturing Futurist ceramics.

The Futurists went into arts and crafts, propaganda art, mural decoration, design, advertising architecture, by creating furniture, toys, posters, clothing, articles of all kinds, interior furnishings and architecture, and so forth. They also took part in the main events of city life: "Futurist floats," with their astonishing, colorful shapes, by Depero, Tato, Rizzo, were paraded about the city on the occasion of annual festivities. The Futurists increas-

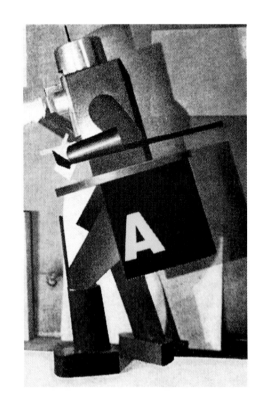

THE DANCER MIKHAILOV WEARING PANNAGGI'S PLASTIC COSTUME
Performing on music by Stravinsky, Teatro Sperimentale degli Independenti of Rome, April 27, 1927.
Private collection.

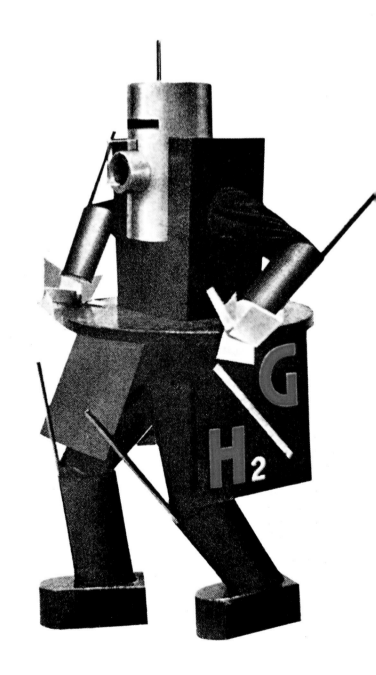

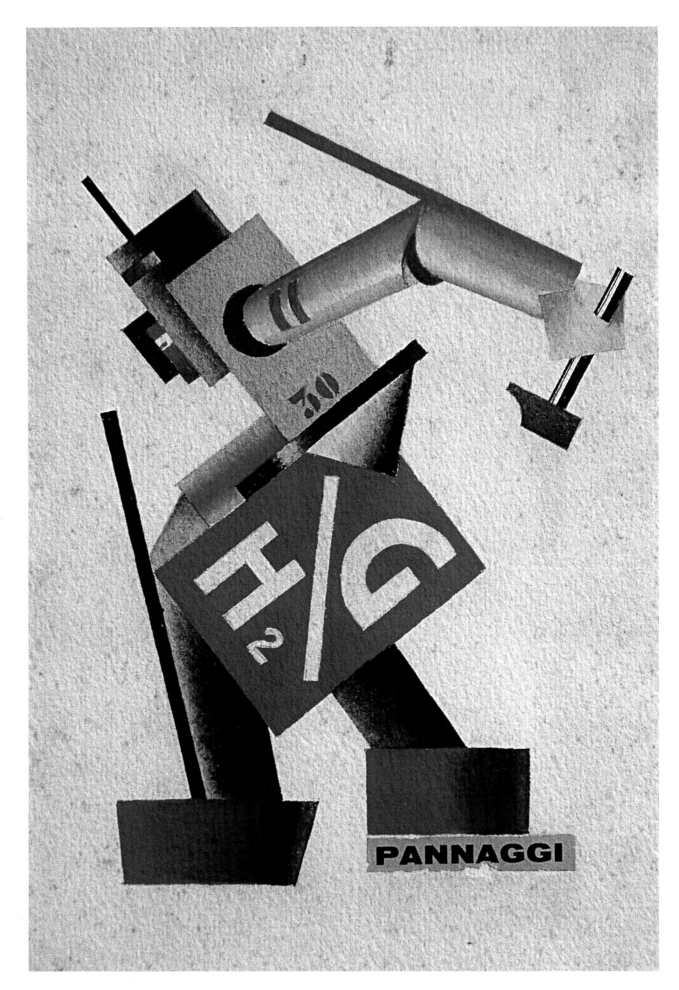

Ivo Pannaggi |
**PLASTIC COSTUME
FOR *THE ANGUISH
OF MACHINES*
BY RUGGERO VASARI**
1926, watercolor
and collage sketch
on paper,
20 x 13,5 cm
(7 7/8 x 5 5/16 in).
Private collection.

Futurist Fashion

Futurism, being a global revolution, could but permeate that art of everyday and social life that fashion represents. Boccioni and Severini once caught Apollinaire, in Paris in 1911, wearing socks of different but complementary colors. Carli walked around the darkest streets of Florence donning a scarlet waistcoat. Guided by Balla, Futurist fashion became increasingly provocative and ephemeral. He launched the manifesto of *Futurist Masculine Clothing* (1914) and thought up bi-colored shoes, polychrome neckties made of plastic, cardboard or wood, sometimes equipped with colorful lightbulbs that would go off and on at will. His clothes were completed by "modifiers," meaning pieces of material of various forms and colors, to be changed several times a day,

depending on the mood of the moment. Balla created, among other things, bright-colored, even phosphorescent asymmetrical suits, whose forms were composed around abstract and dynamic elements, such as cones, triangles, spirals. The painter equally proposed a sketch of a very simple pair of overalls made out of a single piece of material. Thayaht designed it in 1918, calling it *tuta*, esthetic, cheap and do-it-yourself apparel. In Futurist fashion, there was no contradiction between functional character and imagination. They both stemmed from the same idea: Futurist fashion thought much more in terms of the city than in terms of the body, it did not remodel corporeal forms in order to assert the individual's singularity,

| Fortunato Depero
FUTURIST WAISTCOAT
| Model worn by Azari, 1924, patchwork of woolen fabrics, 52 x 45 cm (20 7/16 x 17 11/16 in).
Private collection.

MARINETTI AND DEPERO
| donning Futurist waistcoats, during a performance in the streets of Turin, in 1925.

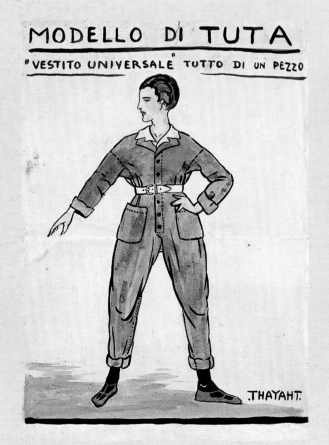

MODELLO DI TUTA
"VESTITO UNIVERSALE" TUTTO DI UN PEZZO

.THAYAHT.

| Thayaht
MODEL OF OVERALLS (*TUTA*)
| 1919, pen and watercolor on paper, 60 x 40 cm (23 5/8 x 15 3/4 in).
Private collection.

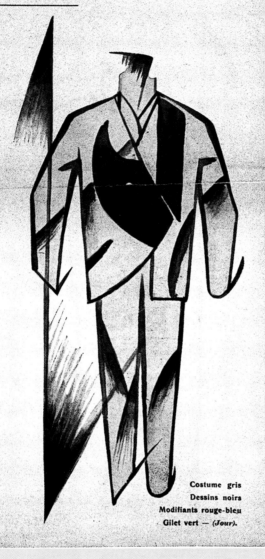

LE VÊTEMENT MASCULIN FUTURISTE
Manifeste

L'humanité a toujours porté le deuil, ou l'armure pesante, ou la chape hiératique, ou le manteau traînant. Le corps de l'homme a toujours été attristé par le noir, ou emprisonné de ceintures ou écrasé par des draperies.

Durant le Moyen-Âge et la Renaissance l'habillement a presque toujours eu des couleurs et des formes statiques, pesantes, drapées ou bouffantes, solennelles, graves, sacerdotales, incommodes et encombrantes. C'étaient des expressions de mélancolie, d'esclavage ou de terreur. C'était la négation de la vie musculaire, qui étouffait dans un passéisme anti-hygiénique d'étoffes trop lourdes et de demi-teintes ennuyeuses efféminées ou décadentes.

C'est pourquoi aujourd'hui comme autrefois les rues pleines de foule, les théâtres, et les salons ont une tonalité et un rythme désolants, funéraires et déprimants.

Nous voulons donc abolir :

1. — Les vêtements de deuil que les croque-morts eux-mêmes devraient refuser.

2. — Toutes les couleurs fanées, jolies, neutres, fantaisie, foncées.

3. — Toutes les étoffes à raies, quadrillées et à petits pois.

4. — Les soi-disants bon goût et harmonie de teintes et de formes qui ramollissent les nerfs et ralentissent le pas.

5. — La symétrie dans la coupe, la ligne statique qui fatigue, déprime, contriste, enchaîne les muscles, l'uniformité des revers et toutes les bizarreries ornementales.

Costume gris
Dessins noirs
Modifiants rouge-bleu
Gilet vert — (Jour).

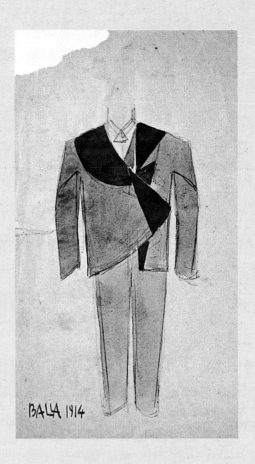

Giacomo Balla |
FUTURIST GARMENT
1914, tempera sketch |
on paper, 36 x 24 cm
(14 1/8 x 9 7/16 in).
Private collection.

| Giacomo Balla
MANIFESTO OF THE FUTURIST MALE GARMENT
20 may 1914, tract folded in two,
29 x 23 cm (11 3/8 x 9 1/16 in).
Private collection.

but, instead, depersonnalized it to turn it into a moving work of art. Actually, against the class connotation of traditional fashion, Futurism demanded a total, enthusiastic embracing of the collective values of urban modernism. It's sole interest was in the street, the privileged location of social life. Thus Futurist fashion glorified the anonymity of the city, even while reacting against the phenomena of massification and standardization of the modern world by ephemeral creations allowing art to burst into life. The Futurists thought up a bright-colored, lively and festive fashion, capable of brightening the streets of the modern city so as to reflect its cheerful utopia of the future. ■

| Enrico Prampolini
PLASTIC PUPPET FOR THE BALLET
THE PUPPET'S HOUR
BY FOLGORE AND CASELLA
| 1927, colored pencils
and ink sketch on paper,
46,8 x 29,5 cm
(18 3/8 x 11 5/8 in).
| Private collection.

Fortunato Depero |
MECHANICAL-KINETIC SET FOR THE BALLET
NEW YORK NEW BABEL
BY DEPERO AND LEONIDE MASSINE
1930, tempera sketch |
on paper, 68 x 102 cm
(26 3/4 x 40 1/8 in).
Museo d'Arte Moderna e Contemporanea,
Trento-Rovereto.

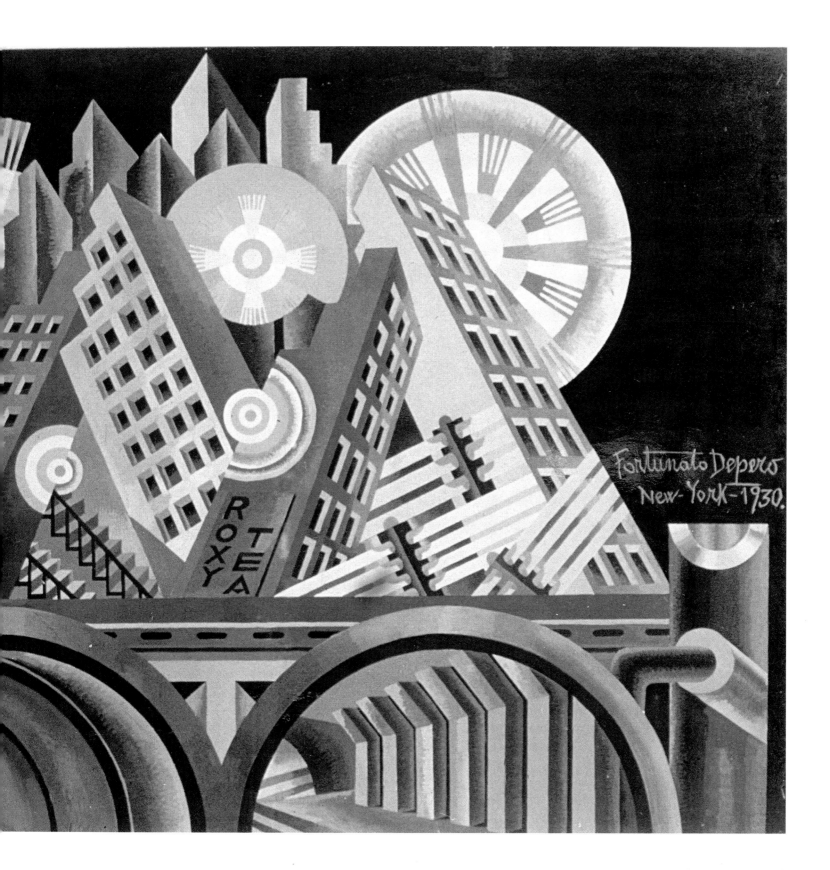

Enrico Prampolini
BADGE OF THE FUTURIST GROUP OF TRIESTE
Worn by Bruno G. Sanzin at the First Futurist Congress of Milan. November 1924, lithographic print on cardboard measuring 4,8 cm (1 7/8 in) in diameter, certified on the back by the Futurist congress stamp, tricolor ribbon measuring 22 cm (8 5/8 in).
Private collection.

Enrico Prampolini |
POSTER OF HOUSE OF ITALIAN ART
1919, lithographic print,
22 x 9 cm (8 5/8 x 3 1/2 in).
Private collection.

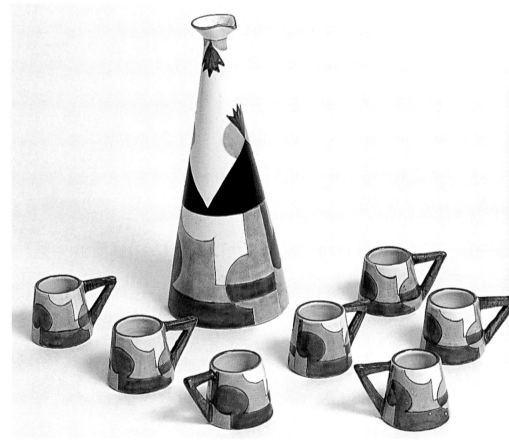

ingly assumed the role of renovators of the culture of the ephemeral and the everyday, since they had entirely given up their aspiration to become revolutionary protagonists of the course of history.

The once-rigorously centralized organization of the Futurist movement broke up into a swarm of small groups that were formed on the scale of the regions, provinces and cities throughout the peninsula. Practically a mass phenomenon, as an alternative culture that did not identify with the official, regime-bound culture, Futurism had hundreds of followers, well-known artists and unheard of figures, making it a nation-wide movement. The Futurists multiplied the opportunities to openly demonstrate their belonging to a cultural, artistic avant-garde. Bright-colored ties, Futurist hats and various badges were donned so as to to proclaim, just like a sports team, the cohesion and the otherness of the Futurist movement.

Concurrently, the pluralism of "styles" sanctioned the splintering of an avant-garde that had unreservedly opted for social integration. In Turin, design as the industrial form of decoration prevailed. Diulgheroff's Futurist furniture used aluminium, metal alloys and chromium-plat-

ed metal, meaning materials belonging to industry. Their forms enhanced the efficiency of the functional object and its vocation to represent the values of technology. Volt outdid himself in Florence by demanding, in his manifesto *Meccano Style*, the assemblying of prefabricated materials, including interior furnishings. Disregarding the esthetics of industry, Cangiullo on the other hand in Rome put out the manifesto *Futurist Furniture* that called for the creation of sonorous furniture equipped with surprise-effect mechanisms, such as the "shaky, jerky chair," or freewordist ones, shaped like the various typographical letters.

In the same playful spirit, Balla devoted his research to interior furnishings: his furniture was made of wood and could be taken apart, all the elements being assembled by an orthogonal interlocking as in popular crafts. The edges were painted a different color to emphasize the mounting of the item. Actually, Balla's approach was diametrically opposed to that of mechanical art. His experiments dealt with the articulated object, thus conceiving all sorts of things as open forms and structures, part-way between the playful values of puzzles and the rejection of the monumental typical of Japanese art. He invented

| Pippo Rizzo
LIQUEUR SET
| 1929, glazed terra cotta.
| Private collection.

| Mario Guido Dalmonte
VASE
| 1930, painted pottery.
| Private collection.

| Giacomo Balla
TEA SET FOR TWO
| 1928, painted pottery, teapot height 17 cm (6 11/16 in).
| Private collection.

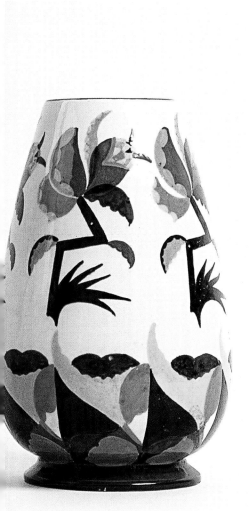

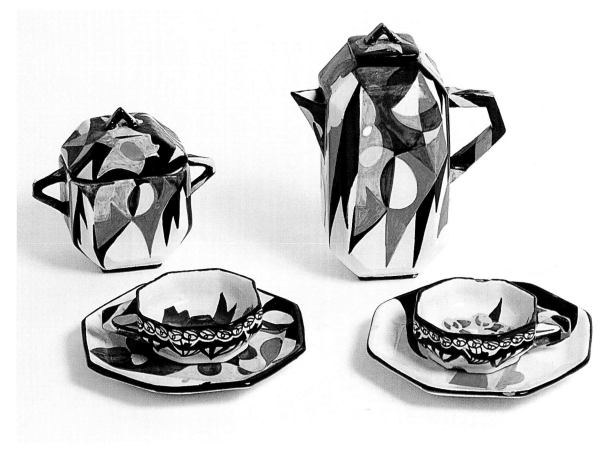

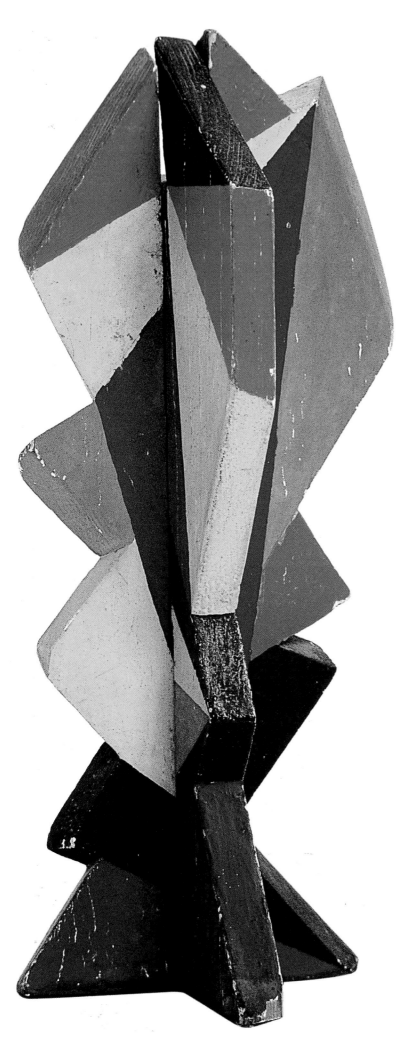

Fortunato Depero |
FUTURIST OBJECT-BOOK WITH SCREW-BOLTS
1927, lithographic print and steel bolts,
24 x 36 cm (9 7/16 x 14 3/16 in).
Private collection.

Fortunato Depero |
OBJECT-BOOK WITH SCREW-BOLTS AND
METAL COVER
1927, special edition, limited
to three copies, chrome-plated
metal cover, thickness 1 mm,
24 x 36 cm (9 7/8 x 14 3/16 in).
Private collection.

Filippo Tommaso Marinetti –
Tullio D'Albisola |
FUTURIST MACHINE-BOOK
1932, lithographic print on tin with
folded-over edge, 23,3 x 23,8 cm
(9 3/16 x 9 3/8 in).
Private collection.

| Giacomo Balla
FUTURIST FLOWER
| 1918, assembled varnished
wood, 30,5 cm (12 in).
Private collection.

"Futurist flowers" that could be assembled and taken apart like real sculptures that a Futurist could take with him when traveling. He created screens that could be dismantled, tapestries that could be turned into two complementary asymmetrical panels, "furniture without nails" built by assemblying and juxtaposing the basics. Even when he did not take apart the structure or the symmetry, leaving the form of the object whole, he would always impose its presence and its materiality through the boundless interaction of signs and colors. By the constantly diversified use of color, Balla could destructure the automatisms of traditional domestic behavior, heighten the perception of the object, provoke surprise, upsetting every single preconceived idea. Ludic randomness, opportunities to spark vital energy, a footloose imagination, the pursuit of a festive, liberated sensuality, in short, an authentic hedonism of everyday life, constantly inspired his work.

The rejuvenation of lifestyles and of everyday space continued in several fields and took various formal directions. Corona, Depero, Rizzo, Prampolini, Angelucci-Cominazzini made tapestries, fabrics, cushions, rugs, presenting the most varied decorative solutions, with effects of symmetry, abstract geometrizations or dynamic stylizations. Ceramics were the object of many experiments, by Dalmonte, Balla, Risso, D'Albisola, Fontana and others, in a style sometimes reminscent of Art Deco. Fillia made pottery with unconventional structures, where spherical, cubical forms, placed in the upper part of the work, were supported by light, dynamic bases, according to mechanical esthetics. The latter would moreover continue to be adopted up to the middle of the next decade.

Its principles could be found in every field of Futurist art. The return to "plastic solidity" in painting coincided, for instance, in freewordist research, with the reconstitution of the book as an object, thus given back to its material compactness according to the model of the machine. In 1927 Depero published an object-book whose pages were held together by two real screw-bolts. Three copies of the book have a chromium-plated cover. Five years later, Marinetti collected his poems in a machine-book, made entirely of tin. D'Albisola followed suit, also creating invitation cards, postcards, posters, poem-paintings, program calendars and leaflets printed on sheets of brass or tin. Thus the Futurists introduced in everyday life materials coinciding with the latest technologies of advertising, consumption and modern sports of speed such as automobile races and airplane expeditions.

Determined to influence contemporary man's living conditions, Futurism would also invest all that had to do with communication and social relations, in particular the new medias of modernism. Advertising art was considered a field for Futurist creativity. Diulgheroff, Farfa, Depero, Balla, Pannaggi, Munari made commercial

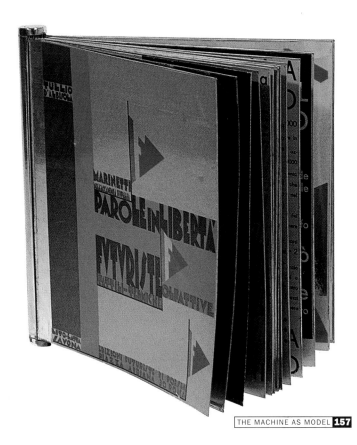

posters, magazine covers, logos, publicity tracts. Marinetti saw in luminous advertising the early stages of an esthetics of the city life of tomorrow. In turn Benedetto and Depero launched manifestos to glorify advertising as an art in its own right. Depero created authentic advertising sculptures; but he excelled especially in compositions with bright-colored flat surfaces. The style of Diulgheroff's posters was more graphic, whereas Farfa's posters revealed a tender, ironic attitude. The series of advertising plates, *Almanach of Speeding Italy* (1930), was probably the Futurist group's most original collective work of this type. Postal communication was also a field where Futurism actively displayed its determination to update the semiotic and esthetic status of every single social practice. The postal institution allowed the Futurists to target the addressee of the esthetic act, thus conferring on their creations a relational, private character. Futurist mail art implied the appropriation of the work, that is, the sensual, individualist and direct enjoyment of the artistic object. Balla renewed, by means of cutouts, the support of the postcard, that became unusual by its dimensions and diversified graphisms, executed

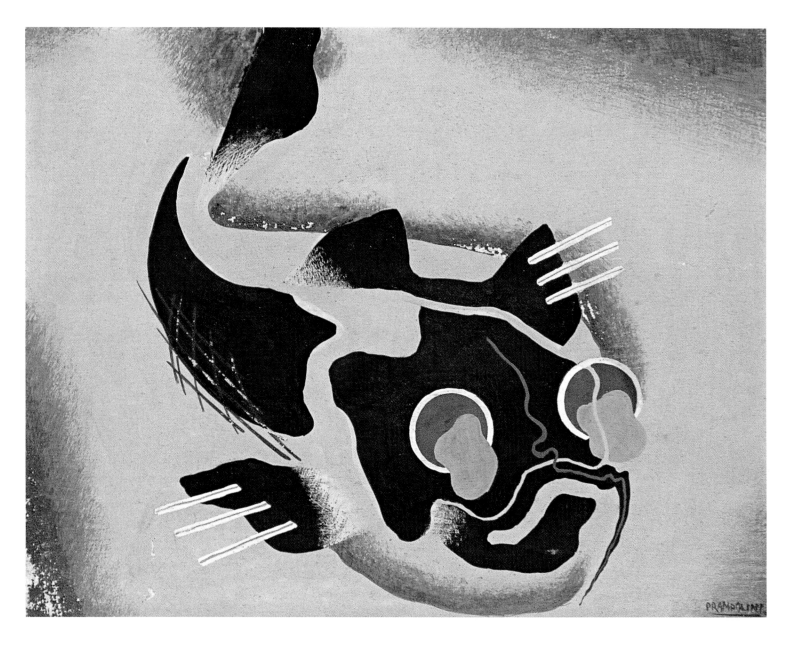

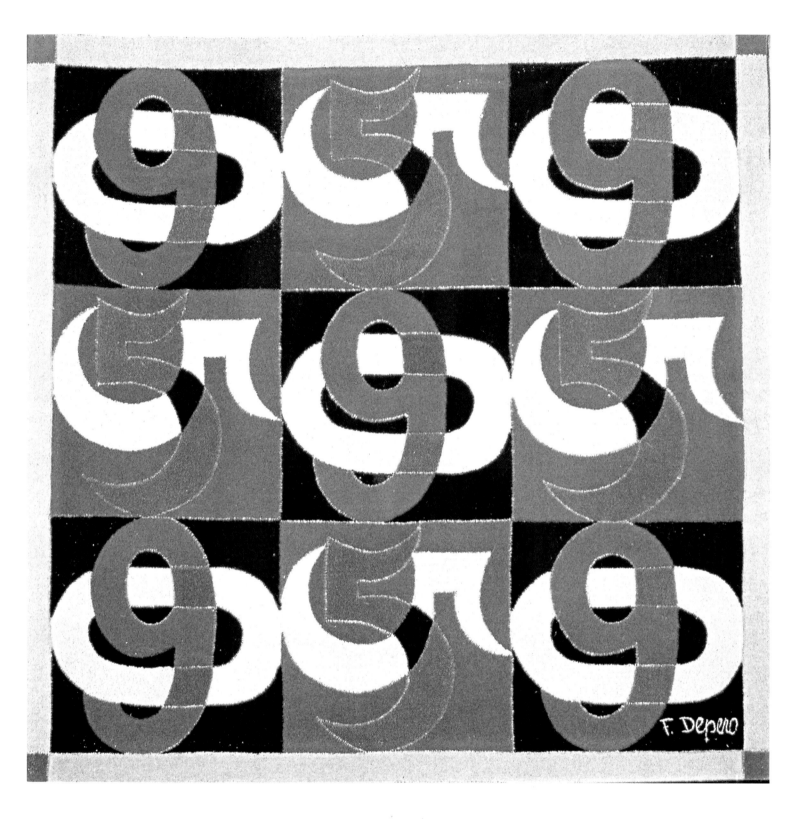

Fortunato Depero |
FIGURES 5590
1925-1926, patchwork tapestry |
of woolen fabrics, 47,5 x 48,5 cm
(18 11/16 x 19 1/16 in).
Private collection.

| Enrico Prampolini
DECORATIVE PANEL
| 1930, oil on
plywood, 33 x 41 cm
(13 x 16 1/8 in).
Private collection.

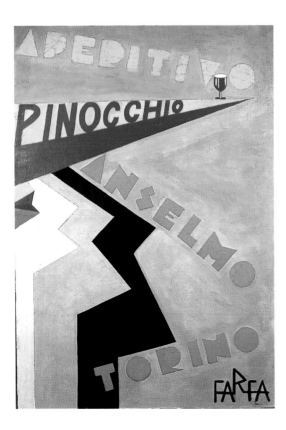

| Farfa
POSTER FOR PINOCCHIO
ANSELMO APÉRITIF
| 1928, oil on canvas,
142 x 98 cm
(55 7/8 x 38 9/16 in).
| Private collection.

Ivo Pannaggi |
POSTER FOR THE BOOK
BY SEBASTIANO LUCIANI
THE ANTITHEATER
1928, lithographic print, |
65 x 50 cm |
(25 9/16 x 19 11/16 in). |
Private collection. |

in watercolor or tempera. Depero and many others constantly did over postcards, envelopes and headed notepaper that they used in the name of Futurism. Pannaggi made collages of various elements, including post-office stickers, to offer an art in which the final signature was the stamping of the postmark. His mail collages, such as the ones he sent to Katherine S. Dreier, played on the multi-plicity of interpretative effects resulting from the interaction between the artist's creation and post office processing. The mail event and the artistic event coincided; the artist was no longer the sole creator, he was the inspirer of the work. Life itself became an essential component of Futurist art, that thus offered a playful reconstruction of the everyday and a perpetual glorification of creative freedom.

Ivo Pannaggi |
MAIL COLLAGE
Addressed October 16, 1926 to
Katherine Dreier, 37,8 x 50,5 cm
(14 7/8 x 19 7/8 in).
Yale University Art Gallery, New Haven.

4

The Myth of Flight, or the Thirties

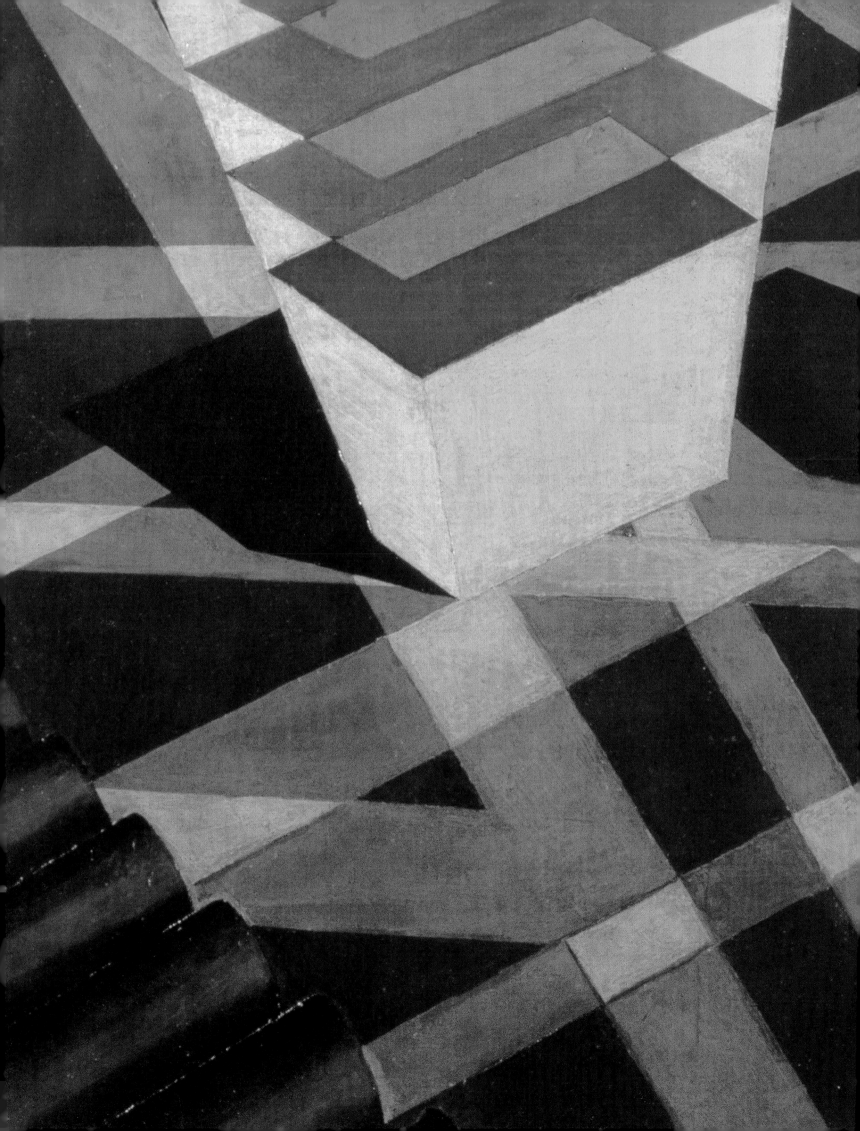

Pages 164-165
Fedele Azari
PERSPECTIVES IN FLIGHT
Detail. 1926, oil
on canvas, 120 x 80 cm
(47 1/4 x 31 1/2 in).
Private collection.

In the thirties, Futurist art became entirely focused on the aerial theme. That new direction may not have been a novelty, but was indeed the assertion of an esthetic turning point. The dream of Icarus the first aviators seemed to have made come true had always been essential to Marinetti's thinking. Thus, in 1909, he had dedicated his play *The Electric Dolls* to Wilbur Wright, the first aviator in history. For Marinetti, "the airplane is the very symbol of Futurism, expressing a total break with the past." Being the most advanced product of technology, it was a concrete metaphor of the Futurist approach. For Marinetti, flight embodied "man's zodiacal development, and "that amazing winged machine that at first runs on the ground, so fast that it can at last break loose and rise in the air, away from every known path and above every obstacle" materialized Futurist man's ideal tension and his very dynamism. The theme of flight made its first appearance in literature with the book *Airplanes* (1909) by Buzzi, while Marinetti ended his novel *Mafarka the Futurist* (1910) on the image of a winged creature rising so as to challenge the sun, according to a Promethean mythology that the Russian Cubo-Futurists were to formulate quite differently. Marinetti actually tried to express in formal terms the sensory and psychic experience of flight. In his collected poems, *The Pope's Monoplane* (1912), he introduced analogical combinations and miniaturization effects meant to render the visual impressions produced by flight. Later, in *Zang Tumb Tumb* (1914), he published a typographical composition that presented simultaneously the emotions and the sensory experiences of a pilot aboard his plane. Thus Icarian man became the new axis mundi. In painting, the attempt to translate into images the aerial experience had also begun in 1914. The Futurists would furthermore treat the theme of flight in various media, such as for instance the opera *Dro The Aviator* (1919) by Pratella, or Azari's manifesto *The Aerial Theater*.

As a matter of fact, the panorama "as the crow flies, belongs to a tradition specific to the Italian visual culture. The cityscape seen from above, observed from a tower or a hill near the city, has been known since Roman times. During the Renaissance, aerial vision was a model of representation reinvented by Leonardo. In literature, it can be found in the famous verses describing the winged horse's flight in Ariosto's *Orlando Furioso*. After the famous view of Venice by Jacopo de'Barberi in 1500, the genre was codified by "catoptic perspective, meaning looking downward from above, that sought to represent virtually, based on topographical charts, the aerial view of the city or the landscape. It was followed by a specific genre of veduta painting, particularly popular throughout the eighteenth century. Later on, the aerial view of the city was revived by the concrete vision of Nadar's. Later on, the aerial view of the city was revived by the concrete vision of Nadar's

| Gerardo Dottori
FLYING OVER THE VILLAGE
| 1930, color pencils and tempera
on cardboard, 48 x 60 cm
(18 7/8 x 23 5/8 in).
Private collection.

Marisa Mori |
THE FLIGHT OF ITALY
1936, oil on wood, 88 x 102 cm |
(34 5/8 x 40 1/4 in).
Private collection. |

"aerostatic photographs." By 1910, posters promoting the first "aviation shows" borrowed those same formal characteristics, showing cities like Paris or Nice in overall views from above.

The Aviator's Eye

It was not until 1914, when, owing to the war, several artists had repeated experiences of flight, that the aviator's vision appeared in painting. Right away, the image sought to be either a mere representation of aerial landscape, or else a formal re-elaboration of the visual experience of flying. Toward the middle of the nineteen-tens, the painting *In Pursuit of a Taube* by C.R.W. Nevinson belonged to the first category, whereas the drawing *Looping-Juvisy Port Aviation* by Delmarle, the canvas *A Swift Flight* by Wyndam Lewis, or still the charcoal *Flying over Reims* by Severini belonged to the second. Certain works by Dottori, Lega, Sironi and Santagata sought to express in dynamic, synthetic terms, the aerial perception of an open space where the perspective was constantly shifting under the pilot's eyes.

When the war ended, Bucci, Édouard García and Baldessari undertook other experiments; but Azari would be the one to paint the first work of "Futurist aeropainting." A professional aviator, in *Perspectives in Flight* (1926), he went back over the visual effects of his aerophotographs, arranging the experimental data in a

synthetic vision. The painting indeed combines the visual and the conceptual: the lights of day and of twilight blend in a schematic spatial arrangement that juxtaposes elements of city and country scenery, architectural fragments and city network layout. The lighted storeys of the buildings are dynamized like a shuffled pack of cards. The elementary geometrization of forms and volumes thus becomes a projection, in a splayed superimposition, of the transversal sections of the buildings. The miniaturization of the city turns architecture into an abstract game. Other paintings, by Crali and Andreoni, combined the airplane and the city in a single view from above, thus making the vertical soaring of urban reality become visible. In 1928, Dottori was inspired by the theme of flying in his large frescoes of the Ostia Hydrobase lounge, prefiguring very directly the creation of Futurist aeropainting. The Futurists' renewed interest in representing flight was due to a particular circumstance. In 1919 Marinetti was appointed a member of the Accademia d'Italia. The purpose was to add a new aura to the founder of Futurism, at the time when the Fascist regime was undertaking a vast industrial restructuring, giving aeronautics a primary role. Six months later, the *Manifesto of Futurist Aeropainting* was published, due to become the reference for nearly all the experiments the Futurists performed throughout the thirties. So it was on the basis of a tacit or negotiated agreement that in the coming years the

Futurist movement was to benefit by the regime's measured approval. The first text on painting Marinetti himself signed, the *Manifesto of Futurist Aeropainting* defined the potentials of an esthetic based on the one hand on the "shifting perspectives of flight," and on the other, on the possibility of transfiguring the "new reality" of aerial vision in the name of an "extraterrestrial plastic spirituality." Working in both those experimental directions, the Futurists' aeropictorial investigations expressed a physical as well as a mental vision of the fact of flight. The first dealt with looking downward, and aimed at directly illustrating the dynamism intrinsic to aerial vision. The second dealt with looking upward, and sought to put into images the psychic experience of the conquest of space, its spiritual, symbolic mythology.

Looking Downward

The aeropainters working on concretely rendering the aerial spectacle began exploring the metamorphoses of the image produced by a shifting observation point. With that purpose, Balla flew over the city of Rome, just as twenty years before he had gone down in the street, with his pencil, to study the transit of automobiles. But he was too old now, and unfortunately was not able to pursue his perceptual experiments. The other Futurists, including Tato, Delle Site, Angelucci-Cominazzini, Crali, Ambrosi, Bruschetti, Mori, Voltolina, Peruzzi, di Bosso, were younger, so it was easier for them to undergo direct flying experiences in order to paint the impressions and sensations provoked by the velocity of flight. It was a highly interesting investigation.

As Marinetti wrote, any experience of earthly speed glues our eye to "the horizontal continuity of the plane over which it moves," while "time and space are shattered by the astounding observation that the Earth is rushing away at high speed under the unmoving airplane." So, aeropainters first introduced highly off-centered visual elements in the static frame of the canvas, as it had been established by the rules of perspective: obliqueness of the line of the horizon, nearly vertical views from above, upside-down landscapes, optical distorsions, etc. Then, in magically enchanted visions, they expressed the dematerialization of the objective appearances of reality: overlayings, unravellings, floating or rarefied forms.

| Mino Delle Site
ALTITUDE
| 1935, oil on canvas,
35 x 45 cm
(13 3/4 x 17 11/16 in).
Private collection.

Alessandro Bruschetti |
THE VORTEX
1932, oil on canvas,
60 x 51 cm
(23 5/8 x 20 1/16 in).
Private collection.

Tullio Crali |
DYING ENGINE
1932, oil on cardboard,
62 x 73 cm
(24 3/8 x 28 3/4 in)
Private collection.

| Fedele Azari
PERSPECTIVES IN FLIGHT
1926, oil on canvas,
120 x 80 cm
(47 1/4 x 31 1/2 in).
Private collection.

In the early days of Futurism the esthetics of speed had led to deny perspective space, that assumes the perfect immobility of the viewer's eye, choosing instead to grasp the urban panorama by referring only to the dynamic elements (crowds, lights, cars) that move through it. On the other hand, the high degree of mobility of aerial vision, as well as its capacity to make time-space appear elastic and reversible, induced the Futurists of the thirties to reformulate the iconography inherited from Renaissance painting, that had above all conceived aerial vision in keeping with the built space of the city. Freed from the most immediate sensations, the eye learned to see all over again. The image rediscovered and assimilated the different techniques of spatial projection.

In Ambrosi's *Flight over Vienna*, a stacking and an interlocking of planes suggest the progression of aerial motion: the rhythm of time prevails over that of space. Crali, in *Diving over the City*, used a zenithal perspective. Located on a level with the aviator's head, the single vanishing point of the composition becomes the core of a centrifugal movement expressing the dizzying dive of the plane in the midst of the city space. By completely toppling over that angle of vision with respect to the traditional horizontal vision, the dimension of time is integrated through a perspective acceleration. With *Dead Leaf Dive over Rome*, Monachesi resorted to a miniaturization of the buildings below, but by juxtaposing the visual data on the plane of the canvas, he created a verti-

cal stacking meant to illustrate the airplane's gradual descent. Thereby, his painting produces the archaic effect of non-perspective space found in medieval representations. In short, for aeropainting, the aerial vision of the city became the object of playful speculation, where the delight of a fresh gaze was enhanced by the mental game of unearthing formal insights that could gauge an ever-expanding space.Perspective had placed at the center of the universe an unmoving man, frozen by his own vision. Aeropainting wanted first and foremost to be the experience of that man's liberation. So the iconographic tradition stemming from the Renaissance was revitalized by

perspective accelerations, anamorphoses, views from above, warped, altered, reduced spaces that materialized the aviator's modern, unfamiliar vision. By conceiving an ordering of the world by means of the aerial vision, perspective "as the crow flies" had shown man's endeavor to discover God's vision.

Modern man found out that gaining height did not clarify the visible, but multiplied it instead. With aeropainting, the world, seen from above, no longer revealed a higher order, but was either ruled by or merged with what went through it: Icarian man. Aeropictorial views thus made the man of speed the only scale of the universe.

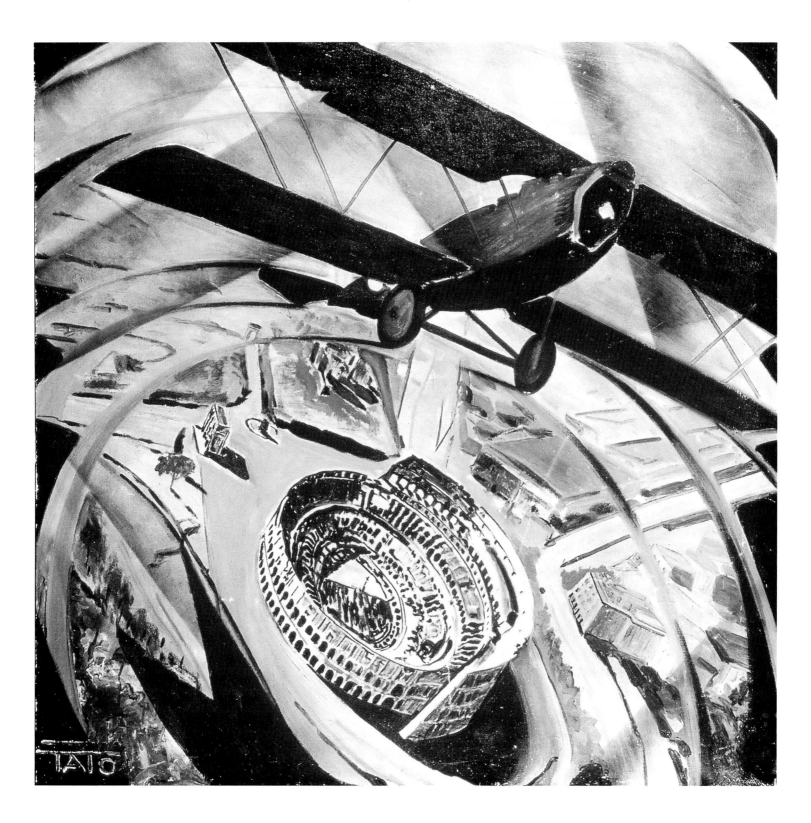

Tato |
SPIRALING OVER THE COLISEUM
1931, oil on wood, 80 x 80 cm |
(31 1/2 x 31 1/2). |
Private collection.

| Tullio Crali
DIVING OVER THE CITY
1939, oil on plywood,
120 x 140 cm
(47 1/4 x 55 1/8 in).
| Private collection.

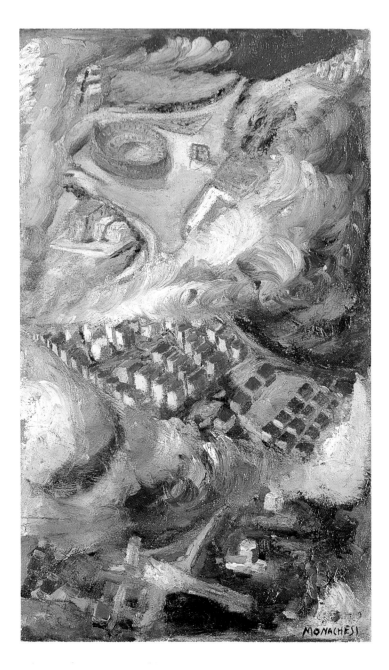

| Sante Monachesi
DEAD LEAF DIVE OVER ROME
| 1940, oil on canvas,
75 x 46 cm
(29 1/2 x 18 1/8 in).
Galleria Comunale d'Arte Moderna,
| Rome.

The setting up of an Icarian point of view was thus explored in different ways, through experiments that went on for years. If sometimes Tato's paintings may appear to feature the visual immediacy typical of posters, that same kind of aeropainting would also, in a more elaborate manner, lead to Di Bosso's kinetic works, that the spectator himself can spin around, thus sharing the kinetic experience of an airplane spiraling down onto an inhabited area. The purpose was to call upon the receiver's playful instinct, since, as Depero repeatedly said, "seen from an airplane, the view of the Earth constantly looks like a toy entirely produced by the plane's cabin." In the most significant works by Dottori, Pozzo, Crali and some others, the three-dimensional masses of the city are swept up into dynamic compositions where oblique planes, asymmetrical diagonals, sharp angles, rotations and curves of space deny the staticity of volumes and their formal coherence. Concurrently with these experiments, Masoero conceived his aerophotographs as mere optical recordings of the movement of the landscape underneath the airplane diving toward the city. It looks like a real cosmic wind is shattering the city buildings,

Filippo Masoero |
FROM THE AIRCRAFT, OVER ROME
1935, aerophotograph,
25 x 28 cm (9 15/16 x 11 in).
Private collection. |

Leandra Angelucci-Cominazzini |
PROPELLORS CELEBRATING
1940, oil on canvas,
54 x 72 cm (21 1/4 x 28 5/16 in).
Private collection. |

dissolving them in a flow of irradiating, whirling, spinning, spiraling motions. Masoero used the camera's instrumental logic to evolve from the impressionism of flight navigation to a sort of photographic action painting. In their denial of any sort of formal analysis, Masoero's aerophotographs naturally became involved in the second expressive hypothesis of aeropainting: the spiritual transfiguration of the sensory experience.

Looking Upward

That other great trend in Futurist aeropainting was prefigured by a pantheist approach to nature, especially in the case of Dottori, who matured spiritual transfigurations of landscape, offering plunging overall views and suggesting the circularity of the cosmos by curving the horizon. He also painted "astral rhythms," a theme he shared with Giannattasio. The turning point occurred in 1930, when Prampolini spoke about "a going beyond the Earth," which meant not just the creation of new plastic sensations, but enriching man with new feelings. In turn Fillia claimed that "the mysteries of a new spirituality" ought to be expressed. The painters of that tendency, to

which Diulgheroff, Oriani, Fillia, Benedetta – Marinetti's wife – and Prampolini belonged, thus sought to build a new symbolic image of the universe through an allegorical language of signs and forms verging on abstraction. This produced an aeropainting with fantastic, even visionary, components that recalled the hidden affinities linking the Futurism of the thirties with the Italian family of Surrealism.

In *The Cloud Diver*, Prampolini introduced the emblematic image of a blueish sphere, the symbol of cosmic reality. Depero hailed the painting right away as one of the leading works of that style. Examining the new signs used on the canvas, he wrote: "Prampolini reached the heart of things thanks to the purity of his synthesis. The action of the forces at play is expressed with a rare penetration and a great economy of means. Without being affected by the pictorial mood of the work (receptive, sweet, nearly evanescent), the overall forms immediately express the very essence of the idea: synthesis of humanity (the window of the man's house) + synthesis of the supernatural (the insuperable bars over the symbol of the universe), absorbed in the outline of a gigantic observation point,

| Fillia
HEAVIER THAN AIR
| 1933-1934, oil on canvas,
| 175 x 150 cm
| (68 7/8 x 59 1/16 in).
Private collection.

Nicolay Diulgheroff |
ATMOSPHERIC SIMULTANEITY
1934, oil on canvas,
73 x 53 cm
(28 3/4 x 20 7/8 in).
Private collection.

| Fillia
**MAN AND WOMAN
IN THE HEAVENS**
| 1930, oil on canvas,
| 100 x 81 cm
| (39 3/8 x 80 7/8 in).
| Musée d'Art moderne, Grenoble.

| Fillia
TERRESTRIAL TRANSCENDENCE
| 1931, oil on canvas,
| 128 x 100 cm
| (50 3/8 x 39 3/8 in).
| Private collection.

Enrico Prampolini |
THE CLOUD DIVER
1930, oil on canvas, |
110 x 98 cm
(43 5/16 x 38 9/16 in). |
Musée d'Art moderne, Grenoble. |

the fear of the unknown and the proud certainty of revelation. The work ought to be named *Psycho-Stratospheric-Diver*. It is entirely unified by the organic simultaneity of a new allegorical language that is the original characteristic of Prampolini's painting." Prampolini's works create a mythology that belongs to the conquest of the universe. The descriptive analysis of sensory data gives way to the imagination, alone capable of taking into account the psychic experience of flight, its "spiritual atmosphere," to use Prampolini's own words. Through a plain, direct idiom, based on a repertory of biomorphic forms, cosmic metaphors, organic elements, symbols and formal analogies such as the sphere, the X-shaped cross, the circle, the ellipse, the spiral, his canvases reflect man's psychic interiority in front of sidereal space.

Fillia, one of the painters of that tendency, continued to be drawn to metaphysical art, with its rarefaction of space and its sense of mystery. His paintings, like *Earthly Overcoming* (1931) and *Heavier than Air*, where red or black spheres appeared, produced an actual mirroring of the globe of the Earth. Oriani in his works created dream images, where dark blue spheres were combined with human-shaped mineral fragments. A surge of mysticism can be discerned in Benedetta. *The Big X* seems to be inspired by the *Manifesto of Futurist Aeropainting*, that spoke of vision "shaped like an X when the airplane dives to the ground, its only base being the intersection of two angles." Yet the total horizon that appears to the aviator's gaze would then be nothing but the most episodic dimension of an aerial vision embracing the four cardinal

Fillia |
AEROPAINTING
1931, oil on canvas,
128 x 100 cm
(50 3/8 x 39 3/8 in).
Private collection.

| Enrico Prampolini
COSMIC MOTHERHOOD
| 1930, oil on canvas,
93 x 120 x 2 cm
(36 5/8 x 47 1/4 x 6/8 in).
Private collection.

points. Marinetti, in one of his typographical composi-tions, had already identified the X with the body, spread-eagled like a cross, of the mother-woman, the symbolic image of the universe. In Benedetta's painting, the same sign was used to organize the simultaneity of opposites within the cosmic order: day and night, heaven and Earth. In that manner, aeropainting constructed count-less archetypal images that turned the journey through space into the return to the bosom of the primordial unity of nature.

Yet the leading protagonist of that symbolical figuration of a rediscovered nature was Prampolini, who wrote: "I can see in aeropainting the means to go beyond the boundaries of plastic reality and to experience the occult forces of cosmic idealism." So for Prampolini aeropaint-ing was an instrument of initiation and knowledge. He would soon associate the theme of the sphere with that of the Great Mother, materializing an ecstasy that would become manifest when "earthly nostalgia was overcome." His painting *Cosmic Motherhood* (1930) suggests that heavenly space may well be the true home of the human being. Thus aeropainting finally connected up with that notion of simultaneity that had always haunted Futurism, as the utopia of the overcoming of all the opposites.

The nineteen-tens' Futurist model of the roaring automo-bile implied the highly concrete experience of the noises, sounds, colors, smells and built forms of the city in motion. The experience of flight, although seemingly more intense and unifying, was actually to lead first of all to a detachment from the concrete world, and then to the mystery of an expanded, disembodied reality that quite shortly, through an authentic spiritualistic sublimation, would blunt all the energetic aggressivity of the most typ-ical formal repertory of Futurism. Spiritualized, but devi-talized in its formal means, aeropainting led to a certain ideological innocuousness, too: the glorification of big industry, now passing through the mythology of aerial flight, suggested at the most the image of the overman (the aviator, the parachutist), rather than encompassing the culture of factory work and thereby reflecting the reality of social conflicts. That is the reason why, whereas Fascism had countered or just barely tolerated mechani-cal art, instead the regime had great consideration for aeropainting, and even presented it abroad (in Greece, France, Turkey, Germany, Russia), up until the mid-thir-ties, as the liveliest expression of Italian modern art.

Benedetta |
THE BIG X
1930, oil on canvas, |
120 x 90 cm
(47 1/4 x 35 1/2 in).
Musée d'Art Moderne
de la Ville de Paris, Paris.

| Fillia
ORGANIZED SIMULTANEITY
| 1930, oil on canvas, 100 x 83 cm
(39 3/8 x 35 7/16 in).
| Private collection.

| Enrico Prampolini
FORMS-FORCES OF SPACE
1932, oil on canvas,
100 x 80 cm
(39 3/8 x 31 1/2 in).
Private collection.

Enrico Prampolini |
THE SPEED-CHARMER
1930, oil on canvas,
87 x 114 cm
(34 1/4 x 44 7/8 in).
Musée d'Art Moderne
de la Ville de Paris, Paris.

Pippo Oriani |
HEAVENS' GATES
1931, oil and collage
on canvas, 50 x 40 cm
(19 11/16 x 15 3/4 in).
Private collection.

Futurist Cuisine

MARINETTI AND THE FUTURISTS
At the opening of the
Santopalato restaurant,
March 8, 1931, in Turin.

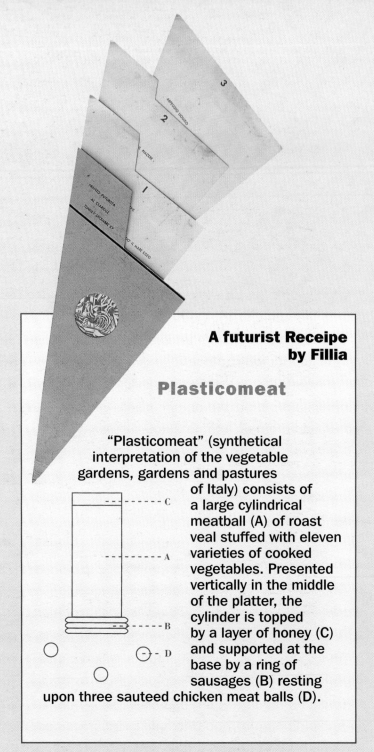

**A futurist Receipe
by Fillia**

Plasticomeat

"Plasticomeat" (synthetical interpretation of the vegetable gardens, gardens and pastures of Italy) consists of a large cylindrical meatball (A) of roast veal stuffed with eleven varieties of cooked vegetables. Presented vertically in the middle of the platter, the cylinder is topped by a layer of honey (C) and supported at the base by a ring of sausages (B) resting upon three sauteed chicken meat balls (D).

FUTURIST MENU
of the banquet given in honor of Marinetti at the Claridge Hotel
in Tunis, December 1st, 1937, lithographic port-folio
with a drawing by Depero, 35 x 17 cm (13 3/4 x 6 11/16 in).
Agnese Collection, Rome.

The very first "Futurist dinner" was organized in Trieste on January 13, 1910. A "Cubist and Futurist dinner" then took place at the *Taverne de Paris* on February 3, 1913. In the month of June of that same year, the French chef Jules Maincave published the tract *Manifesto of Futurist Cuisine*. In it he called for a cuisine suited to the comfort of modern life and the latest scientific conceptions. His notion meant combining foods and liquids traditionally separated, such as rum and pork juice, or using in the dishes all the known scents: rose, violet, lily of the valley… In turn Marinetti launched in 1930 a *Manifesto of Futurist Cuisine*, that suggested a sort of edible art, a forerunner of the American Meat Art in the seventies. Indeed "everyone should have the sensation of eating works of art." A few Futurists, including Fillia, Prampolini, Farfa, participated in that attempt to renovate Italian cooking, meant to counter the primacy of spaghetti and the moral celebration of bread as traditional household food, that Fascism was seeking to impose at the time. It was in 1931 that Marinetti opened in Turin the *Taverna del Santopalato*, a restaurant dedicted to the Holy Palate, which served exclusively Futurist cuisine. Designed by Diulgheroff and Fillia, the room was faced with aluminium from top to bottom. The tableware presented, among other things, aluminium napkins. The dishes they served featured chicken cooked in such a fashion that it was "permeated with the taste of steel-balls," a sausage simmered in very strong coffee and seasoned with eau de cologne, and "tactile aerodishes with noises and smells," whereas the "incitative dishes" were merely shown to the customers with the purpose of stimulating their taste buds. Authentic ephemeral and edible sculptures,

the "plastico-meats" forbade the use of knife and fork so that the consumer, by handling them, could obtain a "prelabial tactile enjoyment." Vaporizers were used to spray perfume on the diners' heads. According to the newspapers, one of the restaurant's first customers, suddenly suffering from terrible stomach pains, had to be taken to the hospital… But that was not to prevent Marinetti from organizing banquets serving Futurist cuisine, the purpose of which was to awaken all the senses in order to heighten man's physiological life. ■

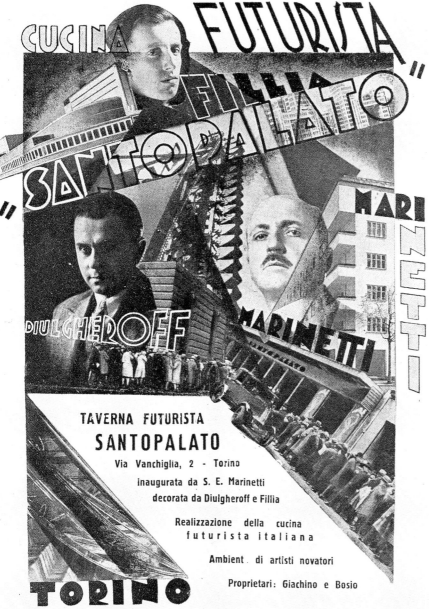

Nicolay Diulgheroff
POSTER FOR FUTURIST CUISINE SANTOPALATO RESTAURANT (HOLY PALATE)
1931, lithographic print, 28 x 21,5 cm (11 x 8 7/16 in).
Private collection.

DIULGHEROFF, MARINETTI AND FILLIA AT THE *SANTOPALATO* RESTAURANT.
March 1931, in Turin.
Private Collection.

The Last Renewal

The artistic theory of aeropainting would also give rise to several special interpretations of its mythical and visionary postulates. Fillia, the leading figure of the Turin Futurist group, intensified his spiritualist investigations, and in 1931 published a *Manifesto of Futurist Sacred Art*. Believing he could compete with some of the Cubists, including Gleizes, he claimed you did not have to be a believer to make art serve God. He painted works in which he combined the themes of the crucifixion, the maternity or the Holy Family, with those of the elevation, physical as well as spiritual, that flight allows. Thus religious subjects and aeropainting came together in the same intent to assert Heaven as a sacred realm and Futurist man as close to the divine. According to Marinetti, Futurism, insofar as it was "the tireless over-coming of art," was the only art that could express "the overcoming of life." Tato, Peruzzi, Caviglioni, Oriani, Thayaht, Pozzo, Dormal, Voltolina and Ambrosi followed that trend, that climaxed with the *Umbrian Futurist Aeropainting Manifesto* Dottori put out in 1941. Indeed he sought a "spiritualization of nature" that aimed at the renewal of the artistic tradition of Umbria, the "land of the mystics" *par excellence*, since, among others, Saint Rita, Saint Benedict, Saint Claire and Saint Francis of Assisi were born there.

Prampolini on the other hand wanted to take aeropainting all the way to its utmost consequences. His paintings would soon recapture the expression of organic energy lying beyond the mere plastic model of the machine. Fluid, continuous lines, as well as "polymaterial collages"

| Gerardo Dottori
BIRD'S EYE LANDSCAPE
| 1938, oil on canvas,
| 38 x 48 cm (14 15/16 x 18 7/8 in).
| Private collection.

Regina |
THE AVIATOR'S MISTRESS
1935, aluminium sheets, |
59,5 x 47,7 x 9 cm |
(23 7/16 x 14 13/16 x 3 1/2 in). |
Private collection. |

| Mino Rosso
SPEED
| 1931, patinated bronze, 41,5 x 44,5 x 18 cm
| (16 5/16 x 17 1/2 x 7 1/16 in).
| Private collection.

Mino Rosso |
THE LADY PIANIST
1932, black lacquered wood
and metal, 76 x 50 x 38 cm
(29 7/8 x 19 11/16 x 14 13/16 in).
Private collection.

enabled him to pursue a direct investigation of the meta-morphoses of matter. For him that quest was tantamount to an exploration of the cosmic mystery: the infinitely large and the infinitely small merge within nature's one and the same life. Achieving abstraction, the painter intended to deny the slightest connection with Surrealism. He preferred to talk about a "bio-plastic esthetic" intent on orchestrating the lyrical, sensory values of organic materials. In fact, that stage of his own research, extending the work of Boccioni's "polymaterial-ist" sculptures, constitutes a sort of historical link between Futurism and informal art.

In the field of aerosculpture, the bronzes by Mino Rosso, whose stylistic approach was somewhere between post-Cubism and Art Deco, illustrated aerobatics. D'Albisola, in his aeroceramic *World* (1929), merely showed the sphere of the terrestrial globe surrounded by two orbits. Among the other sculptors, Di Bosso composed synthe-ses in metal and plexiglass, whose aerodynamic compact-ness was opposed to Regina's works. The latter are light constructions with barely suggested rhythms, made of aluminium, wire, paper, corrugated metal and pins. Instead Peschi, by using untreated wood, played on the contrasts and the symbolical value of matter. He sculpted "aeroportraits of aviators," showing them as so many mythical trees warranting the union of Heaven and Earth within the cosmic all.

The concept of aeropainting gave rise to other theoretic writings, including the *Manifesto of Aeropoetry* (1931), published by Marinetti, or the *Futurist Manifesto of Aerial Architecture* (1934) by Mazzoni and Somenzi, that, inspired by a great utopian impulse, foresaw "the single city of continuous lines, built to be admired in flight." Aeroarchitecture led Crali to conceive a *Planetary Station;* but by adopting a more pragmatic attitude and following a far less rigorous artistic conception, several Futurist architects as De Giorgio and Mazzoni were able to exe-cute their city planning designs inside the cities the Fascist regime was building. Furthermore, the theme of the conquest of aerial space inspired Benedetta's "cosmic novels" or Masnata's freewordist compositions. On the other hand, the composer Giuntini called for an aeromu-sic that could sing "the harmonies of the spheres, the vol-canoes of the sun, the highly dynamic life of the planets."

| Renato Di Bosso
FREE-FALLING PARACHUTIST
1935, painted wood
sculpture, 162 cm
(63 3/4 in).
Private collection.

Tato |
**THE MERRY WIDOW,
DISTORTION**
1930, photomontage,
23,8 x 17,9 cm
(9 3/8 x 11 in).
Private collection.

| Enrico Prampolini
INTERVIEW WITH MATTER
| 1930, plurimaterial composition
on cardboard, 43,3 x 61,1 cm
(17 1/16 x 24 1/16 in).
Private collection.

Arturo Ciacelli |
PLASTIC MURAL
OF THE BÒGIA-BÒGIA CLUB
(LIGURIA-STADIUM, TURIN)
1935, inclusive and continuous
arrangement of space with
frescoes, aeropainting,
plurimaterial compositions of
metal and varnished wood
reliefs. Work destroyed.
Original photograph, private collection.

Prampolini created the Futurist aerodance, that Wy Magito interpreted with a rope tied around her body, symbolizing the earthly condition as well as of the Icarian dream that has ever haunted man. Wearing a helmet and metal overalls that made her look like an astronaut, Giannina Censi carried these experiments even further, making aerodance produce the "mimoplastic" expression of aerial flight.

Those new directions were accompanied by discussions abounding with texts and manifestos. In 1933 Marinetti and Masnata launched the *Manifesto of Futurist Radiart* that called for an esthetic renewal of the radio, an intrinsically modern medium. Marinetti created the first editings of noises, composing what later on would be called "concrete music." Futurism availed especially of an esthetics of microforms, so as to counter the monumentalization of art and culture that Fascism was producing. Thus, in 1934, on the occasion of the launching of his *Futurist Manifesto of Aeromusic*, at the *Galleria delle Tre Arti* in Milan Giuntini performed a piano concert of his "musical syntheses," none of which lasted over twenty seconds. At the same time the gallery exhibited Munari's first "useless machines," that preceded Calder's mobiles. In photography, an authentic inclination for the imaginary was asserted, with Tato, Pirrone, Demanins, Gloria, Thayaht, Parisio, Gramaglia and Castagneri, among others, who explored new techniques, such as photomontage by double exposures, dramatization of objects, photoplastic assemblages, cutouts. In the realm of motion pictures, the greatest achievements were two feature films: *Speed* and *Fair of Types*. The first, still marked by mechanical esthetics and the abstractions of "object dramas," was shot in 1930 in Turin by Oriani, Cordero and Martina. The second, that Viola made in 1934 in Padua, drew its inspiration from René Clair, multiplying references to slapstick movies as well as to the avant-garde motion picture tradition.

Against the "Return to Order"

While the twenties had been the years in which the Futurist movement had been pushed to the sidelines, the thirties brought about a series of more complex relationships between the Futurist movement and the Fascist regime, ranging from actual complicity to the most virulent rejection. During those years, Marinetti strived first and foremost to defend the acquisitions and the spirit of avant-garde art against the return to order that was threatening Italy and the rest of Europe. In January 1930, he held a lecture in Paris "Against Camille Mauclair," the latter having heightened his reactionary stand against "wop art", representative of the avant-garde. On that occasion Marinetti defended Futurism as ardently as Surrealism or Cubism. In October of the same year, the Futurist group started a controversy with Waldemar

George, whose *Calls from Italy* aimed at defending Classicism and the "moral content" of Italian official art. In 1933, the program of a series of major public works the Fascist regime had undertaken gave scope to the rivalry between the Futurists and the artists calling for the return to order. The latter, in a *Manifesto of Mural Painting*, proclaimed the necessity to paint huge frescoes illustrating the history of Italy and the Fascist ideology. The Futurists responded to that attempt to return to the ancient Italian tradition of the fresco by launching a new and ultra modern "Plastic Mural Art," that a manifesto and several exhibitions would illustrate. Marinetti defined it as being "the art of combining, dramatizing or harmonizing, inside the superb, geometric new architectures of Fascism, metals, woods, leathers, fabrics, crystals, electricity, neon, etc., so that the regenerated groups or individuals can absorb a patriotic, dynamic optimism, devoid of nostalgia and decadent depression." Among others, Prampolini, Depero, Benedetta, Tato and Ambrosi won fame with such works, making stained-glass windows and polymaterial compositions using the most up-to-date techniques. Ciacelli introduced the same principle in the decorative arts by creating, in 1935, an aeropictorial environment with metal reliefs for the Bôgia-Bôgia Club at the Liguria-Stadium of Turin. Once again, it was not so much the political framework that appeared determining, since Futurism shared its submission to Fascism with the other trends of Italian art of that time, as the fact of embodying a modernism on a European scale. The works by Prampolini, Rosso and Depero are actually the Italian counterpart of those by Arp, Zadkine and Léger, as the expression of the new international culture.

Over the course of years, the political and ideological atmosphere had grown increasingly oppressive. An exhibition of aeropainting Vasari presented in Berlin, in March 1934, provoked the retorts of Nazi circles, who called the Italian artists "the Bolsheviks of art." On that occasion, the Dadaist Schwitters was determined to pay tribute "to Marinetti the revolutionary." In September of the same year, Prampolini would be the one to take a stand against the condemnations of avant-garde art Hitler had just pronounced in Germany. The attacks against the Futurist movement, coming from the most reactionary wing of Fascism, reached a climax in the second half of the thirties. Their target was just as much Futurism as the other modern trends of Italian art, such as Rationalism and Abstraction, that a relative cultural liberalization the Fascist regime had enacted had allowed to flourish. By 1936, the newspaper *Il Perseo* launched a campaign against the "degenerate art" of Futurism. In 1937, other newspapers relayed those attacks, at a time when the

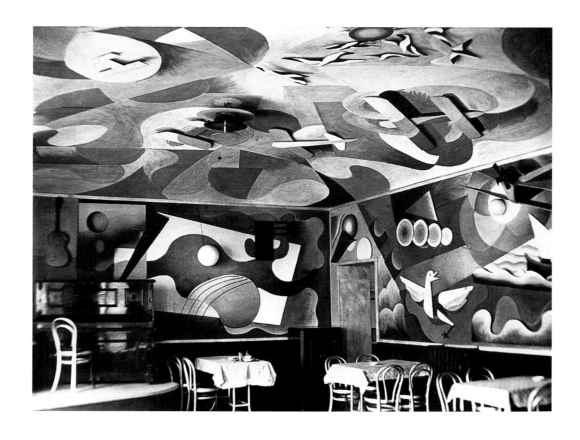

FILIPPO TOMMASO MARINETTI
1934, Rome.

Futurist Aniante undertook a survey on "Hitler and art" in the paper *Il Merlo*, published in Paris. Several Futurists, including Marinetti himself, took part in it so as to retort to Hitler's comments on "the degenerate art" of the avant-gardes. The next year, Marinetti was forced to reply to new, violent accusations, that dubbed Futurism "a Bolshevik and Jewish art." In an increasingly tense atmosphere, he published several writings and organized important manifestations to invigorate his troops and defend the entire Italian avant-garde. Yet in December 1938, the Futurist magazine *Artecrazia* was seized and was no longer allowed to appear. Marinetti's determination to save Futurism and the avant-garde spirit could but force admiration, even on behalf of those artists who no longer believed that Futurism was an expression of Italian artistic modernism. The day after a stormy discussion Marinetti had held in a Roman theater, the abstract painter Licini wrote to Sartoris: "Marinetti, on the evening of December 3rd in Rome, was truly great! Just like the glorious days of heroic Futurism, before the war! Always the first, always ready to assail anything that threatens Italian intelligence, to commit himself and bear the brunt, if necessary! Long live Marinetti!" Those virulent battles of the old lion were the last noteworthy episodes of an avant-garde that was no longer able to get a grip on the realities of the time.

Meanwhile, Futurists were swarming over the peninsula. A new group of poets began to follow Marinetti. The countless group shows set up by the young neophytes formed the strongest bond of the movement. The *Prima Mostra Nazionale Futurista*, held in Rome in 1933, gathered over a hundred artists. Furthermore the Futurists took part in the big exhibitions organized by the Venice Biennale, the Milan Triennale, the Rome Quadriennale.

But the fact of having chosen to back the Fascist regime, in exchange for a bit of freedom for Futurism, was to lead Marinetti to ever-greater compromises with the Duce's policies. At the same time, he did not fail to take advantage of his friendship with Mussolini to obtain the liberation of political prisoners or to help intellectuals opposed to the regime leave the country. It was precisely abroad, in the very circles of the avant-garde, that Marinetti would be able to measure how unpopular his choice had been. During a lecture he held in Brussels in 1931, he was heckled by some anti-Fascists, despite the support the poet Pierre Bourgeois gave him on that occasion. Four years later, in Paris, where Aragon had openly condemned certain Futurists' official embracing of Fascism, Marinetti had to put up with being booed by Italian political emigrants. Yet Fernand Léger did not hesitate to pay tribute to him during a lecture, where he claimed: "Without Marinetti, we would be submerged by an unbearable pre-Raphaelitism and Michel-Angelism."

Besides, suffering attacks from the Fascist regime, Marinetti had to prove his loyalty to Mussolini. Thus, he continued glorifying the colonial wars of Fascism. When he published in 1935, on the occasion of the Ethiopian war, the pamphlet *Futurist Esthetics of War*, Walter Benjamin replied right away with an essay that has since become famous, *The Work of Art in the Age of Mechanical Reproduction*. But Benjamin was condemning the Marinetti who had become the spokesman of Fascism, rather than Italian Futurism, since the German philosopher appreciated and defended the work of Pannaggi, who was living in Berlin at the time and shared his political ideas.

Yet during those years, Futurism was no longer able to play a revolutionary role in Italian society and culture. Countless manifestos followed one upon another, but they merely went on repeating the first principles of Futurism or suggesting ideas that verged on nonsense. The craziest example was that of aerial architecture conceived by Farfa along openly post-Dadaist lines. Several other manifestos of the times, such as the *Manifesto of the Student Spirit* (1932) by Burrasca, or *Imaginative and Qualitative Futurist Mathematics* (1941) by Marinetti, had an odd quirk, humorous and surreal. The oppressive atmosphere Fascism had created encouraged self-caricature among all those who, Marinetti first of all, stubbornly kept to a sheerly verbal form of radicalism that, detached from reality, was asserted only as an alternative to silence. In other instances, these declarations of artistic theories simply masked a recovery of the great traditional forms or a moderate experimentalism.

That constant redefinition of art the Futurists still indulged in has several explanations. In the beginning, it was an attitude that aimed at replacing the creation of the work by the theoretic gesture, thus flaunting the very philosophy of the future in terms of utopia and desire, project and fantasy.

Under Mussolini, and while the Fascization of Italian society was under way, that permanent forward impulse actually became a synonym of creative impotency or impossibility. From then on, the theoretic gesture was enough in itself, the Futurism of the late thirties hardly producing any more paintings or poems, but practically only manifestos. That perpetual mapping out of possibilities, in an Italy subjected to Fascism, immersed Futurism in a sort of pure virtuality, where it pursued a phantasmagorical projection practiced as an end in itself. In other words, forced to act in a world that was more virtual than imaginary, the last Futurists used the theoretic act as a means to escape reality, in an attitude that resembles that of our Net surfers of today. It was Marinetti's death, in 1944, that would bring about the actual dissolution of the Futurist movement.

The Futurist Legacy

A short while before his death, Marinetti persuaded the Italian State to accept the idea of a museum of Futurism in Rome, that would assemble the most important works of the movement. But right after World War II the new Republican State declared Mussolini's commitments null and void. Furthermore, Italian culture undertook to actually obliterate the memory of the years of the Fascist dictatorship, and Futurism, appearing to be historically compromised along with Mussolini's regime, could but sink into oblivion. Toward the middle of the fifties, Benedetta, Marinetti's widow, proposed to the Italian government, at a token price, to purchase her collection of masterpieces by Boccioni. Her offer was rejected. Thus a great number of Futurist paintings and sculptures left the country or went to private collections. Benedetta also got in touch with the last Futurists and organized a private meeting in Milan, opening the discussion on the opportunity of relaunching the movement. Farfa, Crali, Buzzi, Depero, among others, were in favor of resuming the activities of the group. Yet the project never came to anything, because nobody could replace Marinetti in his role as leader and cultural agitator. So Futurism ceased to exist. But what died then was but the official aspect of the "Futurist movement," in other words its operational structure and its name, too compromised by its connection with Fascism.

Indeed, in spite of the *de facto* dissolution of the movement, several Futurists went on with their experiments, playing a relevant role on the Italian post-war artistic scene. Prampolini pursued his work on the organic metamorphoses of matter, gravitating toward post-Surrealist Informal Art. Crali brought aeropainting back to life in intensely lyrical canvases. He put out the manifesto *Orbital Art*, demanding new creations on a cosmic scale. Munari was one of the founders of M.A.C. (Concrete Art Movement), whereas Balla got involved in the program of the group Forma 1, calling for a return to abstract art. Tullier took part in Spatialism and Nuclear Art, the two movements that best reflect Italian art in the fifties.

And Futurism also appears to be an important reference for artists of the new generation taking over the avant-garde. Fontana wrote: "Every day I am more convinced of Boccioni's genius. He is the great initiator of modern art, the true forerunner of spatial artists." Fontana used neon to create ectoplasmic arabesques representing trajectories of energy recalling Futurist lines of force. His *Spatial Concepts* achieve the immaterialization of art Boccioni had dreamed of. Pinot Gallizio was thinking of Futurism when he made his "industrial painting." A friend of the Futurist Farfa, he introduced him to Asger Jorn, an artist of the Cobra group. So, having discovered Marinetti's theories, Asger Jorn immediately claimed Futurism was a boundless source of ideas for contemporary artists.

Other avant-garde trends in the fifties would benefit by the paths Futurism had opened up, in particular the ones that, from Japanese Gutai to American Action Painting, sought to express energy by bringing the body into play, according to a pictorial practice using the concreteness of matter. Kinetic Art enlarged the conception of a direct involvement of art in the realm of technology. Thus Futurist esthetics appeared in the electromechanical performances by Nicolas Schöffer, while Jean Tinguely, to launch his avant-garde tracts, drew his inspiration from Marinetti's style. His "metamechanical sculptures" natu-

rally recapture the playful dimension of Depero's "plastic complexes." The creation of works containing real or virtual kinetism, equally sought by the group Zero in Germany or l'Arte Programmata in Italy, several years later would produce Optical Art.

Thus the Futurist legacy was perpetuated, uninterruptedly, by artists themselves. That situation was already largely under way when Italian art historians, urged by Pierre Francastel, began studying Futurist art and theories. At the time, the Futurist manifestos were republished, bringing about, in the early sixties, an authentic international rediscovery of Marinetti's avant-garde. In 1961 Jim Dine created the polyptych *Four Fountains for Balla*, a tribute to the Italian artist. Three years later, he made works developing the theme of walking and of speed, freely inspired by Balla and Boccioni. At the same time, Mario Schifano produced a series of paintings called *Futurism Revisited*, where he transposed in color the famous picture of the Futurist group photographed in Paris in February 1912. Errò, a "narrative figuration" artist, in turn paid tribute to Futurism in his canvas *The Futurists* (1964). His works followed the Futurist esthetics by the telescoping of forms and the dynamic juxtaposition of several times and spaces. The fondness for the image multiplied or fragmented by kinetic rhythms was asserted by many artists, including the American Ernest Trova or the Belgian Pol Bury, as well as the French Cueco, Moretti, Rouan. Boccioni's vitalistic expressionism can be seen in Bacon's "disfigured" faces, the overdone figuration present in Kitaj, Auerbach and Velickovic, or else, with a different approach, in Bertini's Mec Art.

Toward the middle of the sixties, a singular event was to display the vitality of Futurist ideas. The Italo-American Leo Castelli, who had discovered Futurism in his youthful university days in Milan, imposed Pop Art at the Venice Biennale, appropriating Marinetti's own precepts: the true parameters of art are contemporary life as it happens in the modern city, so Pop Art must take into account the most immediate realities of the "American Way of Life." At the same time, the Poesia Visiva movement resumed Marinetti's activism, organizing street actions, performances and contestation demonstrations. Its founders, including Pignotti and Miccini, composed "visual poems" inspired by Futurism's freewordist collages. Sound poetry and phonetic poetry, that favored the human voice as expressive support, or else the Fluxus movement, that urged art to return to life, in turn would refer to the historical experiments the Futurists had performed.

It was the very myth of "live art" that Futurism had inscribed in the history of modern art. Everything that has to do with happenings or performances, that is, the gesture or the action of the artist who refuses to conceive his role in terms of museums, belongs to the Futurist legacy. Actually, the term "performance" was used for the very first time, in the field of art, in 1914, in Naples, to describe one of Marinetti's and Cangiullo's "Futurist *soirées*." So art took over the forces in actuality of the most immediate present, the artist committing himself with all his being to the becoming of society and history. The heightening of the perishable nature of art Marinetti had called for disclosed its deepest meaning: its immanence to life. Henceforth the museum was no longer the absolute of art. The aspirations of Futurism thus found

| Mario Merz
TONDO
| 1975, stretched canvas,
metal circle, neon and acrylic,
diameter 244 cm (135 7/16).
| Galerie Beaubourg, Vence.

new formulations in the "pure creativity" of Lettrism, or in "the radical transformation of everyday life" demanded by Situationism.

In the next decade the artists of Arte Povera, with Zorio, Kounellis, Boetti and Merz, worked on energy, holding it to be the initiator of form. Their investigations followed up Futurist issues. Fabro was inspired by Farfa to stage the geographic image of Italy, while Kounellis established Boccioni as his "moral master," claiming: "More than any other artist, Boccioni represents the longing for renewal and the determination to confront a History. Without demeaning himself." As for Merz, he referred directly to Boccioni's works in his *Tondo* (1975). On a round canvas stretched as tight as a drum, he sketched a green leg repeated four times so as to retrace the walking man's rhythm. A neon light crossing the canvas transcribes in an elongated, rising, luminous line, both the energy and the speed of the movement. Alighiero Boetti made the drawing *Thinking about Balla* (1979) and resumed, with series of letters, the embroideries Depero had created by composing series of numbers. Other artists directly borrowed iconographies. Likewise, Roy Lichtenstein, in his painting *The Red Horseman* (1974), revisited Carrà's painting with the same title. The American Pop artist raised the

Futurist painting to an icon: his quotation suppressed the color gradation, enlarged the format and incorporated the ensemble of his forms in the background of the image.

A new presence of Futurism asserted itself again in the middle of the eighties, in Italy as well as abroad. Within the Trans-avant-garde, Boccioni's triptych *States of Mind-Farewells* inspired Paladino's triptych *The ones who leave and the ones who remain* (1983-1984). In Milan the group *Nuovo Futurismo* was formed, gathering the artists Lodola, Postal, Palmieri, Bonfiglio, who played upon an ironic misappropriation of mass-media images. The artistic gestures combine in a single playful act art and life, exchanging their roles according to a very Marinettian approach. The American Ted Rosenthal made bright-colored assemblages of cutout pieces of metal that he dedicated to Marinetti. In the United States, this revival of interest for Futurism was expressed also by a reflection on the role of machines in modern society. In California, the Survival Research Laboratories, whose director is Mark Pauline, retrieve technological equipment from the NASA to organize battles between machines controlled from afar by radio-radar.

The contribution of Futurism pertains both to the plastic sphere and to the intellectual sphere. In the first case, Futurist theories revealed to modern art a direction for research that is one of the dynamism, the kinetic rhythm and the transcribing of energy. In the intellectual realm, Futurist established permanently the behavior and the sociological background of the avant-garde artist, calling for the refusal of museums, the manifesto as an ideological act, the emphasis on the ephemeral nature of art and its involvement in society.

The posterity of Futurism can be seen in other fields as well. In music, John Cage claimed that Russolo's manifesto *The Art of Noises*, by the wealth of its suggestions, had been for him, since the thirties, "highly encouraging." The followers of concrete music, including Pierrre Schaeffer, saw in Russolo the pioneer of their investigations. Pierre Henry paid him a direct tribute with *Futuristie* (1973). The Englishman Trevor Horn, who founded the group The Art of Noise, or the Frenchmen Nicolas Frize, Jean Voguet and Jean-Marc Vicenza availed themselves of an ideal legacy of Futurist Noisism. In photography, the Bragaglia brothers' research have nurtured countless avant-garde experiments: from the American Gjon Mili's "kinetizations" to the Pole Victor Skrebneski's "spectralizations." Depero's photoperformances can be found in Rudolf Reiner's self-portraits. Carmelo Bene, the apostle of a theater of voice and the primacy of the actor, referred to Marinetti. In architecture, Sant'Elia's visionary images continue to exert their fascination, while Richard Gehry was inspired by Boccioni's sculptures to build the Guggenheim Museum in Bilbao.

Errò |
THE FUTURISTS
1964, oil on canvas,
139 x 74 cm
(54 11/16 x 29 1/8 in)
Musée d'Art Moderne
de la Ville de Paris, Paris.

| Paco Rabanne
METAL MINI-DRESS
| 1968.

Musée de la Mode
et du Textile, U.F.A.C.
Collection, Paris.

cles with deviated forms. Last, in the graphic arts, around the middle of the eighties, the draftsman and poster artist Mattotti re-elaborated the style of aeropainting in particularly flowing, bright-colored drawings. His characters garbed in Futurist costumes travel through cities deformed by the speed of the winds. His work turned Futurist painting into a popular art.

The rediscovery of Futurism was begun by those artists who, identifying with its creative impulse, consecrated the validity of its theories and esthetic principles. The historians grudgingly followed suit, thus showing their reservations regarding Marinetti's political commitment along with that of some of his followers. Then Futurism provoked a passionate debate, essentially based on ideological condemnations. Yet, according to the philosopher Benedetto Croce, the task of history should leave passions aside: "An event that appears entirely negative – or a period seen as being only decadent – is just a non-historical event, that is, one that has not yet been elaborated by history, that has not yet been grasped by thought, thus remaining prey to emotions and to the imagination." Presently Futurism is a historiographical subject that can be studied, from every point of view, with utter serenity. Marinetti, by aligning with Fascism his project for a cultural, artistic and political *Risorgimento* of Italy, made a grave mistake. His political ideology evidences that perversion of patriotic ideals that can be found in several other Italian intellectuals of his time. Nationalism and bellicism were not Marinetti's invention. They were the principal components of an ideological erring that led to the historical ruination of all of Italy. On the other hand, we can only observe that the other side of Marinetti's Futurism, meaning his project to rid Italy of "the rust of centuries" so as to to give it back to the future, has been validated by history.

Indeed, in the cultural and artistic realm, Futurism embodies the turning point of the idea of nation and modernism in the history of Italy. The Hellenism of the Renaissance had made Italy the land that preserved the myth of the lost golden age. Between the eighteenth and the nineteenth centuries, painters and writers, philosophers and poets had considered Italy as an outdoor museum, the land where you might possibly travel into the past. The aristocrats of the Grand Tour sought out there the awareness of origins. The Romantics, drawn to the natural beauties and archeological ruins, journeyed there to have an experience of the picturesque, of the classical and the sublime. As for the Italians, they could only conceive their identity in terms of nostalgia: being Italian meant first and foremost the evocation of a vanished greatness. Experienced through the fascination of that unique and glorious past, the Italian identity remained an intellectual notion, fostered by the cultural and political élites of the country, that most of the time overloaded it

In the field of fashion, in the middle of the sixties Courrèges launched "cosmonaut dresses" with geometric lines, where the white dominant tone was highlighted by light blue to suggest the purity of aerial space. Paco Rabanne revived Futurism's program of "mechanical fashion," making garments in metal, plastic, rhodoid, cut out and assembled sheet metal, or even dresses made of sheets of tin and woven with metal threads. Last, in the name of "fast life," he suggested changing clothes several times a day. Versace created "masculine suits" for women, with Futurist-style graphic forms, as well as a crystal coat of mail, with thousands of luminous dots, creating an intense sensation of luminous mobility. Gianfranco Ferré invented, "as a tribute to Boccioni," a Futurist dress with geometric patterns of coral red triangles.

In furniture design, Depero's inventions served as a fundamental historical antecedent for the "iconic-trend" creations by Mendini, Sotsass, and the Memphis and Studio Alchymia groups. Their elegant forms sought to "produce an image," thereby composing real middle-class interior designs. The Futurist artistic theory of dynamism and energy was the implicit reference for Gaetano Pesce's arti-

with a rhetorical, bombastic style. So Futurism was the first identifying project of a modern Italian culture.

Marinetti urged Italians to turn their backs on that so-cumbersome past, in order to build an affirmative, modern image of the real Italy. He wanted to popularize the myth of a united country, turned toward the future, capable of being determined on the basis of its historical present, and not of its plurisecular past. That mad wager Marinetti made at the dawn of the twentieth century, his dream of giving birth to an Italian artistic, cultural modernism, a dream to which he devoted his energy and his personal fortune, finally came true.

Whereas the Macchiaioli and the Divisionists belonged to movements that remained on a regional scale, Futurism spread over the entire peninsula. It was the first modern artistic expression of reunified Italy on a national scale. That is how Marinetti launched the idea of Italy into the future, making a very old country become a nation established within European modernism. Futurist Italy is a concrete reality, that the art historian can

approach, just like Renaissance and Baroque Italy, through its regional differences.

Today, the role Marinetti played in the history of Italian culture appears to have been more and more decisive. Ridding Italy of the weight of its past, Futurism rid the Italian artist of his complex of being nothing but the heir of a tradition in ruins. The distance he thus established between modern times and the museum has allowed the contemporary artist to reappropriate the prestigious works of the Italian past with impertinence and lightness. It is precisely that possibility of joining present and past, of creating the disenchanted telescoping between modern and ancient, that has led modern Italian art to elaborate those successful images of elegance in fashion and in design. A multiform phenomenon endowed with great creative vitality, Futurism has returned to its place in the history of modernism, and beyond that constitutes a source of ideas, projects and operational models for the coming creation. It was and remains the archetype of every avant-garde.

Roy Lichtenstein |
THE RED HORSEMAN
1974, oil and magna on canvas, 213,5 x 284,5 cm (123 7/16 x 151 3/8 in).
Museum Modern Kunst, Vienna.

Bibliography

FORERUNNERS

Guido Ballo, *Preistoria del futurismo*, Edizioni Maestri, Milan, 1960.

Giovanni Lista, *Loïe Fuller, danseuse de la Belle Époque*, Éditions d'art Somogy-Stock, 1994.

Medardo Rosso, *La Sculpture impressionniste*, Éditions L'Échoppe, Paris, 1994.

Giovanni Lista, *Medardo Rosso, destin d'un sculpteur*, Éditions L'Échoppe, Paris, 1994.

HISTORICO-CRITICAL ANALYSIS

Rosa Trillo Clough, *Looking back at Futurism*, Cocce Press, New York, 1942.

Raffaele Carrieri, *Il Futurismo*, Edizioni del Milione, Milan, 1961.

Christa Baumgarth, *Geschishte des Futurismus*, Rowohlt, Hambourg, 1966.

Maurizio Calvesi, *Il Futurismo*, 3 volumes, Edizioni Fabbri, Milan, 1967.

Marianne W. Martin, *Futurist Art and Theory*, Clarendon Press, Oxford, 1968.

Marianne W. Martin, *Futurist Art and Theory*, Clarendon Press, Oxford, 1968.

Jane Rye, *Futurism*, Studio Vista Dutton Pictureback, London, 1972.

Dusan Konecny, *Futurismus-ismy*, Vytisklo Rudé Pràvo, Prague, 1974.

Giovanni Lista, *Le Futurisme*, Éditions Hazan, Paris, 1985.

Ryuichi Sakamoto - Shuhei Hosokawa, *Futurismo 2009*, Minamikarasuyama Seragaya, Tokyo, 1986.

Giovanni Lista, *Les Futuristes*, Éditions Henri Veyrier, Paris, 1988.

Enrico Crispolti, *Il Mito della macchina e altri temi del futurismo*, Edizioni Celebes, Trapani, 1971.

Anna Maria Damigella, *Futurismo (1909-1918)*, Lithos Editrice, Rome, 1997.

Giovanni Lista, *L'Avant-garde futuriste*, Éditions L'Amateur, Paris, 2000.

Giovanni Lista, *Le Futurisme: création et avant-garde*, Editions L'Amateur, Paris, 2000.

DOCUMENTARY SOURCES

Archivi del futurismo, (edited by Maria Drudi Gambillo and Teresa Fiori), 2 volumes, Edizioni De Luca, Rome, 1959.

Futurismo & Futurismi, (curated by Pontus Hulten), Gruppo Editoriale Fabbri, 1986, Milan.

FOUNDERS OF THE MOVEMENT

Maria Zanovello, *Luigi Russolo, l'uomo, l'artista*, Edizioni Corticelli, Milan, 1958.

Lionello Venturi, *Gino Severini*, Edizioni De Luca, Rome, 1961.

Guido Ballo, *Boccioni*, Edizioni Il Saggiatore, Milan, 1964.

Guglielmo Pacchioni, *Carrà*, (catalogue of the work), Edizioni L'Annunciata, Milan, 1967.

Filippo Tommaso Marinetti, *Teoria e invenzione futurista*, (edited by Luciano De Maria), Edizioni Mondadori, Milan, 1968.

Giovanni Lista, *Marinetti*, Éditions Seghers, Paris, 1976.

Bruno Passamani, *Fortunato Depero*, Musei Civici, Rovereto, 1981.

Giovanni Lista, *Balla*, (catalogue of the work), Edizioni Fonte d'Abisso, Modena, 1982.

Maurizio Calvesi - Ester Coen, *Boccioni* (catalogue of the work), Edizioni Electa, Milan, 1983.

Giovanni Lista, *Giacomo Balla futuriste*, Éditions L'Âge d'Homme, Lausanne, 1984.

Maurizio Fagiolo - Daniela Fonti, *Severini*, (catalogue of the work), Edizioni Daverio-Mondadori, Milan, 1985.

Gino Agnese, *Marinetti, una vita esplosiva*, Camunia Editore, Rome, 1990.

Giovanni Lista, *F. T. Marinetti, l'anarchiste du futurisme*, Éditions Séguier, Paris, 1992.

THEORY AND IDEOLOGY

Luigi Scrivo, *Sintesi del futurismo*, Edizioni Bulzoni, Rome, 1968.

Giovanni Lista, *Futurisme: manifestes, documents, proclamations*, Éditions L'Âge d'Homme, Lausanne, 1973.

Giovanni Lista, *Marinetti et le futurisme*, Éditions L'Âge d'Homme, Lausanne, 1977.

Giovanni Lista, *Arte e politica: il futurismo di sinistra in Italia*, Edizioni Multhipla, Milan, 1980.

Filippo Tommaso Marinetti, *Le Futurisme*, (edited by Giovanni Lista), Éditions L'Âge d'Homme, Lausanne, 1980.

Giovanni Lista, *Futurisme: abstraction et modernité*, Éditions Trans/Form, Paris, 1982.

FREEWORD WRITING AND TYPOGRAPHICAL CREATION

Glauco Viazzi, *I Poeti del futurismo (1909-1944)*, Edizioni Longanesi, Milan, 1978.

Giovanni Lista, *Le Livre futuriste*, Éditions Panini, Modena-Paris, 1984.

Filippo Tommaso Marinetti, *Les Mots en liberté*, (edited by Giovanni Lista), Éditions L'Âge d'Homme, Lausanne, 1985.

Christine Poggi, *In Defiance of Painting: Cubism, Futurism and the Invention of Collage*, Yale University Press, Yale, 1992.

STAGE AND THEATER

Filiberto Menna, *Enrico Prampolini*, Edizioni De Luca, Rome, 1967.

Mario Verdone, *Teatro del Tempo futurista*, Edizioni Lerici, Rome, 1969.

Giovanni Lista, *Théâtre futuriste italien*, 2 volumes, Éditions L'Âge d'Homme, Lausanne, 1976.

Giovanni Lista, *La Scène futuriste*, Éditions du Centre National de la Recherche Scientifique, Paris, 1989.

Giovanni Lista, *Lo Spettacolo futurista*, Edizioni Panini, Florence, 1990.

ARCHITECTURE

Luciano Caramel - Alberto Longatti, *Antonio Sant'Elia*, (catalogue of the work), Arnoldo Mondadori Editore, Milan, 1987.

Ezio Godoli, *Architettura moderna: il futurismo*, Edizioni Laterza, Bari, 1983.

PHOTOGRAPHY AND MOTION PICTURES

Mario Verdone, *Cinema e letteratura del futurismo*, Edizioni Bianco e Nero, Rome, 1967.

Anton Giulio Bragaglia, *Fotodinamismo futurista*, (edited by Antonella Vigliani-Bragaglia), Edizioni Einaudi, Turin, 1970.

Giovanni Lista, *Futurismo e fotografia*, Edizioni Multhipla, Milan, 1980.

Giovanni Lista, *Photographies futuristes italiennes (1911-1939)*, Musée d'Art Moderne de la Ville de Paris, Paris, 1981.

Arnaldo Ginna - Bruno Corra, *Manifesti futuristi e scritti teorici* (edited by Mario Verdone), Edizioni Longo, Ravenna, 1984.

Giovanni Lista, *I Futuristi e la fotografia*, Museo Civico d'Arte Contemporanea, Modena, 1985.

Giovanni Lista, *Futurism and Photography*, Merrell Publishers, London, 2000.

MUSIC

Francesco Balilla Pratella, *Autobiografia*, Edizioni Pan, Milan, 1971.

Luigi Russolo, *L'Art des bruits*, (edited by Giovanni Lista), Éditions L'Âge d'Homme, Lausanne, 1975.

EVERYDAY ART

Giovanni Lista, *L'Art postal futuriste*, Éditions Jean-Michel Place, Paris, 1979.

Filippo Tommaso Marinetti - Fillia, *La Cuisine futuriste*, (edited by Nathalie Heinich), Éditions Métailié, Paris, 1982.

Lia Lapini - Carlo V. Menichi - Silvia Porto, *Abiti e costumi futuristi*, Palazzo Comunale, Pistoia, 1985.

BIBLIOGRAPHY

Enrico Falqui, *Bibliografia e iconografia del Futurismo*, Edizioni Sansoni, Florence, 1959.

Jean-Pierre Andréoli De Villers, *Le Futurisme et les arts: bibliographie (1959-1973)*, University of Toronto Press, Toronto, 1975.

Gaetano Mariani and others, *Futurismo italiano*, Edizione Archivio Italiano Cooperativa Scrittori, Rome, 1977.

PHOGRAPHIC CREDITS

AKG photos, Paris: p. 22 (center), Giovanni Lista Archives, Paris: cover, p. 2, 5, 11, 16, 17, 18-19, 20, 24-25, 25, 26, 28-29, 30, 31, 32, 34, 35, 36, 37, 39, 46, 47, 50, 51, 54-55, 56 (left), 62 (left), 62-63, 64, 65, 72, 73, 75, 76, 88, 89 (right), 90, 91 (below), 92, 93 (below), 95 (above), 97, 98, 99, 100, 101, 102, 103, 104, 105, 106, 110 (left), 120-121, 122, 128, 130, 131, 133, 134, 135, 136-137, 138, 139, 140-141, 142, 143, 145, 146, 147 (above left; below left), 148, 149, 150 (above and below right), 151, 152 (left), 154, 155, 156, 157, 158, 159, 160, 166, 167, 168, 171, 172, 173, 174-175, 175 (right), 178 (right), 182, 184 (below), 186 (left), 187, 188, 192, 193, 194, 195, 196, 201, Bibliothèque Nationale de France, Paris: p. 54, 58 (left), The Bridgeman Art Library, Paris: p. 6-7, 44-45, 53, 56-57, 60-61, 79, 83, 112-113, 114, 115, 116, 117, 119, 164-165, 170, Centre de documentation du Musée National d'Art Moderne, Centre Georges Pompidou, Paris: 70 (left), 93 (above left), Civica Galleria d'Arte Moderna, Milan: p. 14-15 (photo Marcello Saporetti), 22-23 (photo Marcello Saporetti), 80 (photo Marcello Saporetti), 89 (left, photo Marcello Saporetti), Civico Museo d'Arte Contemporaneo, Milan, p. 52-53 (photo Marcello Saporetti), 82 (photo Marcello Saporetti), 91 (above, photo Marcello Saporetti), Gino Agnese Collection, Rome, p. 186 (right), Giorgio Franchetti Collection, Rome, p. 200, Private Collection, p. 180, Courtesy artist, p. 203, Courtesy Galleria Arte Centro, Milan, p. 189, Courtesy Galerie Beaubourg, Vence, p. 202, Courtesy Galerie C. et A. Bailly, Paris, p. 107, Courtesy Galleria Gian Ferrari, Milan, p. 181, Courtesy Galleria Il Vicolo, Genoa, p. 176, Courtesy Galleria Il Narciso, Turin, p. 177, 185, 190, 191, Galleria d'Arte Moderna, Brescia, p. 33, Galleria Comunale d'Arte Moderna, Rome, p. 174 (left), Kagoshima City Museum of Art, Japan, p. 123, Kröller-Müller Museum, Otterlo, Holland, p. 70-71, Kunsthaus Zurich, p. 81, Musée de Grenoble, p. 86, 109, 178 (left), 179, Musée National d'Art Moderne, Centre Georges Pompidou, Paris, p. 69, 108, 110-111, Musée de la Mode et du Textile, Paris, p. 204 (UFAC Collection), Musée Toulouse Lautrec, Albi, p. 9, Museo di Arte Moderna e Contemporanea di Trento e Rovereto, p. 1, 93 (above right), 94, 95 (below), 126-127, 129, 144, 147 (right), 152-153, Museo Centrale del Risorgimento, Rome, p. 22, Museum of Modern Art Ludwig Foundation, Vienna, Austria, p. 205 (loan from the Ludwig-Stiftung, Aachen, Photo MMKSLW/Lisa Rasti), The Museum of Modern Art, New-York, p. 38, 48-49, 58-59, 74, 87, Museum of Art, Rhode Island School of Design, Providence, p. 21, The Peggy Guggenheim Collection, Venice, p. 84 (The Gianni Mattioli Collection), 85 (The Gianni Mattioli Collection), p. 77 (The Solomon R. Guggenheim Foundation), p. 96 (The Solomon R. Guggenheim Foundation), The Solomon R. Guggenheim Foundation, New-York, p. 68 (Photo David Heald), Scala Group, Florence, p. 19, 22-23, 80, 89 (left), 150 (below left), Staatsgalerie, Stuttgart, p. 78, Van Der Heydt-Museum, Wuppertal, p. 67, Yale University Art Gallery, New-Haven, p. 161.

© ADAGP Paris 2000: Giovanni Boldini, Giacomo Balla, Carlo Carrà, Gino Severini, Fernand Léger, Fortunato Depero, Mario Sironi, Francis Picabia, Jacques Villon, Georg Grosz, Giuseppe Oriani, Frantisek Kupka, Natalia Goncharova.
© Succession Marcel Duchamp/ADAGP, Paris 2000: Marcel Duchamp.
© Estate of Roy Lichtenstein, New-York/ADAGP, Paris 2000: Roy Lichtenstein.
© Succession Delaunay/L & M Services B.V. Amsterdam 201110: Robert Delaunay.
© 2000 The Gianni Mattioli Collection.
© 2000 The Solomon R. Guggenheim Foundation.

The publisher remains at the disposal of the concerned parties regarding the iconographic sources that we were not able to identify.

ACKNOWLEDGEMENTS

The Éditions Pierre TERRAIL and the author wish to thank Gabriella Belli,
Laura Biancini, Ester Coen, Sandra Divari, Claudia Gian Ferrari,
Laura Mattioli-Rossi, Aude Simon, Suzanne Warner, as well as Gino Agnese,
Piercarlo Bellagente, Massimo Carrà, Jean-Luc André d'Asciano, Errò,
Giorgio Franchetti, Jan Huebner, Didier Lénart, Carlo Mansuino, Marzio Pinottini,
Carlo Prosser, Francesco Scaglione, Éric Valentin
for their invaluable contribution to this work.

This book is printed in
ITALY - Grafiche Zanini - Bologna